Museum and gallery education: a manual of good practice

Edited by
Hazel Moffat and
Vicky Woollard

Museum and gallery education: a manual of good practice

ALTAMIRA
PRESS

A Division of
ROWMAN & LITTLEFIELD PUBLISHERS, INC.
Walnut Creek • Lanham • New York • Toronto • Oxford

ALTAMIRA PRESS
A division of Rowman & Littlefield Publishers, Inc.
1630 North Main Street, #367
Walnut Creek, CA 94596
www.altamirapress.com

Rowman & Littlefield Publishers, Inc.
A wholly owned subsidiary of The Rowman & Littlefield Publishing Group, Inc.
4501 Forbes Boulevard, Suite 200
Lanham, MD 20706

PO Box 317
Oxford
OX2 9RU, UK

First Published in Great Britain, copyright © 1999 by the Stationery Office
Typeset by Graphics Matter Limited, Lowestoft
Copyright © 2004 by AltaMira Press

British Library Cataloguing in Publication Information Available

A Library of Congress CIP catalogue record has been applied for.

ISBN 0-7425-0408-5

Printed in the United States of America

♾™ The paper used in this publication meets the minimum requirements of American
National Standard for Information Sciences—Permanence of Paper for Printed Library
Materials, ANSI/NISO Z39.48–1992.

CONTENTS

FOREWORD

Many of us concerned with the promotion of museum education have long regretted that the substantial 1973 UNESCO *Museums and Monuments* series bestseller *Museums, Imagination and Education* (UNESCO, Paris) co-authored by some of the world's leading museum education practitioners, has long been out of print, though it is of course still readily available in museum and general libraries around the world. Far worse was the fact that the serious international financial problems of the late 1970s meant that the follow-up to this book, examining and promoting the museum's potential in more informal learning, was never formally published. However, that proposed additional manual, based on very different case studies covering 13 countries across the world, *Museums as an Educational Instrument: A Study for UNESCO on Museums as Out-of-school Activity*, was nevertheless completed in 1978 and very widely distributed in duplicated form (UNESCO Ref. ED.78/WS/7).

This new manual is therefore a very welcome, indeed vital, addition to the international literature of museums and gallery education. It brings both a practical and a philosophical perspective to what an increasing body of both museum professionals and educators see as a central function of museums. The focus is very much on education as a central and vital role of museums and galleries, and on the development and promotion of specialist expertise and services in the field. This approach to education in museums has become increasingly accepted over the past half century or so. We have certainly moved on from the days of the early 1960s, when the then Education Committee of the International Council of Museums (ICOM) voted to dissolve itself because of irreconcilable ideological differences between traditionalist curators and guide-lecturers on the one hand and the professional educators of the children's museum and museum education services movements, insisting on a child-centred view of museum education, on the other.

The ICOM International Committee for Education and Cultural Action (CECA), established as a replacement for the dissolved committee in 1963, has promoted the modern view of museum education reflected in the key UNESCO and UK studies cited above. However, there are still very many museums and galleries, indeed whole countries, where education is still regarded as no more than the provision of formal – often very academic – lectures or guided tours. Even more cynical and worrying is the view, found in some more commercially oriented museums, that education should be seen as no

more than a revenue-earning element of the museum's commercial operations, an extension of marketing and promotion.

Drawing on a range of internationally respected authors and their practical experiences in museum and gallery education, this new book, *Museum and Gallery Education: A Manual of Good Practice*, through both its main texts and its supporting materials – summaries of key points, references, bibliography, glossary and address list – should serve as a benchmark for museum education development and provision for many years to come. The main chapters and case studies offer much to specialists, such as museum education staff and students, and to wider audiences including museum directors. managers, curators and policymakers in both cultural and educational services.

Patrick J. Boylan
Professor of Heritage Policy and Management
City University
London

PREFACE

Museums and galleries make our world accessible, whether they are displaying the life of people remote in space and time, the work of immediate predecessors, the natural history of local and more distant environments or the creativity of present-day artists and craftspeople. The very collections can excite wonder, pleasure and curiosity.

However, visitors do not automatically get access to the meanings embedded in each item by simply looking or touching, where this is possible. Many forms of interpretation, from the ubiquitous label to the particular juxtaposition of objects and specimens and a variety of audiovisual resources, can contribute to visitors' understanding and enjoyment. Increasingly, interpretation is taking into account the varying learning needs and styles of visitors, as educators and audience advocates are involved in exhibition planning teams.

As well as the interpretation available at all times in the exhibition spaces, education programmes can add considerably to the enjoyment, insights, knowledge, skills and capabilities of young and old alike. What is also special about museums' and galleries' capacity for facilitating learning is that they can appeal not only to the many different styles of learning attractive to all age ranges but also to many people's desire to relate what they see to their own particular experiences. In other words, learning in museums and galleries or in their outreach programmes is not simply about acquiring a body of knowledge or specific skills, although individuals may choose to do both of these things. It is also about providing the freedom for people to make sense of their own life experiences through their personal responses to individual items or whole collections. These responses could be to do with tastes, emotions or memories triggered by what is absorbed through their senses.

Over the past two centuries, museums and galleries have seen the steady development of education practice. From the simple beginnings of the guided tour, museums and galleries had begun to encourage school visits and to loan collections by the end of the 19th century. Now, museum and gallery education embraces many disciplines and practices. Some have evolved out of the museum context itself, such as exhibition design or visitor studies. Others have been borrowed and developed from other fields of study and research such as psychology or from the commercial world, marketing and sponsorship. As can be seen from the chapters and case studies that follow, education in any museum or gallery, anywhere in the world, can incorporate face-to-face teaching, the use of interpretative materials such as handling

collections, activities for all ages and interests, and the opportunity to design exhibitions.

Some practitioners may well argue that the term 'education' is redundant, as the emphasis should be towards visitors being in control of their own learning, with the museum professional's role being to ensure that the context and content of the collections inspire and bring about knowledge and understanding. However, many museums and galleries are still engaged in education by using a whole range of strategies to lead the visitor to make connections in the displays.

For many of the authors in this book, education is central to the activities and policies of their institutions. They are the fortunate few. In the majority of museums and galleries, education is still considered an accessory, there only on occasions and at the periphery. Educational staff are not included in debates or in the decision-making process. This situation limits the opportunities for learning from the very collections which had been gathered to help us understand the past and present world. Furthermore, a failure to use a collection as an educational resource sets the museum or gallery apart from the community it serves, encouraging the view that it is irrelevant or − far worse − unnecessary.

The UK is often thought to have a forward-looking approach to museum and gallery education, but during 1994/5 one of the largest-ever surveys of museums and galleries found that over half did not offer any educational service at all. The report, *A Common Wealth: Museums and Learning in the United Kingdom* (1997), found that those which did were scattered haphazardly across the UK and were varied in both quality and quantity of provision. This report made a very strong argument for the need for investment in both financial and staff terms. We support those aims and hope that this book contributes to generally raising awareness of the value of museums and galleries to society.

Hazel Moffat
Vicky Woollard
July 1999

ACKNOWLEDGEMENTS

We would first like to thank all those who came from some 30 countries to attend the British Council seminars on museum and gallery education in 1996 and 1997, in London. They shared a wealth of experience with us. To the seminar delegates who contributed to this manual we owe a particular debt of thanks. We should also like to thank most warmly those colleagues in the UK who contributed to the seminars and have written chapters. We are grateful to Professor Patrick Boylan who, as well as writing the Foreword, commented constructively on a draft of the manual.

Work such as this does not emerge in isolation. We should like to acknowledge the books written and edited by Eilean Hooper-Greenhill, which have done much to identify key issues in museum and gallery education and have played a part in making many of us more reflective practitioners. We are grateful to the British Council not only for inviting us to run the museum and gallery education seminars, but also for contributing to the administrative costs of preparing the manual. Finally, we thank our families for their forbearance and support when deadlines loomed.

Hazel Moffat
Vicky Woollard

ABOUT THE GENERAL EDITORS

Hazel Moffat writes, advises and lectures on museum and gallery education. Formerly an HM Inspector, with national responsibility for museum education, she has served as a council member of the Association of Independent Museums, is an honorary member of the Group for Education in Museums and a member of the International Council of Museums and the American Association of Museums. She co-directed the British Council seminars on museum and gallery education in 1996 and 1997.

Vicky Woollard is a lecturer in the Department of Arts Policy and Management, City University, London, and a museum education consultant to individual museums and related agencies. She previously spent 18 years in museum education at three London museums: the Horniman, the Museum of London and the Geffrye. She is a committee member of the Group for Education in Museums and, in 1996 and 1997, was co-director of the British Council seminars on education in museums and galleries.

Chapter 1 MAKING THIS MANUAL WORK FOR YOU

Hazel Moffat
and
Vicky Woollard

This book is called a manual because of both its practical and philosophical use to anyone interested in museum and gallery education. It explains what has been done to develop educational possibilities in museums and galleries, why staff have chosen to work in particular ways and the outcomes of their work. It is not a catalogue of easy successes; in many cases it shows the painstaking work of building common goals with colleagues and the many other agencies who have responsibility for education, while still catering for the needs of existing and potential visitors. Nor is this manual like the kind of car manual that recommends the correct way of working on a precise make of car with very specific tools to achieve guaranteed outcomes. Instead, it encompasses a wealth of experience gained by people who have worked in very different circumstances with very diverse collections, but who nevertheless have similar commitments to two goals: enabling museums and galleries to fulfil their educational mission; and producing work of the best quality possible.

It is hoped that this book will encourage practitioners to enter the debate of what is 'good practice', not only for the profession but also for the visitor. While acknowledging that there is no single 'right way' to develop education practice, the examples of good practice featured here have been chosen to highlight processes, strategies and materials which have been seen to work and which, above all, have left members of the public satisfied with the learning experiences on offer. We believe that the process of thinking about and developing good practice in museum and gallery education in this manual is enhanced by two factors:

- The experiences of museum and gallery education in a wide range of countries where many challenges are shared, but where the needs of different communities provide particular contexts for educators.
- The cross-fertilisation of ideas where educators not only have to work with a great diversity of collections, but also with contemporary artists and craftspeople. This develops varied ways of understanding and responding to the past, to recently produced work and to work in progress.

The examples of good practice have been designed to encourage reflection about the applicability of theories and the diversity of

practice. It is hoped that this habit of reflection will enable you to be selective, to reconsider existing practice and to make decisions about how possible changes can be made.

The manual shows how any museum or gallery can establish sound foundations for fulfilling the educational aspect of its mission. These foundations depend on many factors, which are the main themes of this book:

- Developing a policy for an education service at the outset. The process of doing so and the common aims reinforced by the policy can enable priorities to be agreed to make the best use of limited staff time and other resources (see Chapter 2).
- Ensuring that exhibition planning takes learning needs into account while developing additional learning programmes and support materials (see Chapters 3 and 4).
- Identifying potential visitors (audiences) and responding to their diverse learning needs (see Chapters 5, 6, 7 and 8).
- Accepting the need for evaluation in order to check that aims have been achieved and to find out if any improvements are necessary (see Chapter 9).
- Determining the staff's training needs and using a variety of training techniques to satisfy them (see Chapter 10).
- Responding to local and national policies and, where possible, playing a part in influencing them (see Chapter 11).
- Appreciating the value of international links to learn from others' achievements and problems, and finding ways to strengthen those links (see Chapter 12).

Finding routes through the manual

The chapters reflect the main themes of the book, as described above. Response to the chapter theme, its problems and successes form the body of each chapter which concludes with a list of key points and recommended texts. Five of the chapters are illustrated with additional case studies, many of them from contemporary art galleries.

In addition to the main themes, several subsidiary themes are included. Many main and subsidiary themes are found in more than one chapter or case study and these are listed below, with brief outlines of the main points:

Relating theory to practice

The projects described in this manual are underpinned by various theories, such as those summarised in Hein and Alexander (1998), to

help clarify and strengthen the role of education in museums. Here are some examples of how theories have been applied to learning and public culture.

- People learn in different ways and therefore have different learning needs. The implications of this for diversity in exhibition design is central to Chapter 3.
- Learning can be stimulated through different forms of interaction where several senses are engaged. Interaction, both with exhibits and with members of small groups such as families, is an important dimension in the potential for learning described in Chapter 7. Chapter 4 discusses how a range of interactive support materials can extend the way that people learn about exhibits.
- Learning can be enhanced through comparisons. The application of this theory to museum and gallery staff's own learning is the theme of Chapter 12.
- Communities have a key part to play in the interpretation of their heritage and of art forms produced by others. They are no longer treated simply as the recipients of culture whose material remains are interpreted only by museum and gallery staff. The ways in which different ethnic groups can work with museums and galleries to give their points of view are covered in Chapter 5. An outreach programme which empowers groups of local people to share their histories was developed by the National Museum of Colombia and features in Chapter 8. Case Study 3 shows how a contemporary art gallery worked with builders to learn about their responses to new exhibitions, while Case Study 4 shows how different communities were encouraged to respond to sensitive issues.

Developing new audiences

Museums and galleries must be continually aware of the make-up and size of their audience. Education services in museums and galleries can play a significant part in attracting new audiences, whether by targeting groups with characteristics in common, such as cultural minorities, or by attracting individuals through an imaginative and mixed programme of activities.

- Taking the decision to develop a new audience needs to be placed in the broader context of the education policy and the overall aims and objectives of the museum or gallery itself. Chapter 2 demonstrates the need for careful examination of the strengths and weaknesses of the organisation before embarking upon such a project.

- Ways of establishing contacts with specific groups and determining their interests and needs are the main focus of Chapters 5 and 8, and Case Studies 3 and 4. They also feature in Chapter 4 and Case Study 1.
- One method of attracting visitors is to accommodate a range of learning styles in the exhibitions, as described in Chapter 3.

Enabling visitors to make their own meanings

Following post-modernist thinking, some museums and their staff are reconsidering how stories are told through displays, exhibitions and other material. Opportunities are being made to allow several authors to create different texts using the same material (the collections) and sometimes those authors come from the general visiting public. In this book we see a number of examples of this:

- Chapter 8 describes how local people using everyday objects from the past help to redefine their communities.
- In Case Study 1, children were asked to select and interpret the collections at the Boijmans Van Beuningen Museum.
- Such interpretation can be done in implicit ways, as seen in Chapter 4 where the staff believe in visitors being given every opportunity to make their own conclusions from the evidence put before them.
- Social interaction between families, which can enable them to make their own meanings, is discussed in Chapter 7.

Working with people with physical, cognitive and sensory disabilities

Many museums and galleries have worked over a number of years with groups and individuals who are disabled or who have special educational needs. Increasingly, governments require all museums and galleries to improve access to buildings and services. In the UK, for example, such requirements are made in the Disability Discrimination Act and this applies, of course, to education provision in museums and galleries. Appropriate strategies are needed to understand the particular needs of people with physical, cognitive and sensory disabilities and to develop suitable educational materials and programmes for them.

- Ways of identifying the needs of children with visual impairments, developing programmes and resources, and working with pupils' families and specialist agencies are included in Chapter 4.
- Liaison with specialist agencies can contribute to museum and gallery staff's professional development in responding to the needs of people with disabilities, as shown in Chapter 10.

- The advantages of learning from expertise developed in other countries is included in Chapter 12.
- Basic facilities necessary for visitors with disabilities are included in Chapter 7.

Creating new resources for education

A major part of museum education work is interpreting the collections in ways which will attract and develop the interests of a wide-ranging public and be appropriate to their intellectual, emotional and physical needs. Devising support materials, be they worksheets or other audiovisual aids, demands staff time and expertise. None of these materials can be developed without prior research nor should they be expected to have a long life. All materials need constant evaluation and frequent updating. There is a wealth of examples in the chapters and case studies, including:

- replicas and herb gardens (Chapter 4)
- materials made primarily for outreach work such as the Museum-in-a-Box project in Botswana (Case Study 5), and oral history tapes and CD-ROMs in South Australia (Case Study 6)
- materials for use with family groups (Chapter 7).

New technologies

New technologies offer many opportunities for communication in the various aspects of a museum's or gallery's functions. Exhibitions can incorporate computers to provide additional information, engage the visitor in some interaction to provoke thought, and increase understanding. Visitors can also 'visit' museums via the Internet to gain an overview of the collections as well as look more thoroughly at records. Behind the scenes, museum and gallery professionals can communicate across the world using faxes, e-mail and video conferencing. Though some authors have made reference to information technology (IT), it should be noted that the world of hi-tech education is still not available to many small museums and galleries.

- Schools are the one particular visitor group which has been targeted for IT projects. The Boijmans Van Beuningen Museum in Case Study 1 is the first Dutch museum to have created a special website for pupils. The Vasa Museum in Sweden (Chapter 4) encourages children to take part in an ongoing conversation about their visit by e-mail.
- To create such complex communication systems a range of skills and

knowledge is needed. Case Study 6 lists a number of different agencies involved.

- Chapter 9 looks at the significance of computer packages in delivering accurate and complex data for the evaluation of a service.
- The importance of disseminating information internationally to colleagues through the Internet is discussed in Chapter 12.

Working in partnership

Working in partnership with other organisations has become a necessity for many museums and galleries, not only for reasons of financial prudence but because of a belief that partnership enriches all those who contribute. Partnerships vary according to the characteristics of each partner and the individual aims and objectives each wishes to accomplish. Some partnerships can be purely financial, exchanging money for knowledge, staff time or publicity; others can involve a pooling of expertise, resources and solutions which benefit all equally. We see through the chapters and case studies a number of partnerships working:

- between museums and schools, as in Chapter 4
- between museums and community groups, as in Chapters 5 and 8
- between one museum and another, as in the exchange programmes discussed in Chapter 12.

Managing people, finances and resources

Management is concerned with providing mechanisms and approaches to enable people to carry out their jobs in an efficient, effective and economic way. This involves funding programmes, allocating responsibilities to other staff and maximising opportunities appropriate to the available resources. It is important that museum educators take this aspect of their work seriously and that they ensure their management skills are continually reviewed to tackle the changes and challenges in the museum world today.

- Management is concerned with delivering policy and Chapter 2 looks at the process and purpose of policymaking in great detail.
- A number of case studies outline their aims and objectives for either projects or for the gallery or museum as a whole (see Case Studies 2 and 4). Having clear objectives enables staff to assess the short- and long-term benefits as well as highlighting weakness; see Chapter 6 and Case Study 1 for good examples.

- With clear objectives, it is easier to evaluate the service. Chapter 9 looks at this area in detail and demonstrates the advantages.
- The success of some educational or multidisciplinary teams shows how small groups of people can accomplish so much more than individuals, not just in terms of production but, more importantly, in creating more imaginative and better-planned projects. This is fundamental to the exhibition work discussed in Chapter 3 and Case Study 6, and is also highlighted in Chapters 2 and 12.
- Management is concerned with maintaining a skilled and competent staff and Chapter 10 looks at a range of strategies to accomplish this.
- Funding and staffing projects with limited resources is a common factor across the world and Case Study 6 shows how ideas can be adapted in order to work on a limited budget, while Chapter 12 demonstrates a number of ways in which individuals can raise funds for travel abroad.
- Raising finances can involve a range of partners, be they commercial businesses (Chapter 3) or government agencies (Case Study 6).

Projects relevant to smaller museums

The examples of museum and gallery learning in this manual all originate in large museums and galleries. However, many of the suggestions are applicable to small museums and galleries where, for example, there is no education specialist on the staff or where the whole institution is staffed by volunteers.

- Whatever the size of a museum or gallery in terms of staffing or collection, an education policy is essential to clarify priorities, as described in Chapter 2.
- Choosing more than one way of displaying the collections is also essential in order to cater for the different learning needs of visitors. Aspects of the different styles of exhibitions described in Chapter 3 are therefore useful for smaller institutions.
- Additional learning resources can be developed to supplement some elements of the displays. Ideas can be selected from those given in Chapters 4, 6 and 7.
- Evaluating whatever learning strategies are used in the exhibitions and supplementary material will benefit small as well as larger museums and galleries (see Chapter 9).
- All staff, whether salaried or volunteers, need to make a commitment to continued professional development. Examples of a wide range of training opportunities are given in Chapter 10 and 12.

Evaluating educational projects

Evaluation is an integral part of ensuring that museum and gallery education is achieving its aims and providing effective services. It needs to be built in to the development of the service as a whole, and to individual programmes and projects.

- Evaluation as part of the development of a whole education service is discussed in Chapter 2.
- The ways in which education services make use of evaluation is the main focus of Chapter 9 and is discussed in Chapter 6 and Case Study 7.
- The importance of evaluating training needs is covered in Chapter 10.
- The present lack of evaluation of international links and suggestions for ways of evaluating them in the future are outlined in Chapter 12.

Responding to local and national policy decisions

Various local and national policy decisions have an impact on museum and gallery education.

- Some policy decisions relate to the formal education sector, particularly to schools, and these have to be taken into account when museums and galleries wish to attract schools' use of their resources. Responses at a national level are discussed in Chapter 11. Examples of individual museum and gallery responses are included in Chapter 4 and Case Study 5.
- Whether at local or national level, financial decisions can often have implications for the continuation of museum and gallery education work. Outreach activities described in Chapter 8 depended on local authority funding and could not continue when the funding ceased.
- The political climate can affect the relationship of museums and galleries with their communities and the type of education programmes developed. This underpins Case Study 4.

Starting new initiatives

Educationists need to be innovative if they are to capture the imaginations of audiences (actual and potential) and other museum staff and sponsors (government or private). New initiatives can arise from a variety of sources; they need a little daring, commitment and sound research if they are to succeed in any way.

- Links with outside agencies are key, such as those developed in Chapter 4 when an art teacher working with children with visual disabilities contacted the Vasa Museum in Stockholm.
- The potential for exploiting the educational opportunities created by

a new construction was taken up by the new contemporary art gallery, Kiasma, Finland (Case Study 3) when staff worked with the builders on the site of their new building.

- Other projects can be developed by a group, as described in Chapter 10. Education staff from various museums and galleries brought together their expertise, resources and observations to form a piece of active research.

How the manual came about

All the chapter and case study authors from outside the UK attended one of two British Council courses held in 1996 and 1997, both on the theme *Learning in Galleries and Museums: Towards an Education Policy* (see Moffat and Woollard 1996). The courses drew on good practice in museum and gallery education in the UK and enabled delegates from some 30 countries to share their own, in many cases considerable, experience in this field. Appendix 5 provides an outline of the two courses, to help others planning such training, and Appendix 6 has a participant's evaluation of this and another course. The UK-based chapter authors led or contributed to the courses or were part of an organisation involved in the courses. Course members were invited to contribute to the book according to their areas of expertise.

The contributors to the book bring an immense wealth of knowledge and skills based on practice in museums and galleries worldwide. At the same time the contributors have shared a common experience on the courses. The manual fulfils an aspiration expressed by delegates on the courses to continue the professional dialogue and draw together in a publication ideas and information which could empower and inspire other museum and gallery educators.

The manual builds on the process of sharing which characterised the courses. It is intended that reflection about all the work described will not lead to carbon copies of projects and processes but will encourage others to adapt them in the light of their own circumstances while holding to the value which those concerned about museum and gallery education everywhere have in common: a passion for creating opportunities for people to be inspired by and learn in a wide variety of ways from the collections.

Key texts

Anderson, D. (1997). *A Common Wealth: Museums and Learning in the UK*. Department of National Heritage.
This report examines the state of museum education in the UK and finds that

there is a need for further provision within the context of a national policy. It argues the case for museums and galleries being at the heart of society through the educational opportunities they offer. The report provides the reader with case studies and key recommendations which would be appropriate for any country.

Hein, G. E. and Alexander, M. (1998). *Museums: Places of Learning.* American Association of Museums.
In this concise summary of a wide range of writing on learning in museums, this booklet gives helpful outlines of many theories underpinning the diversity of learning possible in museums and galleries.

Moffat, H. and Woollard, V. (1996). Reflections on a course for museum and gallery educators. *GEM News* (63) 7–9.
This article describes the first of two British Council courses which were instrumental in the decision to write this manual. It provides the common background for all the contributors.

Hooper-Greenhill, E. (ed.) (1999). *The Educational Role of the Museum* (2nd edition). Routledge.
This is an 'omnibus' of topics looking at the issues which influence and dictate museum education practice. It includes the history of UK museum education and looks at the importance of communication theories before going into more specific issues to do with practice.

Chapter 2 DEVELOPING A POLICY FOR
Sue Wilkinson **AN EDUCATION SERVICE**
Director,
South Eastern
Museums
Education Unit

The South Eastern Museums Education Unit (SEMEU) was established in 1994 to provide education support, resources and advice to museums in the south east of England. It acts as both a consultant and as a trouble-shooter for museums who wish to develop an educational policy or have concerns about their educational work. Museums are either advised to use SEMEU by the regional directors of the South Eastern Museums Service and given a free advisory day to help them do so, or they contact us directly. The unit is funded by a grant from the Headley Trust and operates a mixed economy of free advisory days and chargeable work. Since 1994 the unit has worked in over 200 museums in the south east and run a variety of projects. The unit's staff have:

- *developed teaching programmes and resource materials*
- *written education policies and strategies*
- *carried out visitor research and evaluation*
- *written training manuals and information leaflets*
- *advised on grant applications and displays*
- *run training courses for education officers, curators and teachers.*

Over the past five years SEMEU has worked with a range of different museums and organisations. The unit has run projects in national and regimental museums, and those run by local authorities, independent organisations, universities and volunteers. The unit staff therefore have experience of working in a wide range of different types of organisations and seeing the problems that they face. The unit's remit is to work with colleagues in these institutions to expand and improve the provision they can offer to their visitors and to develop and encourage good practice in working with audiences of all ages.

One of the critical issues for many of the small and specialist museums that SEMEU has worked with has been to increase visitor figures and to broaden access for audiences who have not, in the past, made much use of the collections. These museums have tended to do education work in a rather ad hoc way, without access to specialist staff and with very little information about the needs of groups they are trying to attract into the museum. Almost all of them have no policy to guide their work. They have not thought about what they really mean by the term 'education',

nor about who they want to work with and what they are going to do. It often turns out that a museum that has called us in to assist with writing a resource pack, developing a programme for schools or training front-of-house staff is facing these issues for the first time when they brief us about the project.

As a result of this, SEMEU sought and received funding from the London Borough Grants Committee to work with four museums in London to develop education policies for their museums. The museums involved in this project were the Ragged School Museum, the Museum of Fulham Palace, the Black Cultural Archives and Wesley's Chapel. This project then fed into training courses for curators and education staff which SEMEU has run for a number of different organisations as well as for individual museum services (Wilkinson 1997).

All the courses run by SEMEU and all the work done by the unit with individual museums on policy-writing start by looking at the reasons for having a policy and the work it will involve. There are many advantages to having a written policy. Policies establish priorities. They help to guide and shape the work, and they provide an organisation with direction, cohesion and a sense of purpose which all staff can share. On a more pragmatic note, organisations with policies usually find it easier to attract sponsors and to win funds.

However, devising an education policy takes a lot of hard work. They involve lots of research, discussions and meetings. They can produce fierce dissension and criticism and they are certainly very difficult to write. They also take an enormous amount of time. It has come as a shock to many of the organisations the unit has worked with to be told that writing an education policy can take up to a year – especially if they were hoping to have the job completed at the end of a training course or an advisory visit.

Writing successful education policies

There are three critical success factors for producing a good education policy. Good policies:

- are based on detailed background research
- have the support and backing of all staff, managers and stakeholders
- establish priorities and make decisions.

The first stage of developing a policy for an education service is to know what you are taking on board. You need to look realistically at the work involved and the time it is going to take. A good policy will make clear:

- what the vision is for the organisation (its mission)
- what it hopes to achieve (its aims)
- how it proposes to realise these aims (its objectives)
- how it will know when these objectives have been reached (action plan and performance indicators).

Background research

The key feature of any policy is that it establishes priorities and makes decisions. When someone outside the organisation picks it up they should be able to see very quickly what you want to do and how you plan to do it. However, nobody can take decisions and establish priorities without having lots of information. Any museum wishing to write an education policy needs to know the baseline it is working from and the opportunities available to it. It therefore needs to review:

- the resources available for education (space, money, collections, time, facilities)
- the skills of its staff
- the profile, needs and expectations of visitors and non-visitors
- the external competition
- the networks it has or could have.

Only when the museum has all this information available can it start to think about who it is going to work with and what sorts of services and resources it is going to provide.

One of the biggest tasks for anyone writing an education policy is to identify the audience groups that the museum intends to focus on. Almost every museum wants to work with all possible audience groups. If asked at a training course who they see as their target audience, almost every person on the course will come up with a list which could be summarised as 'everyone'.

While this may be a laudable aim, in practice most small museums cannot work with everyone. Even the larger services and the nationals, with all their resources, inevitably find when they appraise their work that some groups have either slipped off the list or never set foot in the museum. Unless one has the time and resources to work with all possible audience groups it is important to decide where to target one's time and efforts in order to avoid dissipating the impact of an initiative through lack of consistency and follow-through.

It is impossible to establish the audience groups most in need or those which the museum is best equipped to serve without knowing a great deal about what visitors or potential visitors want from the museum and

how the collections can relate to their interests and learning needs. This means that visitor research is a prerequisite for anyone engaged in writing an education policy. We may think we know what families, children, adults, unemployed people or teachers want from museums but all the research in this field makes it clear that museums often get it wrong. Museums make assumptions about their visitors' skills, knowledge, tastes, interests and needs at their peril. If time and money are going to be used effectively, decisions about exhibitions, resources and programmes need to be based on hard information, not on vague generalisations, stereotypes and assumptions.

So, before beginning to write a policy it is important to find out:

- who your visitors are and how they view the services, resources and facilities you provide
- the needs of your visitors and potential visitors, including their learning needs
- how the collections relate to the learning needs of your actual and potential visitors
- what resources you have for education
- the skills your staff have and what further skills they might need if they are going to play a more active role in the education of your visitors
- the collections you have in store and what access you can provide to them
- what the competition is, including the services, facilities and resources they offer to visitors
- how visitors and potential visitors rate your museum against the competition
- the networks that are available and how you could key into them.

Not all visitor research has to be done from scratch. It is worth finding out as much as possible about any research which has already been done either nationally or by other museums within your region. It is also worth looking at the research techniques used by other museums; it might save you a great deal of time and effort.

There are also some recognised techniques for helping you with your research. You could ask colleagues to work together on a SWOT analysis of the museum's educational activities. This means that, as a group, they have to look at the strengths and weaknesses of the current service, at the opportunities available and the threats facing the museum. The SWOT analysis is usually presented as a grid, which people complete together. Ask people to prioritise their lists so that key issues are highlighted.

SWOT

Strengths	Weaknesses
Opportunities	Threats

Involving the staff

One of the critical elements in writing an education policy is involving as many of the staff and stakeholders as possible in the process. This is often seen as being too difficult for large museum services with huge numbers of staff. However, museums that do not involve their staff run the risk of developing a policy which staff are either indifferent to or actively oppose. The more staff that are drawn into the process, the more the policy will permeate the work that they do – whether it is meeting and greeting groups, supervising them in the galleries, taking their bookings or running programmes and events.

One of the first things you need to do before beginning work on your education policy (and it can be done while the background research is being carried out) is to decide what the term 'education' means. This is important not only for those writing the education policy, but for everyone in the museum. 'Education' has become something of a loaded word. For some people it means the formal process of teaching and learning which takes place in schools, colleges and universities, with the emphasis very much on teaching rather than on learning. For others, it has much more to do with learning; it encompasses self-education and lifelong learning and is more interactive than didactic. Many museums now see education as a core function, though others still view it as an add-on service.

These issues need to be resolved as part of the policy-writing process. While it is not always possible to involve all staff in writing an education policy, they do all need to share in the museum's vision and to support the priorities and choices it has established. Without this sense of shared understanding, ownership and direction the policy will be obsolete even before it has been formally adopted.

Building team ownership of the policy

There are two games which have been developed by SEMEU which can be used to establish a sense of the process involved in policy-writing and to develop shared values which can feed into developing a mission statement.

The first is the spaceship game. This game asks everyone to decide individually on seven items of personal significance that they would take with them on a spaceship. Once everyone has completed this sheet they then have to do the exercise again, but as a group. The group can only take seven items altogether and these must be drawn from everyone's individual lists. Once the group list is completed, the answers can be written on a blackboard or flipchart. Then ask the group to list the skills they used to complete the exercise. The list should contain skills such as listening, talking, negotiating, prioritising, humour and decision-making. Once all the skills have been listed, the session leader should explain to the group that they would need all these skills to write an education policy, especially the skills of decision-making, prioritising and negotiating. This game works very well as an ice-breaker and team-builder. It doesn't require any previous knowledge to complete the sheets and people generally find the game both fun and useful.

The second game is the statement game. Everyone is given a list of statements about education and a large sheet of paper with two columns, one headed Agree, the other headed Disagree. Working in groups they have to decide whether they agree or disagree with each statement and then cut it out and stick it on the large sheet under the relevant heading. It is important to make people do the cutting out and sticking because it helps to make them discuss the issues in more detail than simply going down a list. The choice of statements is the session organiser's chance to collect together views about education which they want colleagues to discuss. Statements used are designed to be controversial but also to get people to address fears, prejudices, visions, and aspirations that museum staff have expressed over the years. For example, 'Education in museums helps to secure sponsorship', 'Education allows our visitors to have fun in the museum' or 'Education raises our profile in the community'. The game is a good way of allowing people to talk about such ideas in a neutral setting. No one owns the ideas so they can debate them more freely than they might have if they had had to think of them in the first place.

Developing a mission statement

A mission statement is the starting point for the whole policy-writing process. It sets out your vision for your organisation, and everything else in the policy should then demonstrate how that vision is going to be realised. The mission statement should tell people why you exist, what you believe in, what you want to achieve and who for. Mission statements are very difficult to write. The best ones are short, punchy and inspirational. It is worth collecting and looking at other people's mission statements before starting work on your own. Don't just look at other museums' mission statements; look at those written by commercial companies as well. Some food and restaurant chains display their mission statements in every outlet. One of the most noticeable features of many commercial mission statements is that they tell you what sorts of services people can expect from the organisation. This is worth considering. Many museum mission statements tell you what the museum will do (collect, conserve, etc.) but not why they are doing it or what visitors can expect when they walk into the museum.

The statement game can, if you have chosen your statements carefully, help you to write your mission statement. When everyone has discussed all the statements, ask each group to identify the three they most agree with and the three they most object to. Write these on a blackboard or flipchart so that everyone can see them. What you will have is a series of statements about education that everyone agrees with and which can be used to help create your mission. When using this game, the same sorts of statements tend to appear in the Agree column. Statements about education being a core function of the museum appear often, as do those about the need to involve the community in any programmes and resources that are being developed.

The South Eastern Museums Service (SEMS) has an education policy. Its mission statement is as follows:

> *SEMS believes that education is central to the purpose of every museum. It believes that museums exist to provide opportunities for lifelong learning and for enjoyment. Our mission is to work in partnership with our members, sponsors and fund holders to promote and develop standards, policies and projects which will broaden access to collections and which will enhance the understanding, use and enjoyment of museum collections by people of all ages.*

Establishing priorities and making decisions

The point of visitor research is to enable staff to take effective and realistic decisions about:

- the role and function of education in the museum
- the target audiences the museum wants to work with
- the type and standard of service it will offer
- the networks it will develop
- the resources it will use.

These decisions are then translated into policy aims and objectives.

Developing your aims

Your aims are your goals. They will tell anyone reading your policy what it is you are hoping to achieve. They should be appropriate (it is no use, for example, deciding that you want to offer local schools a high-quality teaching service if your collections do not relate to the school curriculum), realistic and achievable. However they can also be quite broad and long term.

A useful tool for helping to develop aims is the grid below. It asks people to identify where they are now, where they want to go, how they will get there and what resources they will need. It is a way of getting people to use the background research they have done to help them think strategically and to start planning what they want to achieve. It is also a way of forcing them to be realistic. Analysing the resources needed to achieve something can mean rethinking the approach to be taken or even the goals to be achieved. The exercise should help you decide what your aims are so that you can then start writing them up.

Planning grid

Where you are	Where you want to be
How you are going to get there	What resources you will need

The grid can leave you with a whole host of objectives and the need to establish some sort of priority for the service.

Nominal group technique

A useful way of getting consensus about the aims you should be pursuing is the nominal group technique. You need to set a question which everyone then answers on their own. The question might be 'What do you see as our key aims over the next five years?' or 'What do you think should be our priorities in the field of museum education?' Everyone writes down their answers without consulting anyone else. The facilitator then goes round the room collecting one answer from each person and writing them down. When everyone has given one answer, a second is collected and so on until all the answers are written down. It is very important that only one answer at a time is collected. If the first person is allowed to give all their suggestions in one go, the last person may have nothing to contribute to the list.

Once all answers are collected, split the list into several different ones and display them around the room. Give everyone a different coloured pen and ask them to go round the room looking at all the ideas. They should then choose the five they think are the most important and record their views by placing a tick against the five ideas they consider to be the most important. When everyone has recorded their ticks, add them all up. The ideas with the most ticks against them then become the priorities for your service. You can then begin to turn these into aims.

Two sample aims from the SEMS education policy are to:

- encourage member museums to adopt the Museums and Galleries Commission's guidelines on museum education, particularly the recommendation that museums should have education policies
- encourage and assist the establishment of specialist education posts in member museums.

Deciding on objectives

Once you have decided on your aims and obtained agreement on these you then have to start translating them into objectives. Objectives are short-term goals. They demonstrate how you are going to achieve your aims. Unlike aims, they outline what you expect to achieve in an identified period of time. For example if your aim was to increase the number of families visiting the museum, one of your objectives might be to interview ten families who visit the museum over the summer holidays and ten who have never visited, to find out more about the sorts of services, facilities and resources they all want from the museum. Where possible, objectives should be SMART:

Specific
Measurable
Agreed
Realistic and Relevant
Time bound

One of SEMS' key objectives for 1997–2000 was to continue to support SEMEU (which is the principal means of achieving their aims) by:

- extending the contract of the director of SEMEU until April 2000
- running a minimum of four training days per year on museum education issues
- making a number of free advisory days available to member museums to provide access to support, resources and advice in the field of museum education.

Action plans and performance indicators

Action plans and performance indicators do not need to be included as part of the policy you take to the board, trustees or local councillors for agreement and approval. They are the tools that the education officer or museum manager will use to monitor progress and service delivery. However, it is important to develop the action plan and performance indicators as part of the policy-writing process because they enable you to work out the implications of any decisions you have taken and to modify them as appropriate. Once you start translating objectives into an action plan and look at the tasks staff need to perform in order to achieve that objective, you can then start to check whether it is possible to achieve all you intend to achieve in the timescale allocated to it. You may need to rethink your aims and objectives or to look again at your priorities for the period covered by the policy.

Evaluation

A successful policy is one which staff and stakeholders can be committed to and support. It should hold no surprises for them because they should all have been involved at some stage in the process. One measure of how successful the process has been is whether staff can tell you something about the museum's vision for its education service once the policy has been written, or if they know the key audiences the museum is working with and why.

Policies should not, however, be seen as something set in stone. They should be reviewed every three to five years because, while your mission

may remain the same, many of your objectives will be achieved along the way and your aims will therefore change. A clear example of this can be seen in the example from Boijmans Van Beuningen Museum in Rotterdam, where the education department's policy has had to change over time to reflect the needs of its public and that of the museum as a whole (see Case Study 1).

Key points

- Policy decisions should be based on thorough research.
- All staff need to be committed to the policy.
- Policies should set out a vision for the museum and should establish clear aims and objectives.
- Policies are best kept short.
- Policies need to be reviewed regularly.

Key texts

Davies, S. (1994). *By Popular Demand: A Strategic Analysis of the Market Potential for Museums and Art Galleries in the UK.* Museums and Galleries Commission. This publication provides useful information about the potential market for museums and can help with the research stage for the policy-writing process.

Davies, S. (1996). *Producing a Forward Plan: MGC Guidelines for Good Practice.* Museums and Galleries Commission. This looks at the process of writing a forward plan and guides readers through each of the stages in the process.

Dodd, J. and Sandell, R. (1998). *Building Bridges: Guidance for Museums and Galleries on Developing New Audiences.* Museums and Galleries Commission. This publication looks at techniques for broadening access to collections and for finding out what visitors need and want from museums.

Durbin, G. (ed.) (1996). *Developing Museum Exhibitions for Lifelong Learning.* The Stationery Office. An anthology which draws on a wide range of books and articles dealing with exhibition planning and design. The sections on visitor research and expectations will be useful to someone working on writing an education policy.

Johnson, G. and Scholes, K. (1993). *Exploring Corporate Strategies.* Prentice-Hall. This publication sets out a framework for corporate strategic planning and

looks at developing mission statements, aims and objectives and at the strategic implementation of these. It has useful chapter summaries.

Wilkinson, S. (1997). *Education Basics: A Training Manual for Preparing Curators to Develop their Education Work*. Committee of Area Museum Councils.
This training manual is the published version of the courses run by SEMEU. It has a section on writing an education policy which includes some of the activities outlines in this chapter with guidance on how to use them with staff. A copy of the manual was lodged with each Area Museum Council and should be available in their library or resource centre.

CASE STUDY I

Hanneke de Man
Curator of
interpretation,
Boijmans Van
Beuningen Museum,
Rotterdam

Developing and revising an education policy

In the course of its almost 150-year existence, the Boijmans Van Beuningen Museum in Rotterdam has grown into one of Europe's most important museums, famed for the great diversity of its collections. The collections of painting and sculpture, prints and drawings, decorative art and design cover a period from the Middle Ages to the present.

The museum has a long record of educational activity. The first guided tours for secondary school classes began in 1948. By the early 1970s an extensive educational department was organising tours for some 30,000 children, young people and adults from diverse backgrounds every year. Direct contact and interaction between guide and group was an essential element of these tours, with a specific work of art perhaps acting as the trigger for a discussion of colour, composition, material, technique and representation.

Changing educational concepts towards the end of the 1970s had fundamental consequences for the educational department. Guided tours were virtually abandoned in favour of written information in the form of leaflets and text panels, and a start was made with educational exhibitions and school projects. Educational work then took an art-historical approach rather than one inspired by art appreciation. The aim was no longer to arouse the enthusiasm of the uninitiated but to satisfy the interested visitor's thirst for information. This revised philosophy was confirmed by the new name given to the Educational Unit in 1987. Henceforth it was known as the Communications Department, its tasks extending to marketing and public relations.

Over the past ten years the various forms of conveying information have gradually increased in number. Individual visitors to exhibitions and presentations of the museum's own holdings are catered for with a wide range of information leaflets, audiovisuals, text panels, detailed captions and a reading area. Groups of adults can attend courses, lectures and guided tours. Schools are another important target group. There are tours for primary school classes, while a questionnaire focuses the

attention of secondary school groups on specific aspects of their visit. The museum is the only one in the Netherlands with a special website for schools, set up in 1996, at <http://www.boijmans.rotterdam.nl>.

Even though all these facilities are provided, education is now understood in the wide sense of any museum activity pursued with a view to conveying knowledge or experience to the public. This definition includes exhibitions, implying that a vision of education is in fact a vision of the museum's purpose as a whole.

In his lecture 'The active eye: rethinking art education', given in 1997, the museum's department head, Ernst van Alphen, contended that

> in the last ten years museum education has focused too exclusively on practical and instrumental matters, and has taken its goals and contents too easily for granted ... What is or are the functions of museum education? What kind of knowledge or experience do we want to stimulate or pass on?

These questions are particularly relevant in the light of the museum's ambition not only to increase the number of visitors (from about 200,000 to 220,000 a year) but also to attract a more widely varied public, one that is more international, younger and more culturally diverse. The museum hopes to achieve this aim by developing a differentiated approach to the public. The principle will also be applied to the exhibition programme. In practice, this means that concurrent exhibitions will address different groups in terms of theme, character and level of information. In 1997 the museum experimented with clustering; that is a central exhibition was surrounded by a few smaller 'satellite' presentations intended for a more specific public. An exhibition of sculptures by Max Ernst aimed at the general public was accompanied by a small, art-theoretical presentation of Surrealist photography and a 'surrealist' arrangement of the museum's own collection by guest curator Edwin Carels. A major exhibition of 17th-century marine painting was complemented by a selection of Van de Velde's drawings of ships and a photo project by Alan Sekula.

In individual exhibitions the idea is to provide highly differentiated information in terms of layers of meaning and specific target groups. Rotterdam is a city with a multicultural population. Thanks to educational activities, the youngest generation of 'New Netherlanders' have been frequenting the museum for years. Adult members of minority ethnic groups are a different case. This is the first year that the museum has explicitly targeted that group with a special project

for Moroccan women during *Pavillon du Maroc*, an exhibition of Moroccan pottery presented not in an ethnographic context, but in a museum of art.

A recent activity organised for children, *Children Choose Art*, proved interesting for a much larger target group. Pupils from a Rotterdam primary school chose their own museum favourites. In the subsequent exhibition the selected works were placed on show, along with the children's comments, poems and drawings. Artists also contributed to the project. Helena van der Kraan made a series of portraits of the pupils in poses inspired by works of art in the collection, while Daria Scagliola's collage-photos visualised the children's comments on the works. Such an exhibition exemplified a shift in the rationale evident in planning many other exhibitions.

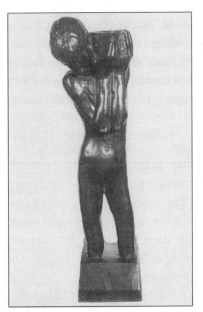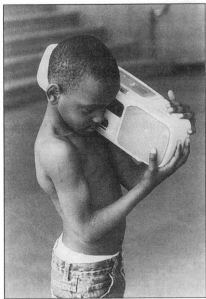

Eddy (aged 11): That boy's carrying a radio.
Majid (aged 13): But you don't do that with no clothes on. I think he's an Egyptian slave.
Photograph on the left of 'Small reliquary-bearer' by George Minne courtesy of the Boijmans Van Beuningen Museum. Photograph on the right of Eveander (aged 6) by Helena van der Kraan.

The way children look at art and interpret it was the real theme for *Children Choose Art*. In previous decades, the principal theme has been the artist's intention or the art-historical meaning of a work of art, but a number of recent exhibitions have focused on the reception and

different interpretations of art. Examples are the shows guest-curated by artist Hans Haacke and philosopher Hubert Damisch, illustrating their respective views of the museum's holdings. The Boijmans Van Beuningen Museum Policy Plan (October 1997) states that:

> the Boijmans Van Beuningen Museum's aim for the 21st century is to be a 'forum' ... in which presentations of the collections, exhibitions, lectures, courses and symposia will explore and mutually confront various visions of art and culture.

This aim and how it can be implemented in the future is a topic of considerable discussion at the time of writing, as the museum is currently undergoing a major extension, and a rearrangement of its collections is being planned for its reopening.

Methods and insights have changed radically in the half-century since the museum began its educational programme. To a certain extent those changes are reflected in the personnel of the educational department. In the beginning, educational staff had trained at art academies, but in the early 1980s they were joined by art historians and then by marketing and PR experts. The present department head had studied literary theory and taught at university.

The theme of a meeting of the Association of Dutch Museums held in 1998 was 'How can we involve the public more in modern/contemporary art in museums while retaining respect for both the public and the work of art?' During the discussion an educational worker remarked that he had taken part in the same discussion 20 years previously. He was quite right, but that does not make the current debate any less necessary. After a period in the 1980s during which PR and marketing were given more emphasis, education is now very much a central focus. However, history is not repeating itself. Given the changing views about the meaning of art and the museum's role, the answer to the question 'What are the aims of museum education?' must be that it is in need of constant reformulation.

Chapter 3 CREATING EXHIBITIONS FOR LEARNING

Jean-Marc Blais
Exhibitions
planning officer,
Canadian Museum
of Civilization

The Canadian Museum of Civilization (CMC) opened in 1989 in Hull, Quebec, and is the largest museum in Canada. Its mandate is to preserve and promote the heritage of Canada and all its peoples throughout the country and abroad, thereby contributing to the collective memory and sense of identity of all Canadians. Every year, more than 1.3 million visitors explore the museum's numerous exhibitions, attend performances, IMAX films, demonstrations, lectures and a wide range of educational programmes. Jean-Marc Blais is in charge of the exhibition development process at CMC. In this capacity, he receives proposals from within CMC and from other institutions, analyses them and makes recommendations to the museum's executive as to their suitability. For the past eight years, he has held several positions related to education and interpretation.

Setting the scene

While researching for this chapter, I became aware of a cliché made by museologists in the 1990s: museums are one of the best learning environments offered today. I would like to investigate this supposition. Let us imagine a typical Sunday afternoon visit made by a middle-aged couple and then turn to a discussion held at a Monday morning meeting of museum professionals.

When we first encounter the visitors, they are walking slowly through the temporary exhibitions hall of the museum. On their right, they can see entrances to various exhibitions on topics as diverse as folk art, traditional Inuit clothing and antique furniture. The folk art exhibition attracts their attention. They make their way through the exhibition, stopping from time to time. Let's listen in on their conversation.

'Oh, this reminds me of the old man in the village where I grew up who used to make these tacky things. Imagine finding this stuff in a museum!'

As they continue, the couple stop at a touch cart full of hands-on objects. They obviously enjoy this opportunity to interact with real artefacts. They start chatting with the animator about a wonderful item they saw, saying that it looked exactly like one they own and that they would like to donate theirs to the museum. As they end their visit to the

exhibition, the woman starts reading a panel out aloud, which describes a well known museum curator who collected these objects. She reads just one sentence, then selects an occasional word here and there.

The couple continue their walk through the rest of the museum in the same manner. They feel tired after two to three hours of seeing wonderful things and decide to leave for a nearby café, but not before visiting the museum shop to buy some Christmas gifts – gifts with some cachet as they were purchased at the museum.

The next day, a group of museum professionals meets to talk about a project that will open in the coming year. The discussion revolves around the importance of the visitor in planning an exhibition. The interpretative planner on the team points out how visitors in general react within an exhibition context and how useful it is to determine precise interpretative objectives. Despite the repeated requests to the curator to articulate the main and secondary messages that need to be communicated, evasive responses are given. Instead, he answers coldly that all these questions about questions, messages and levels of information are pointless and only hinder his plans for this exhibition, where he wants simply to display the rich collection that he has been studying for a long time.

These two fictional situations are very near the truth of what happens in museum contexts. In the first example, the visitors tour the museum at their convenience, examining showcases that attract their attention, but reading labels or panels only rarely. They had not considered, before coming to the museum, that this outing could be a significant means of learning. Should they learn or remember something from the exhibition, so much the better. Their main objective, however, was to enjoy themselves by visiting a museum, which they do infrequently. Falk *et al.* (1998) call these kind of visitors 'unfocused to focused', and they constitute a significant proportion of our visitors.

In the real context to the second example, professionals developing an exhibition may well spend their time arguing about the length of the panels and labels because there is so much information to convey. Planning this type of exhibition is an exercise where it is more important to put across the curator's perspectives than anything else. In this case, an interpretative planner or audience advocate was involved, but in reality they are often not invited.

Changing approaches to learning in exhibitions

As museologists, we can certainly play a role in increasing the learning potential of our exhibitions. In little more than a decade, museums have

drastically changed the way they define themselves in relation to society and the cultural world. From elitist institutions oriented towards research and knowledge, most museums have officially adopted a 'public' orientation, which means that visitors should be the focus of most, if not all, activities. As the examples of the middle-aged couple and the behind-the-scenes discussion given above mirror reality, museum professionals will have to work very hard to make exhibitions real learning environments, especially given that visitors tour exhibitions in a leisure context where learning only may take place. As Belcher stated: 'In the context of museums, information about the visitor is essential if informed decisions are to be made in respect of all aspects of its services to the public, and especially with regard to its main "product" – the exhibition' (Belcher 1991: 175).

Museums are becoming more orientated towards the public. I think there are three points to bear in mind when defining ourselves and what we intend to achieve.

1. Museum professionals do not all work in the same environment. My personal perspective is that of a professional working in a large institution with reasonable funding and a rich collection. When we refer to learning in museums, the size, scope and location of the museum have a tremendous impact. Leaving aside the nature of the collection, visitors do not interact in the same way when visiting small and large museums.

2. To be a genuine place for learning, museums need to define themselves as visitor-orientated and as cultural centres where many activities can be experienced, for example exhibitions of different types and on various topics, demonstrations, live interpretations and concerts. This seems to be more and more the reality. It is interesting to note that when the CMC established this approach more than ten years ago, it was highly criticised by the museum world. Since then, this expanded definition of a museum has become more generally accepted.

3. Many museum directors state that their institutions are educational, which is well liked by governments and other funding agencies. At the same time, owing to budget constraints, I believe that the first function to be cut in museums is often education. This paradox has to end. Education must become the function of the new millennium.

A few years ago a new creative process based on a team approach was introduced at the CMC to improve the entire museum experience. Most of the exhibitions are developed by a team of four professionals:

- a curator (who deals with content)
- a designer
- a project co-ordinator (who works out the logistics)
- an interpretative planner (who acts as an advocate for the public's interests).

Recently, a new exhibition development process was introduced which fully analyses any given exhibition proposal. Guidelines for the team are then established, including parameters such as the size of the budget and availability of other resources. The CMC aims to create the optimum conditions for improving the exhibitions and consequently the visitors' experience. In fact, the main objective is to place visitors at the centre of all our actions. The exhibition teams make a special effort to use a variety of approaches to communicate with our visitors, to make sure that visitors both enjoy themselves and learn.

We believe it is imperative that we keep reflecting on what we must do to create the necessary conditions for learning in our museums. Education and exhibitions should be the focus of our attention so that we can guarantee a full and complete museum experience for our visitors.

Conditions and factors for learning

In the past few years, many specialists have proposed useful and thought-provoking models to help better understand the ways visitors learn in museum exhibitions. In two issues, the *Journal of Museum Education* (1998) focused on the visitor experience in theory and practice. Many models from disciplines such as psychology, pedagogy and sociology were examined, among them socio-cultural, constructivist learning styles and multiple intelligence or behaviourist approaches. I believe that at present none of these theories have reached any sort of consensus. Some of them try to encompass so many different elements that they become either too theoretical, or worse, lack any applicability. Creating theories that are based more on actual museum practice will be more useful. We can already see the beginnings of this approach in the work of Falk *et al.* (1998).

Control of the environment

It is a common belief that learning takes place in a controlled environment. However, visiting an exhibition in a museum is anything but a controlled activity. Visitors choose their own route around the exhibitions, they choose when to pause or to pass on. Most visitors read nothing or at best a small proportion of what is written. Yet long panels

and labels are still the main vehicles used by museums to communicate with our visitors. As Scott J. Paris wrote in the *Journal of Museum Education*: 'A critical issue for museums is how to nurture autonomous learning, respecting the individual's control of what exhibits are visited and how they are engaged, yet still encourage thorough exploration of the themes, issues, and exhibits' (Paris 1998: 24).

Variety of visitors

Gender, origins, wealth, disability, education, personal interests, past experiences and psychological types are well-known factors that make each person unique. Of all of them, I believe that the last three are probably the most important ones for determining the individual's approach to learning. When an individual visits an exhibition, many mental operations influenced by these variables take place. Despite the efforts of many exhibition planners to orient exhibitions towards the general public, it is clear that in order to achieve such a goal, it is essential that we cater to the varying learning needs of individual visitors. Museum professionals have not yet understood the implication of this strategy in exhibition development; for example, time is not taken to evaluate what visitors already know about the themes of the exhibition.

Motivations

As well as their various characteristics, the public will have a multitude of reasons for visiting museums. These reasons might include the desire to view beautiful objects, to accompany friends and family, find out about the locality, while away a rainy day with the children, escape a hot summer day in air-conditioned comfort, see a newly opened exhibition, appreciate a unique collection, view the latest blockbuster, and maybe … to learn something.

Exhibition styles

Although there are many alternatives in the different types of museum exhibitions, we can distinguish two broad categories: diachronic and synchronic. The first is concerned with the development of a topic through time (chronological) while the second explains it from the point of view of a precise point in history (thematic). Both approaches provide a suitable context for learning, but it is important to keep a balance of the two within an exhibition and across a whole museum.

Since museum visitors are assumed to be in a relaxed mood, exhibitions need to be convivial. This atmosphere can be created

through the provision of adequate and comfortable seating, accessible staff, good signage, unobtrusive security and nearby refreshments and other facilities.

Theory into practice

If we believe that museums can be significant learning environments, it is imperative for exhibition planners to focus on learning. The Papalote in Mexico City is a good example of an institution that put learning at the core of its activities and, in 1994, their administrators limited the number of visitors each day to improve the quality of each individual's visit and thus of their potential to learn.

Learning in museums has very little to do with dictionary definitions, which stress the process of learning through study. Most professionals would agree that in exhibitions, learning involves looking, observing, absorbing, and above all constructing meanings from existing knowledge. This broad definition, drawn from Tassé and Lefebvre's essay (1996) on adults in museums, is a good illustration of what learning might mean in an exhibition context. Constructing knowledge comes from a variety of experiences. As there are many ways to learn, there are also many styles of learning.

By looking at how people learn and their preferred style of learning we can develop display techniques which respond to those styles. We cannot possibly deal with all the issues about how people learn, so the CMC focuses on cognitive, affective and kinetic learning styles. Individuals for whom cognitive learning predominates usually visit an exhibition in a meticulous way to acquire factual knowledge. Those who prefer an affective approach to learning are more perceptive of their environment, while those preferring kinetic approaches show a clear inclination to interact physically with the displays.

In 1995, we opened an exhibition on folk art entitled Les Paradis du monde. This exhibition, which subsequently went on tour, was developed in three sections, each representing distinct parts of the museum's collection. The importance of visitors was stressed, as was the need to set objectives and clear messages right from the beginning of the creative process. The team created three distinctive sections in the exhibition, each responding to a specific learning style:

- The section aimed at cognitive ways of learning was very traditional in design, with long text panels, identification labels and typological display cases.
- The affective area was a gigantic evocation of a living room with a canvas on which we drew various elements mingled with artefacts as

if they were in their place of origin; love seats were installed and special lighting was added along with an audio component.

- In the section devoted to kinetic ways of learning, a series of small, distinct display areas required visitors to interact in some way. For example, there were display cases made to resemble 19th-century cameras, which forced visitors to look through a small hole in order to view very small items. Another was a recreation of a bar where visitors were asked to sit and look at artefacts displayed in various ways while reading a menu-like brochure listing all the objects.

Camera-like display cases in which visitors could examine very small artefacts. Photograph courtesy of the Canadian Museum of Civilization.

Despite a low budget, the exhibition was a success. Sponsorship from Ford Canada allowed the exhibition to travel across Quebec province.

Evaluation

Most of the articles and books on museum learning conclude that we expect visitors to learn extensively when they tour exhibitions. We forget that learning takes time. How much can a visitor learn in a two-hour visit to a museum where dozens of exhibitions are on view? How much can one get from an exhibition, given that most visitors spend a very short amount of time looking at each item, or groups of items?

Visitor studies are flourishing in an attempt to answer these questions, and many museologists are surveying, evaluating and quantifying their visitors' learning. However, many of the evaluation

methods used view visitors as if they were vessels to be filled. Often, evaluation of what has been learned is done through a series of questions at the entrance to an exhibition, which are repeated at the exit, and then the results are compared. Others ask questions only at the end of an exhibition. Rarely do we find more sophisticated evaluations that try to determine the 'self-image' of visitors by following them seriously during their tour. In other words, it is important to map people's minds by trying to assess how various different individuals perceive a subject.

I believe that most professional evaluators are overly optimistic about how much people can learn in the context of an exhibition. We need to reduce those expectations. The more empathic our approach when we develop exhibitions (while having real learning objectives in mind), the more successful we will be. By trying to use evaluations as a basis for our actions, we tend to ignore our instincts. In working too hard behind the scenes, many of us have not had enough time to observe what really happens in our exhibitions. When asking colleagues about their own visiting habits, it appears that most of them cannot enjoy a museum exhibition without seeing it with a 'professional' eye. It seems that the longer we work in museums, the more we lose the ability to look at exhibitions through the eyes of visitors. That is why we need to rely on our instincts as communicators and educators, backed up by research, to create effective exhibitions.

At CMC we were eager to conduct a summative evaluation to discover whether our approach was responding to visitor needs. Without entering into technical details, our evaluations confirmed that most visitors show preferences for displays geared towards kinetic learning, followed by displays directed towards cognitive and affective learning. There were clear indications that the kinetic section of *Les Paradis du monde*, which included the opportunity to meet a contemporary artist at work, was by far the most popular. There were many factors that might have influenced the outcome, such as the nature of the artefacts and the attractiveness of the design. One revealing result, however, is that most visitors' answers to evaluation questions referred to *feeling* more than to *learning*. The exhibition's goal was to help visitors develop an appreciation of folk art. I think we succeeded in this aim, but cannot gauge how our visitors actually learnt.

Being relevant

If we want visitors to learn in exhibitions, we have to offer relevant topics and displays. What does it mean to be relevant? Exhibitions must

be pertinent to visitors' interests and life. This does not mean presenting only easy topics in trendy ways. To help visitors learn, we need also to find out what they already know and reflect seriously on issues that matter to them. The Musée de la Civilisation in Quebec City puts this policy into practice. Its exhibitions always have some resonance for the public and the museum has no fear (or less fear than most institutions) of dealing with cutting-edge exhibitions on topics such as drugs, soap operas and the concept of difference.

We cannot expect visitors to take real learning away from a museum visit when the purpose of an exhibition is to display a particular collection which the curator finds interesting. Only if we make an effort to reach visitors by creating appropriate contexts and raising pertinent issues will we be able to create exhibitions for learning that help generate meaning. As Doering said: 'the most satisfying exhibitions for visitors [are] those that resonate with their experience and provide information in ways that confirm and enrich their view of the world'(Doering and Pekarik 1997: 20).

Role of educators

Whose role is it to promote learning in exhibitions? There is no simple answer to this complex question. Learning should be the responsibility, or at the least the objective, of everyone in the museum – from the director to the staff at the reception desk. Unfortunately, this is not always the case. The process of determining communicative objectives and messages is the basis of any learning process. As an interpretative planner, one of the greatest challenges I encountered was to explain and re-explain the importance of setting – right at the beginning of a project – a series of objectives linked with themes and the target audience. This was always a stressful exercise. Writing clear objectives and messages is not easy, but a good educator should be able to perform this task without too much difficulty.

At the CMC, educators have been involved formally since 1994 in the exhibition development process. Despite initial resistance, their involvement is now accepted and even desired – and their expertise has made a difference. As well as looking at various public programmes, educators contribute positively to the development of, for example, interactive displays, websites, electronic components and publications. I believe that the learning environment has improved and gets better with each new exhibition.

A few years ago, the Special Interest Group in Education and Cultural Action of the Société des Musées Québécois (SMQ) conducted an

exercise where members were asked to reflect on their current practice and on the role educators could play in the future. An impressive document was produced, listing all the tasks that educators could perform within various spheres of work such as exhibition development, educational products and programmes, commercial products, and the use of new technologies (SMQ 1995). At the end of that process, a group of educators and other museum professionals interested in education gathered to initiate a plan of action to work towards transforming this document into a reality. It was surprising to see that some educators were hesitant about the document. Some did not recognise themselves as part of it while others thought that many tasks, especially those related to exhibition development, had nothing to do with their role. Many assumed that educators had to be more combative and demanding.

It appears from this exercise that educators themselves are not yet convinced of the necessity of using their expertise outside their traditional field of work. Resistance to involving educators in exhibition development does not always come from other professionals. I strongly believe that museum exhibitions will become better learning environments when educators take part in every aspect of development but this will not happen until educators themselves are convinced.

Conclusion

I have attempted to illustrate that creating exhibitions for learning, although not an easy task, is both desirable and possible. As suggested by the examples of the couple visiting the museum and the professionals working behind the scenes, the main principle behind learning is the desire to learn and to focus on learning. I would say that most museum visitors are not thinking about learning nor do most museum professionals focus on learning. Learning takes time: a desire to learn must be instilled, connections with pre-existing knowledge must be created and changes in behaviour or perceptions must be observed. How many of us have witnessed this process by simply visiting an exhibition?

Humility and empathy will guarantee success in creating museum experiences that can lead to learning. There are many ways to learn in today's society, and museums are only one link in a long chain of places that offer learning opportunities – a fact that is often overlooked in most of the literature on learning in museums.

Do museums really provide the best learning environment? I will conclude by saying that we museum professionals need to put learning

at the centre of all our actions. This is the first premise to be addressed. But in the end, I question the assumption that a museum setting is an ideal learning environment.

Key points
- Learning takes time and is a very complex phenomenon.
- To be successful in developing or transforming our exhibitions for learning, we need to have reasonable expectations of the different ways in which people learn, and what interests them.
- Learning must be the main focus of museum professionals if we really want to create exhibitions for learning.

Key texts
Côté, M. and Viel, A. (eds) (1995). *Museums: Where Knowledge is Shared / Le Musée: lieu de partage des savoirs.* Canadian Museum Association and Société des Musées Québécois.
'Sharing of knowledge' was the theme of the special joint CMA–SMQ conference in 1995. The book is divided into two parts: the first offers very interesting reflective texts on knowledge and museums while the second describes various cases studies of Canadian museums that have tried to address this particular topic.

Delacôte, G. (1996). *Savoir apprendre: les nouvelles méthodes.* Éditions Odile Jacob.
Delacôte has been the director of San Francisco's *Exploratorium* since 1991. He talks about new ways of learning in scientific milieux and describes three revolutions that are currently changing radically our relation with science.

Falk, J. H. and Dierking, L. (1992). *The Museum Experience.* Whalesback Books.
This book is a classic that has been used by museum professionals since its publication. Falk and Dierking describe a framework in which to understand people's learning in museums.

Hein, G. E. (1998). *Learning in the Museum.* Routledge.
George Hein proposes a constructivist model of learning in museums and gives an overview of museum education, explaining various educational theories.

Bibliography

Anderson, D. (1997). *A CommonWealth: Museums and Learning in the United Kingdom*. Department of National Heritage.

Belcher, M. (1991). *Exhibitions in Museums*. Smithsonian Institution Press.

Doering, Z. D. and Pekarik, A. J. (1997). Questioning the entrance narrative. *Journal of Museum Education* **21** (3), 20–3.

Falk, J. H. *et al.* (1998). The effect of visitors' agendas on museum learning. *Curator* **41** (2): 107–20.

McLean, K. (1993). *Planning for People in Museum Exhibitions*. Association for Science and Technology Centres.

Miles, R. S. *et al.* (1982). *The Design of Educational Exhibits*. Unwin Hyman.

Paris, S. J. (1998). Situated motivation and informal learning. *Journal of Museum Education*. **22** (2–3): 22–6.

SMQ (1995). 'Les educateurs de musée: leurs rôles, leurs fonctions – present et futur', unpublished document. Société des Musées Québécois.

Tassé, C. D. and Lefebvre, A. (1996). *Psychologie du visiteur de musées: contribution à l'éducation des adultes en milieu muséal*. Éditions Hurtubise HMH.

Weil, S. E. (1997). The museum and the public. *Museum Management and Curatorship* **16** (3): 257–71.

CASE STUDY 2
Anne Grey
Director,
Lawrence Wilson
Art Gallery

An exhibition for learning: painted women

The Lawrence Wilson Art Gallery is the permanent home for the University of Western Australia's art collection. Its mission statement is to assist in developing the cultural profile of the University of Western Australia (UWA) through its gallery programme and to maintain the university's collection as an educational resource.

The UWA art collection consists of over 2500 works ranging from late 19th-century Australian to contemporary works, but chiefly dating from after 1940. It includes works by the Australian artists Arthur Boyd, Rupert Bunny, Sidney Nolan and Fred Williams. It also has substantial holdings of works by Western Australian artists.

The collection began in 1927; however, original works of art were not added to the collection until 1945. The development and nature of the collection has been, to a great extent, determined by gifts and benefactions.

The role of the gallery is, among other things, to:

- *make visitor learning an integral part of its activities by presenting innovative, stimulating and intellectually challenging exhibitions, programmes and information*
- *develop the skills of learning from works of art at all stages of education*
- *make gallery exhibitions, programmes and information accessible to the widest public*
- *develop the educational capabilities of staff, volunteers and others working for the gallery.*

The exhibition

The exhibition, *Painted Women: Australian Artists in Europe at the Turn of the Century*, was shown at the Lawrence Wilson Art Gallery between 24 July and 13 September 1998. The exhibition was curated by the author, with advice from a working party of experts on the artists, the period and women's issues. It was one of a programme of educational exhibitions which fulfil the gallery's role as a teaching arm of the university. The exhibition was arranged in conjunction with the centenary of women's suffrage in Australia. It offered new research through the catalogue, didactic texts and labels in the exhibition, and a specific framework of viewing which highlighted the social and historical

context in which the works were created.

The subject of the exhibition was the portrayal of women by eight Australian expatriate artists – Rupert Bunny, Charles Conder, Ethel Carrick Fox, Emanuel Phillips Fox, George Lambert, Bertram Mackennal, Kathleen O'Connor and Thea Proctor – at the turn of the 20th century. Women have always exercised a fascination over artists, both male and female, but the focus of *Painted Women* was the particular way in which this small group of artists depicted women during this relatively short time (1890–1920) and what this told us about these artists, this period and their subjects.

Works in the exhibition were divided into themes – the artist's model, the contemplative woman, motherhood, female companionship, male–female relationships, working women, New Women, the *femme fatale* and the Ideal – in order to provide a way of looking at the pictures and to draw out attitudes to women which prevailed at this time. The final themes decided upon were believed to present most closely the period's ways of thinking about women. Text panels outlining these themes, which included quotations from works of literature, were located in the vicinity of the works. Some works fitted naturally into the themes and others less so, while some could easily have been placed in more than one category. These themes were used as tools through which visitors could survey the imagery of women at this time; they also prompted conceptions of the women's lives. The themes led viewers to consider the (non-narrative) 'stories' told by these pictures.

Viewers were able to compare the lives of these women with those of women today, and thereby gain insight into the ways in which women's lives have stayed the same and the areas in which they have advanced. The context in which the works were made was enhanced by hanging them in an environment which evoked the sumptuous atmosphere of a drawing room of the time – using an oriental carpet, potted plants and chairs arranged in 'period' fashion. At the same time the exhibition maintained a modern finish, using somewhat brighter than period colours on the walls, to suggest that it was a contemporary look at the past.

Educational aspects
With a view to enhancing the educational aspects of the exhibition a special one-day symposium was organised with speakers from the National Gallery of Australia, the Art Gallery of Western Australia, the Western Australia Museum, the University of Melbourne, the University

of Western Australia and Curtin University of Technology. The papers placed the exhibition in a broader context, looking at various ways in which women were depicted in Victorian times and how they are seen today. The audience at this symposium was made up largely of women, although some men did attend. This may have been a consequence of the particular focus of the symposium, but it did not differ substantially from the audience range at a symposium on a local male artist held the following weekend at another venue.

Weekly lunchtime talks were presented by experts on the artists and on women's studies. An education kit with questions about the works and about the portrayal of women was made available to schools. Many of the school groups who attended the exhibition were studying artists of this period and were interested in seeing the links between this particular combination of artists. In these various ways the exhibition assisted in developing the cultural profile of the university.

The exhibition encouraged people to share their interpretations of the paintings. For instance, one Sunday afternoon, without any prompting from gallery staff, a group of people stood in front of Lambert's *The Blue Hat* and debated the roles of the two women depicted in it. Was the artist portraying a nanny nursing a child with the mother standing apart in her finery, or a mother immersed in her child with an independent career woman looking on?

Resources
The project required considerable staff resources in the area of research, and additional funding to produce the scholarly catalogue and symposium. In-house staff were supported through the generous assistance of scholars who advised on the project and contributed essays to the catalogue and papers at the symposium.

Outcomes
This exhibition received the greatest number of visitors to any exhibition at the gallery during recent years. Visitors responded to the feel of the exhibition, the quality of the works, its human focus, and the narrative told by the exhibition. They appreciated the way in which the exhibition was limited to a particular theme and restricted to a limited number of artists. They also liked having the opportunity to view works from major local private collections.

Following the success of the show, a revised exhibition held from February to June 1999 – *Painted Women Revisited* – looked at some

of these works through a different framework. This exhibition presented the paintings in themes which directed viewers to the artists' aesthetic approaches — such as quotation and appropriation. It emphasised that the meanings of works of arts are obtained through complicated and active processes — including the attitudes and aesthetics of the time in which they were created, and the expectations and responses of viewers.

Chapter 4
Birgitta Stapf
Head of education, Vasa Museum, Stockholm

DEVELOPING EDUCATION STRATEGIES AND SUPPORT MATERIALS FOR CHILDREN

In 1961, after 333 years under water in the outer Stockholm harbour, the Vasa, a newly built man-of-war, was brought up into the daylight again. An excavation of the hull was made where more than 25,000 objects were found – the belongings of the conscripted peasants, who made up her crew – as well as the remains of 25 individuals. Some 13,000 pieces of the ship itself were also found and brought up from the seabed.

After more than 20 years of the ship being under temporary display while vital conservation was carried out, a permanent museum was finally opened in June 1990. Today the ship rests, fully restored with both original and replica parts and with her lower rigging back in place, in the middle of a huge ship's hall, measuring 34 metres from floor to ceiling. Even the 700 sculptures are back on the ship in their original places. Around her, on seven levels, are the galleries telling the history of the ship and the society which built her.

The Vasa is the only fully identified and wholly preserved ship in the world from the early 17th century.

The museum has an independent education unit, with a staff of five – four education officers plus the head of the department. The unit delivers a range of programmes mainly for schools, and has its own budget for salaries and activities. This has proved to be a great advantage as it enables the team to be independent in decision-making and to co-operate with other units of the museum on an equal basis. Thus everyone and everything may benefit from the unit's educational experiences.

Education policy at the Vasa Museum

An education policy has recently been put together whose key aim is that the Vasa Museum shall be a resource for all those who wish to learn. So far, the education unit has emphasised formal learning for children only, as it enables the museum staff to develop strategies with teachers. Their needs and the needs of their pupils have encouraged the education unit to establish themes which can be useful for the complete learning process, involving preparations made at school, museum visits to collect material, and ideas and thoughts for the final work at school.

The average museum visit includes opportunities for the pupils' own exploration: hands-on activities, storytelling, collecting experiences and material – written or sketched – to take back to school. The museum

staff have no set questions, because they believe their task is not to judge what is interesting to children. They believe such a rigid approach limits their imagination. They have also noticed that pupils almost always end up with the questions that were initially relayed to them as facts, such as when, why and how the museum knows what happened so many years ago.

The School Act and the curriculum

In Sweden as elsewhere, if museums wish to work with schools they have to take into account the learning requirements placed on them by government. The School Act 1994, for both compulsory schools (children from six to sixteen years of age) and voluntary upper secondary schools, gave Sweden a new curriculum, new syllabuses and new time schedules for the various subjects. It states the ways in which subjects should be studied, but at the same time allows each community a considerable amount of autonomy concerning the financial and educational self-governance of their schools. The goals are common for the whole country and the achievements are evaluated nationally. One of the curriculum's key tasks is to teach pupils learning methods, in order that they may handle today's vast flow of information by critically examining the facts and predicting the consequences of various alternatives. In other words, they should be able to review, understand contexts and evaluate statements. Pupils must be given opportunities to take the initiative and have the necessary chances to solve problems.

All subjects should be studied from four main perspectives – environmental, international, ethical and historical. So, even if the time scheduled for history as a subject has been reduced, the curriculum stresses that all subjects are part of history. The curriculum deals with four interpretations of the word 'knowledge' – facts, understanding, skills and confidence – which all interact. Among the 'goals to aim at', developing curiosity and a desire to learn are particularly emphasised.

How can museums respond to the new curriculum?

Museums are excellent sites for schools to use in all aspects of the new curriculum. Rather than serving merely as decorations or illustrations in schoolbooks, museums can be part of long-term learning processes, thus offering a deeper form of learning in all the ways the word 'knowledge' is used. Museums are unique. They not only offer pupils excellent learning possibilities by investigating the objects as historical evidence, but also show how they were made – the technology involved – and also the context in which they were used. Pupils thus stimulate all

their senses, as well as their imagination, and can extend their understanding by using written and pictorial sources. All museums contain history, technology, arts and crafts, natural history and sciences in their collections and galleries. They are indeed cross-curricular and these relate not only to subjects within the curriculum but also to the methods which encourage pupils to learn in a variety of ways. To use museums in the curriculum therefore becomes of value to both pupils and teachers, since all categories of museums contain every aspect of human life. In all types of collection there are traces of the individuals who once invented, created and used the objects – this applies to both artefacts and pictures. By placing the children in the centre and building on their perception of reality, the adults around them will automatically become involved in the pupils' work. While this applies primarily to teachers and parents, it means that other experts can be drawn in, especially those who work with children with special needs.

It is therefore of great importance that museum educators and schoolteachers work closely together to explore all the educational possibilities. Museum educators must be aware of how work is done at school and teachers must be familiar with the wide range of museum activities which complements the learning activities in schools. The collaboration between museum and school, when the pupils' needs for access to the collections are combined with the teachers' first-hand knowledge of the children, should be the starting point for the museum's educational activities. Support material offered by the museum must give the pupils a wealth of opportunity to ask their own questions and draw their own conclusions. This material should involve all the senses if possible, not only the traditional museum ones of reading texts and looking into display cases.

There follow examples of such collaborations.

Immigrant children

Sweden has 8.8 million inhabitants, of which almost 1 million, more than 10%, were born abroad. The largest minority group comes from Finland, but many are relatively recent immigrants from the Middle East. In the major cities, where the immigrants tend to settle in certain suburbs, the schools are having to cope with particular challenges, arising from the pupils not having Swedish as their first language. It is not unknown for schools to have pupils whose mother tongues represent a total of 50 different languages, while others have classes where there are no Swedish-speaking pupils at all. The teachers in these schools emphasise the fact that language and communication must be

the main subjects at school. They are ready to try all possible ways to improve their pupils' Swedish. Some of them have turned to the Vasa Museum for help and ideas.

Over the last few years the Vasa Museum has carried out a series of long-term collaborations with such schools. Projects lasting a term or a whole school year, at school and in the museum, have resulted in the pupils guiding their parents through the museum. The main aim is language training, but it is just as important to acquaint parents with a cultural institution in their new homeland, while supporting the work done in the Swedish school system. These collaborations are both time-consuming and require a lot of staffing, but they are rewarding for all parties involved.

The museum education staff always start with a planning meeting with the teachers in a particular class to help them get to know each other's areas of competence and educational resources. After that, the museum staff often invite the entire school staff to the museum for an in-service training day. This is because these long-term themes seem to involve everyone at the school and the pupils very much need support and understanding from all the adults around them.

The next step is the first museum visit or, alternatively, the museum education staff visit the class if the school is within a reasonable distance of the centre of Stockholm. The latter is sometimes preferred as teachers have found that classes where the pupils come from predominantly closed communities meet few Swedes and their initial interest is to find out about the person or a new environment and what it stands for. So, the children are invited to ask their visitor any questions they like, whether personal or museum-related. This initial meeting helps the children to establish a good learning relationship in preparation for their visit to the museum.

The first museum visit is made up of both experience and adventure. Sometimes the children, up to a maximum of 30, come without any prior preparations other than the staff visit to the classroom. But on other occasions a form of preparation has been to read a book, set in the 17th century, about two young sons of one of the carpenters working at the Stockholm shipyard building the *Vasa* (Wahl and Nordqvist 1995). This book is one of our most important examples of support material in the preparation for a museum visit as well as being a source for follow-up work in the classroom. The first chapter takes the reader back to the time of the *Vasa*. The factual part was written by the education team at the museum and describes the ship itself and the thousands of finds, both large and small. The book was written for 8–14 year olds but has been

equally successful with younger children and adults.

The first encounter with the museum and the view of the ship astonishes them, and it is particularly rewarding for the museum staff to witness their intense emotions. 'Is this the *real* ship?' It is not difficult to guess what they will choose as interesting to show their parents. Back at school they dig deeper into the lives of people from the early 17th century. Activities such as reading books, writing their own stories, painting, cooking and carving occupy them either in the museum or at school over the next few months. Arts and crafts are the main subjects through which they gain their knowledge. Most schools use a whole day or one or two mornings a week for the *Vasa* project. After that they make two or three more visits to the museum to discover more about their particular areas of interest.

During these last two or three museum visits, the museum staff work with the pupils on how to give guided tours. They discuss how to stand in front of an audience, how to speak loudly enough and to pronounce correctly, and also to remember to relate what is really interesting. This is because when guides tell their favourite stories they usually engage their audiences more, and people enjoy enthusiastic guides.

The final visit to the museum takes place in the evening. The occasion draws whole families to the museum – parents, grandparents, sisters and brothers – sometimes around a hundred people in all. Most of them will not have been to a museum before, either in Sweden, or in their home countries. They meet their proud children who are familiar with the museum, dedicated to their subject and able to answer nearly every question. The parents themselves may comment that they recognise the craft techniques, used with wood and textiles in early 17th-century Sweden, as those similarly employed today in villages in the Middle East.

These projects, or rather co-operations, are not expensive but they are time-consuming, especially in planning the museum visits and in supplying the pupils with relevant and useful material for their work at school. Over the years, the museum education unit has developed a wide range of materials, including:

- historical sources from the Swedish National Archive
- ship provision records with keys to help understand the 17th-century handwriting, but still leaving scope for the children to draw their own conclusions
- replica objects positioned alongside photographs of the excavated items, with questions and suggestions on how to use them
- worksheets, other photographs and bibliographies to prompt children to experiment and draw their own conclusions.

In addition to supplying these materials, museum education staff must always be prepared to answer questions or give advice quickly if needed – by phone, fax or e-mail.

A garden with roots in the 17th century

The education unit has laid out a garden outside the museum. Many people ask the staff why they have done this. The Vasa Museum houses a ship and is part of the National Maritime Museums of Sweden. The idea for a garden began to grow even before the staff moved into the new building in 1990.

Among the finds from the excavation were hundreds of barrels for provisions. Deep down in the hull is a brick-built galley containing a 180-litre cauldron. On the gun decks, the conscripted peasants have left behind their individually carved wooden spoons, bowls and tankards. Questions regarding food and drink on board are partly answered by handwritten provision lists placed in the National Archive. But much remains unanswered. The barber surgeon's equipment found on deck poses questions such as: what illnesses could he cure or relieve, and with what kind of medicines? Fortunately a book by Arvid Månsson first printed in 1628, now available in a facsimile edition, entitled *A Very Useful Herb Book*, lists 132 different plants, with instructions on how to prepare the medicines. It also tells whether they will help on their own or 'with the help of God'. The book is used, for example, when children make ointment of pot marigold and 'burn water' with crisped leaf mint. Museum-prepared factsheets and worksheets are taken back to school for follow-up work.

In 1998 the garden was finally completed in a Renaissance layout. Nine square areas, arranged three by three, are enclosed within a silver-grey wooden fence, with an arbour overgrown with honeysuckle. No gardens from the early 17th century have survived in Sweden, so this is a reconstruction in many respects. Its form is developed from various original illustrations – Swedish, Dutch and English. Valuable flowers grow in the garden's centre square, sparsely planted as they were rare and precious. In the squares surrounding the central flower square are the kitchen garden and the medicinal herb garden. There has been extensive research in attempting to find the correct plants from the period. Some are difficult to get hold of – for example there were white and yellow carrots instead of today's orange, and the peas were dark blue. After much careful selection, the garden demonstrates the range of plants, flowers and vegetables that were cultivated during the early 17th century as food and medicine for the nobility, farmers and seafarers.

There are several ways to use this garden from an educational point of view. The pupils are allowed to sow, plant and harvest, as these are not common experiences for today's urban children. The education unit has provided a kitchen where the children can cook cabbage or pea soup in a large cauldron, though not the size of the original from the ship. The children work to original recipes but each dish tastes quite different, depending on what is available in the garden and the quantities used. The museum staff send the schools recipes for bread which they bake and bring to eat with their freshly made soups. On the full-scale replica of the upper gun deck, the children eat together in groups of seven, just as the seamen used to on board the *Vasa*, with carved spoons from wooden bowls. The smell and tastes of past times are one of the ways to get closer to everyday life of the seamen and ordinary people.

Another dimension to the garden is the spiritual one. Investigating nature used to be seen as a path towards the understanding of God's intentions for his Creation. Faith and science went hand in hand. The plants were given symbolic meanings which linked people to God. These matters can be dealt with and discussed on many different levels with pupils of all ages. Many are genuinely interested in reflection and meditating on the philosophical issues and perspectives as experienced 400 years ago.

The garden can also be used for artwork classes. In the autumn, staff and pupils have experimented with still-life painting – in watercolour and acrylic. It is amazing how many green colours plants have, and how many different shapes leaves can have. And it is just as thrilling to observe the bees and butterflies on the herb flowers. After having sketched and painted in the garden, or on rainy days in the museum's schoolroom, some of the classes visited the National Museum of Arts, to learn about symbolism in still-life paintings in the early 17th century and how the different paints were made and mixed.

A wide range of cross-curricular activities takes place in the garden. However, as the Swedish climate only allows outdoor work between late May and early October, careful advance planning is necessary.

- In the spring the staff cultivate, sow and plant with the pupils.
- The summer holidays between June and late August allow the garden to be enjoyed by the general public.
- There are roughly six weeks left to work with the schools before it is time for the garden to have its winter rest.
- During the remainder of the year the pupils can use parts of their harvest for cooking food and preparing medicines – both in practice and theory. The support the museum offers schools for this particular

theme is in the form of recipes and lists of ingredients for both food and medicines as well as providing a modern kitchen to allow children to make soups and other dishes.

Children with visual impairment

In Sweden pupils with a visual impairment go to their local schools alongside sighted contemporaries. Children with multiple disabilities attend special boarding schools. However, the Tomteboda Resource Centre in Stockholm provides visually impaired children with special facilities and training at certain times of the school year. The centre also trains teachers who have these pupils in their classes, and they provide help and support to parents on how to handle their children's special situation.

In 1992 the museum was contacted by an art teacher at the Tomteboda Resource Centre, who was planning a get-together week for 12 year olds. The museum education staff were interested in such a collaboration, but at the same time a little apprehensive. Firstly, the Vasa Museum ship hall is a large space with 63 corners and seven open levels from floor to ceiling, in which it must surely be very difficult for partially and non-sighted visitors to orient themselves. Secondly, neither the ship nor the objects are accessible for touching. The staff were unsure of what could be offered or what was expected, so it was an opportunity to learn.

The project started by the museum education staff attending a one-day course for teachers at the resource centre. The facilities for arts and crafts were shown which included the art teacher's work and her studio. The staff also spent a couple of hours blindfolded, first in a room investigating its four walls and then moving to the middle of the room. Despite the fact that there were 25 adults, there were no collisions when they were trying to find the centre. These experiences certainly challenged the assumptions made about the space in the ship hall and the other facilities.

Back in the museum the staff investigated everything as to its potential use for the pupils and discovered many things not thought of before. Items such as full-scale replicas, a cut-through model of the ship, cannon, ballast stones, replicas of seamen's woollen clothes and other personal belongings, which were regularly used to help other pupils study form and material, could provide tactile experiences. Access to the keel level made it possible to embrace the rudder of the ship itself.

The resource centre staff then came to discuss the suggested collection and found other items and displays which were felt to be of

interest. For example, the slide show of the trial after the *Vasa* capsized, where individuals involved in the building and sailing of the ship attempt to explain the ship's top-heaviness, was re-examined. This had not been considered as a sound show, as the staff had thought of the slides as the primary impact of the presentation.

Having completed the necessary groundwork, the museum staff started planning for the children's visit. The children were going to stay for a week at the Tomteboda Resource Centre. Monday was set aside for an introduction and Tuesday for the Vasa Museum – to explore and to investigate. The rest of the week involved different workshops at the centre all on the *Vasa* theme. Staff from both organisations collaborated on the programme of activities for the *Vasa* day, and the starting point was to be a model of the *Vasa*. This model was not made for people with a visual impairment, but because it is so small, it can easily be investigated with one hand at either end of the ship. Part of the rigging is made from cotton threads, but more importantly it shows the rudder. All 48 gun ports are pasted to the hull in a half-open position, but as they are rather small it is difficult to understand how they were constructed and operated. Even though it is not an ideal model for partially or non-sighted people – some parts are too intricate while others have too few details to distinguish them – it went some way towards explaining the ship. Other items selected included two cannons and the original rudder, plus replica cannon balls weighing 12 kilograms each, which would have been loaded from the front of the cannon.

Then the group visited the garden to harvest some of the plants, as few of the children knew how cabbage, leeks and carrots grew, although they could recognise them in the supermarket – cleaned of soil, without tops and in perforated plastic bags. New knowledge and skills were acquired, for example in identifying the smells of the different herbs. Lunch had already been prepared and all ate together out of common wooden bowls with carved wooden spoons on the replica upper gun deck.

Finally all returned to the model once more to investigate the rudder and the gun ports in order to compare the scale model to the actual ship. The children also handled the replica woollen clothing. Records of what had been heard, seen and touched were then made on small Braille typewriters.

In the meantime one of the education staff took care of parents who had accompanied the children and who were not visually impaired themselves. It was felt to be of great importance that parents should be able to talk with their children about their experiences. The parents'

tour of the museum focused on the objects and activities their children had encountered during the day.

The workshops at the resource centre during the rest of the week resulted in drawings and models made in clay and wood, of the ship, its cannon and the peasants' drinking cups. It is interesting to note that the ship models all had proportionally big rudders and that their cannons had balls in the muzzles. For drawing, a special plastic film was used, retaining a raised version of the impression made by the pencil, enabling everyone to see or feel the pictures. The results were later put up on display in the museum's annual summer holiday exhibition, together with captions in Braille.

Model of a cannon on the Vasa, *made by a pupil with visual impairment. Photograph by Hazel Moffat.*

Since its first meeting with visually impaired children, the museum education unit has become more involved. The Tomteboda art teacher wrote a paper for Stockholm University on the project in relation to image therapy and its educational achievements, thus spreading the museum's reputation to associations for adults with visual impairments. At present the staff work with several groups; Braille sheets are provided for general visitors with a visual impairment giving suggestions for suitable experiences they can have independently.

All the pupils from the Swedish School for the Blind in Helsinki, Finland, visited the Vasa Museum to study part of the two countries'

common history. Important *Vasa* literature has been published on cassette by the Swedish Library of Talking Books and in Braille, and is now available in every library in the country.

The unit decided to build a model of the *Vasa* (scale 1:50) to meet the special requirements of visually impaired people. The model came into use after a special inauguration. The principal speech was given by a 25-year-old blind woman who is a childminder at the Tomteboda Resource Centre. She had participated in the visits made by the children to the Vasa Museum, and knew the museum well. In addition, her hobby was sailing, so she was familiar with boat terms and ship construction. The model has

Model of a gun port on the **Vasa** made by a pupil with visual impairment.
Photograph by Hazel Moffat.

attracted considerable financial investment. The total cost of SEK 90,000 (£7000) was partly paid from the education unit's budget during the three years that it took to build the ship model. The Tomteboda Resource Centre and the Vasa Rediviva Trust sponsored the rest. The model builder, whose own children had disabilities, was extremely aware of the delicacy of his task and had the blind childminder as a consultant. The decision that no surface treatment should be put on the model was hers, for example. By leaving the surface untreated, it is possible to feel the difference between the structure of the pine deck planking and the oak of the hull.

Finally it is important to emphasise that those with a visual impairment need plenty of time to take in what they 'see' and feel. As such groups and individuals often feel excluded from museums and other cultural institutions, it is even more important to respect their needs.

Conclusion

Our society has assigned an educational role to museums. It might seem an obvious role, but it is very often neglected. The situation appears to be the same all over the world. Even in such a small country as Sweden there seems to be a great disparity in the different ways the museums regard education. Unfortunately, there is often an imbalance within the museums themselves, where diverse activities are given different priority. Clear strategies are necessary for education – an education policy – which enable children to have full access to museum resources. The curriculum actually states society's view on children's learning in a world of constant change. Cross-curricular studies, to learn how to discover and understand entities and connections, is becoming an increasingly vital ingredient to schools of today. The support material the museum can offer must give pupils a wealth of opportunities to ask their own questions and draw their own conclusions. This material should involve all the senses, not just the traditional ones of reading texts and looking into display cases.

Key points

- To establish a good-quality learning situation, museum education staff must work very closely with teachers when planning museum visits.
- Pupils must always know why they are at the museum and what they are going to do.
- To understand the relation between the museum's education work and the pupils' understanding of its substance is the essence of education.
- Museum staff must always build in extra time for pupils to investigate, explore and draw conclusions.
- It is vital for pupils to spend time learning how to identify, use, understand and interpret primary historical sources, such as documents and paintings.
- Historical sources should be made available, but not turned into 'ready-to-use facts'. Room should always be left for pupils to ask their own questions and draw their own conclusions.
- All replicas should be recognised as such but must be of the best quality and be fully accurate in all details.
- Replicas should be made in quantity to send out to schools accompanied by drawings and instructions on how to make them, for the museum's knowledge should be made accessible to all schools throughout the country and abroad.

Key texts

Durbin, G., Morris, S. and Wilkinson, S. (1990). *A Teacher's Guide to Learning from Objects*. English Heritage.

This book explores the many ways in which schools and museums can work with objects. Besides revealing the different curriculum subjects which can be tapped, the book demonstrates the skills of description, analysis, deduction and how they contribute to the importance of object handling.

Wahl, M. and Nordqvist, S. (1995). *The Vasa Sets Sail — Fantasy and Facts about a Ship and her Day*. Bonnier/Carlsen.

This book is divided into two sections. The first is a fictional story involving the twins Erik and Johan who experience a series of adventures relating to the ship in the early 17th century, while the second half examines the evidence of the *Vasa*, and from the thousands of small and large objects reveals the real story behind the ship. This is an excellent example of collaboration between museum staff and artists.

Bibliography

Månsson, A. (1628). *En myckit nyttigh Örta-book*. Borkförlaget Rediviva, Stockholm (facsimile 1998).

Chapter 5 WORKING WITH DIVERSE COMMUNITIES

Vivien Golding
Senior education
officer, Horniman
Museum, London

The aim of the Horniman Museum is 'to use its world-wide collections and Gardens to encourage a wider appreciation of the World, its peoples and their cultures and its environments' (Walker 1997). The museum is located in a multicultural area of south London which is disadvantaged by poverty – according to a demographic survey undertaken in 1994 by one of the museum's local boroughs, Southwark, it is the second poorest in England. There is evidence that south London has had a multicultural population since Roman times, and the Horniman Free Museum has served its diverse communities since its inception in 1901 (Anim-Addo 1995). Today, the museum directs two-thirds of its educational work towards these well-established communities via the school system.[1] The museum works in close collaboration with teachers, curriculum advisors, school inspectors and teacher training establishments.

The Horniman Museum's education centre receives core funding from the museum to deliver an exceptionally high-quality service, which is free to booked groups. The centre's staff operate as a team comprising the head of education, a full-time senior education officer, a full-time community education officer, a full-time education officer, three part-time education assistants, two part-time tutors for art workshops, two part-time tutors for music workshops and two part-time tutors for nature exploration workshops. In addition more than 30 freelance tutors are employed on an annual basis. The museum's formal education service is mainly preoccupied with pre-booked groups from schools and colleges.

Historically there has been no formal management structure at the Horniman Museum to facilitate joint project work on public displays from the earliest stages of exhibition conception. Information and ideas about forthcoming exhibitions are channelled informally between departments and at the annual museum-wide briefings. The work of the education unit is therefore largely concerned with attempts to engage visitors in a long-term, ongoing dialogue with objects that are already framed in the glass cases of the public exhibitions.

> …writing from within the museum allows the kind of appropriating of texts which can only bring more Black women and their families into museums to look with fresh eye and to validate their interpretations (Anim-Addo 1998a: 103).

This chapter outlines the particular 'kind of [museum] practice' which makes collaborative projects with multicultural communities possible

(Anim-Addo 1998a: 103). This 'practice' is rooted in an overriding theoretical concern to question current ways of working and open up museum discourse; to raise the voice and visibility of those previously silenced or not represented within its walls.

I hope this chapter encourages museums to collaborate with their multicultural communities; to take a principled standpoint; to challenge their insularity; and to develop interdisciplinary approaches with local communities (Philip 1992). The key points at the end of the chapter highlight the possibility of making vital connections at the museum frontiers, between diverse fields of study and disparate groups of peoples. The chapter also raises some 'uncomfortable questions', such as 'What is the place of the Black woman in your museum?' (Anim-Addo 1998a: 100).

To provide breadth and depth to the analysis, special attention is paid here to a long-term liaison with one group – the Caribbean Women Writers Alliance (CWWA) – while relevant points which may be transferred to other locations are also drawn out. In particular, a series of creative-writing workshops, hosted by the education centre between 1994 and 1996, is outlined.[2] The voices of the CWWA and other Black women writers will echo throughout this chapter, serving as a guide, point of reference and reminder of central issues.

Encouraging collaboration with different cultural groups

The Handling Collection

Educational sessions for the formal education section essentially revolve around face-to-face work with objects from the Handling Collection, which we employ to widen the ways in which the museum represents peoples and cultures. Handling objects cater for a range of learning styles and enable the development of 'multiple intelligences' through multi-sensory approaches to museum learning (Gardner 1993a; 1993b).

The Horniman Museum Handling Collection comprises more than 1800 original artefacts from all over the world. It is important for visitors of different ethnic backgrounds to see aspects of themselves reflected in museum objects, and the Handling Collection shows the diversity and similarity among the world's peoples. Museum handling objects largely mirror those in the public galleries which display historical collections of natural history, musical instruments and ethnography. These handling objects are vitally complemented by some modern artefacts, slides and video, which allow us to present a broader

picture of contemporary life around the globe. Handling is highly valued by visiting groups, according to the evaluation sheets filled in by visitors who attend the museum's courses.

Multicultural school communities

The important groundwork that helps our youngest students begin to question and challenge stereotypes is done by experienced museum staff and teachers. In this way, museum sessions are seen to raise young participants to what Vygotsky terms a 'higher zone of proximal development'. In other words they are able to achieve much more and think more deeply 'with assistance' from museum staff and teachers than they could by themselves (Vygotsky 1986: 187). The ways in which children can study the culture of Benin at the Horniman Museum illustrate this point. The culture of this former great West African kingdom in Nigeria can be studied by 7–11-year-olds for the National Curriculum in England, and many teachers choose this option following our in-service training (INSET) on this topic. Liaison with the school enables students studying Benin at the Horniman Museum to make first-hand observations and connections with past and present lives in Benin and England. Through dialogue they can challenge media portrayal of 'Africans' in general as starving and incompetent. Most importantly, racist views of 'primitive' Africans are countered, since the superb artefacts are constructed by the extremely complex processes of lost wax casting, a technique indigenous to this culture which developed over many centuries.

A programme which addresses power–knowledge relationships in this way, and which prioritises new interpretations, can transform the historical museum space criticised by Nourbese Philip:

> For Africans, the museum has always been a significant site of their racial oppression. Within its walls reasons could be found for their being placed at the foot of the hierarchical ladder of human evolution designed by the European ... Where else could you find the preserved genitalia of the black South African woman, Saartjie Baartman, known as the 'Hottentot Venus', but in the Musée de l'Homme in Paris? (Philip 1992: 104)

Museum staff and teachers collaborate because they recognise the developmental value of close attention to, and dialogue about, real things for the students in their groups and for themselves. Professional dialogue promotes respect and understanding for the diversity and

similarities of cultures across time and place. Close collaboration at the museum frontiers is time-consuming but it is of enormous benefit to all, since learning is a lifelong process – museum staff and teachers continually gain in knowledge and understanding alongside their students.

How museums perceive their visitors

The formal education service works intensively and collaboratively with diverse communities, who are identified for trustees' reports according to the following categories:

- groups of pre-schoolchildren and their carers
- schoolchildren
- further education students
- Art, BA, PGCE and MA students
- teachers and lecturers.

It is important to point out that communities are composed of individuals who bring to the museum many standpoints according to previous relationships and experiences. This enables them to interpret what museums have to offer and to make their own meaning.

Identity, in the words of Beryl Gilroy, is not concerned with 'strands of effectiveness, group belongingness or economic stability'. Gilroy defines identity in terms of a 'fear of being forgotten, of failing to resist the anguish of indifference, rejection and betrayal' (quoted in Anim-Addo 1998a: 101). The Horniman Museum works in tandem on this platform of forgotten identities, to acknowledge and respect the many standpoints we all occupy in our daily lives. Stuart Hall elucidates the understanding of individual identity as arising from these many standpoints. He speaks of 'the different ways we are positioned by, and position ourselves within, the narratives of the past'. This concept of fluid and dynamic standpoints is further illuminated through the term 'hybridity', which emphasises the enormously complex and vitally changing mixture of multicultural society (Hall 1994: 394, 402).

Raising the concept of 'many voices' in the museum

In a 12-month period an average of 23,000 visitors will attend specially designed sessions and work collaboratively with staff in the formal education department, while an average of 10,000 visitors attend community education programmes. The content of each session is carefully worked out in collaboration with group leaders, according to the particular interests and ability levels of group members. Seventy per

cent of the work done in the formal education unit comprises this kind of partnership programme in order to meet the demands of the National Curriculum. Most of the remaining 30% of the audience for formal education at the Horniman Museum is made up of people working towards further education certificates, degrees, postgraduate qualifications or following INSET courses.

A small yet vital 4% of our formal education programmes comprises project work with the Caribbean Women Writers Alliance (CWWA). All our collaborative programmes are long term and our working relationship with this group is quite distinct from a one-off tokenistic association; it is intense and demands a deal of committed work from all participants. The value of such a deep collaborative involvement is the clarity it brings to thought, especially ethical considerations about power relationships at the museum 'frontiers'.[3]

Working with the Caribbean Women Writers Alliance

The Alliance embraces mainly, but not exclusively, Black women. The regular workshops, conferences and support groups held at the Caribbean Centre of Goldsmiths College (part of the University of London) are a vital and pleasant means of international networking for the Horniman Museum's senior education staff. They also provide ample opportunities for learning about the culture of a particular community and acquiring skills such as storytelling. There are currently 130 members of CWWA who range from teens to elders. A large proportion of members are teachers who subsequently attend, or collaborate with, the museum's INSET, and organise school trips for their students. Their family members visit at weekends.

The CWWA was originally formed to provide a forum for dialogue, and in particular to facilitate a movement into new forms of writing by people whose voices have been marginalised. Towards this end a journal, *Mango Season*, is published four times a year. The Horniman Museum is invited to contribute pieces on museums and to publicise collaborative museum ventures, such as Black History Month workshops.

We are also invited to publicise the now annual Emancipation Day event on 1 August, which marks the end of the transatlantic slave trade. (The museum first celebrated 160 years of emancipation in 1997, in the conservatory of the Horniman Gardens. Sixteen African-Caribbean contributors, one for each decade of freedom, performed their poetry, stories and music for more than 120 visitors, to make the evening a

healing experience of remembrance for all of us.) By means of collaborative events such as this, the education centre is able to make reparation. In this case the largely historical artefacts from Africa are made more personally meaningful to Africa's 'living children', whose ancestors were wrenched from home during colonial times and totally dehumanised for monetary rewards. These events complement and widen the museum discourse, and render it contemporaneous. The official museum readings of traditional African artefacts on display are revalued by African-Caribbean collaborators, who set them within new systems of knowledge which survive and are replenished by means of oral culture.

On Emancipation Day, Caribbean culture sends out a praise-song to an enduring African heritage by means of its oral tradition and through its fantastic and humorous tales about overcoming the mighty, all of which helped to nourish peoples through the trauma and tragedy of transatlantic slavery. This is the same transatlantic slave trade whose monetary profits helped to furnish our ethnographic galleries and whose systems of knowledge displayed there helped to silence and disparage one-fifth of the world's peoples, along with her uprooted children. There is an overlapping of time and space in the location of the museum which creates a clearing in our everyday common-sense thinking. This jolts our minds as empathetic readers of museum artefacts, to 'actively listen'. 'Active listening', as coined by Gemma Corradi, is empowering (Corradi 1995). It enables the conscious remembering and articulation of 'unspeakable thoughts unspoken', the ghosts of the 'Middle Passage'; that is the brutal transport of newly captured slaves from Africa to the Americas in the triangular trade with Europe, Africa and the Americas (Morrison 1988: 199).

Emancipation Day activities constitute just such a positive individual and collective healing in the museum, and this is made possible through close collaboration. A successful long-term collaboration leads to committed relationships, predicated on trust and protracted efforts towards mutual understanding. To achieve this end it is essential for all collaborators to enter the relationship with respect for each other's humanity and individual standpoints. In Paulo Freire's words people do not enter 'the struggle as objects in order later to become human beings' (Freire 1996: 49–50).

In addition to the Emancipation Day event, a series of rewriting-the-museum workshops, which culminated in the publication *Another Doorway*, marked collective acts of healing remembering for museum staff and members of the Alliance. Joan Anim-Addo describes the

purpose of this rewriting as being 'to insert a hitherto largely absent presence, that of the Black woman, into the museum context' (Anim-Addo 1998a: 93). The museum permitted the women to assert themselves as subjects by providing opportunities for discussion and facilitating their creative writing. Donna Haraway notes the 'special significance' writing holds 'for all colonised groups', since it 'has been crucial to the Western myth of distinction between oral and written cultures, primitive and civilised mentalities' (Haraway 1991a: 175). The poem on page 63 is by Joan Anim-Addo and it illuminates the relevance of Haraway's thesis to the museum.

Maternity Figure: *a source of inspiration for poetess Joan Anim-Addo.*
Afo People, Nigeria 19th century, wood.
Photograph by Heini Schneebali, Horniman Museum and Gardens.

The Horniman Museum's collaboration with CWWA requires the museum to take responsibility for the absence of Black women's voices within it. This facilitates a questioning challenge to the 'authoritative' tone of the public displays, by developing alternative responses to

Was that Sethe or her sister?
(after Toni Morrison's *Beloved*)

Maternity figure of woman
on Ashanti stool
suckling child
– wooden, still –
milk-breathed
and at one.

Maternity figure of a woman
another situation we know full well
no child to suckle. Child done gone.
Sold. Mother wooden – still –
too drained, too whiplashed.
A stone; no stool.

A stone is not a stool.
In this hard place no comfort; no rest
where body thieves
separate sister, husband, infant
Even the wisdom of elders absent
How to cook without a stool?
How to grind peppers for the pot
with earth spirit not knowing libation
and palm oil an acrid memory?
In this corner, the heart of man
is only stone.

Maternity figure of a woman
Wooden. Still. Echoing a faint, faint
bu-dum, bu-dum, bu-dum.
So, infant body wooden now
stiff still. No to mothering
in this stone place.
No. No. No-oooh!
Howling into stone
On stone/through stone.

Joan Anim-Addo

curatorial interpretations and power. As Foucault notes, there is always 'resistance to power', which 'is multiple and can be integrated in global strategies' (Foucault 1980: 142). In collaborating, the museum does not give voice to, nor speak for, these women; CWWA is a highly articulate forum for dialogue and the collaboration aims to improve the practice of museum education by expanding the Horniman Museum's areas of relevance to this new audience.

In this kind of collaborative work there is a 'blurring and questioning' of the 'borderline between theoretical and non-theoretical writing' so that 'theory and poetry necessarily mesh' (Trinh 1989: 42). This is a post-modernist platform, but not one where 'anything goes' (Crimp 1985: 44). Our contention is rather that post-modernist theories sensitise us to difference and thereby open up the museum to a range of fruitful, more powerful positionings. Foucault highlights the political nature of all writing which 'fictions' it. He says, 'I am well aware that I have never written anything but fictions' which does not imply 'that truth is absent.' Furthermore:

> It seems to me that the possibility exists for fiction to function in truth, for a fictional discourse to induce effects of truth, and for bringing it about that a true discourse engenders or 'manufactures' something that does not as yet exist, that is, 'fictions' it. One 'fictions' history on the basis of a political reality that makes it true, one 'fictions' a politics not yet in existence on the basis of a historical truth (Foucault 1980: 193).

The work of the Horniman's education unit is mindful of the political world in which 'historical truth' is constructed and presented in the museum. It draws out the 'historical and institutional factors constraining what is written and why' (Clifford and Marcus 1989: 13). Interpretations at the Horniman are shared between collaborators who are intent on gaining greater mutual understanding and on transforming the world.

Key points

- Integrity. Commitment in terms of time rather than simply money is essential to establishing community projects. Sincerity in deciding priorities is vital in allowing the passionate pursuit of goals.

- *Empowering research.* It is essential to do background research, to read, attend courses, arrange to meet established groups and individuals, and to write joint or parallel articles. Research that empowers cannot appropriate local knowledge for personal gain and will avoid a patronising or 'box-ticking' mentality which disillusions communities.
- *Self-reflexive questioning.* Facilitate ongoing, non-hierarchical dialogue with collaborators. This involves 'active listening' to the questions of project team-leaders, and the offering of thoughtful responses. It requires mutual respect and acknowledgement of challenging views. It may demand radical changes to strategies and traditional ways of working, but not unconditional agreement.
- *Non-hierarchical collaboration.* Allocate sufficient time to agree common ground for joint project work (this may take months or years). It will then be possible to establish clear aims, objectives, financial obligations, marketing details and a reasonable timescale for all parties involved to achieve those aims. Throughout the process, it is important to adhere to the collaborative framework and strategies for collaborative action.
- *Flexibility and openness.* Be flexible and keep an open mind to the range of possibilities for how the museum might work with its local communities. It is not necessary to have all the answers all the time. If there is an attempt to keep the control of all knowledge, interesting options or areas of expertise may be dismissed. Community challenges to museum messages are liberating for both parties. They introduce difference and dynamism which prevent museum knowledge remaining static and stagnating.
- *Long-term commitment.* Maintain a trusting relationship and mutual sense of responsibility with your groups. This attitude guards against tokenism and any sense among the communities that they are being used and then discarded.
- *Get out and connect with your potential audience.* Don't just read this. Telephone, write to and visit community groups, churches and adult education institutions and invite community representatives to discuss collaborative activities at the museum.

Notes

1. For discussion of how the Horniman Museum has worked with local schools, see, for example, the video *Using Museums* (cited in Key texts and resources, below) and Golding (1995, 1997).

2. The culmination of these museum-based activities is marked by Anim-Addo (1998b). The 1997 annual museum ethnographers' conference 'Education and Ethnography' was jointly organised by the ethnography and education departments of the Horniman Museum and the Museum of Mankind, British Museum where Joan Anim-Addo first delivered her paper 'Another doorway? Black women writing the museum experience'. The work is discussed from the perspective of the Black women (Anim-Addo 1998a).

3. Gloria Anzaldua first developed the concept of museum 'frontiers' and Henry Giroux usefully elucidates her ideas for educationalists (Giroux 1993).

Key texts and resources

Giroux, H. (1993). *Border Crossings: Cultural Workers and the Politics of Education.* Routledge. London.

Giroux is a democratic educator who has applied the libertarian thoughts of Paulo Freire to his particular location in the USA. He writes in an accessible style which stimulates and inspires those of us who live under ever increasing financial constraints.

Hooper-Greenhill, E. (ed.) (1997). *Cultural Diversity: Developing Museum Audiences in Britain.* Leicester University Press, Leicester.

This collection of essays provides a comprehensive overview of current work which is being developed to expand the traditional museum audience. It highlights the perspective of museum practitioners who write up a number of detailed case studies which describe and analyse collaborative endeavours in the fields of museum learning and display. My essay 'Meaning and truth in multicultural education' deals with a range of issues concerning work with disadvantaged early-year pupils and their teachers.

Using Museums

Two videos made for Channel 4 comprising projects with primary and secondary schools. Engaging in this formal educational work increases our knowledge base and permits a natural networking with 'other' communities who are often parents and/or carers.

Bibliography

Anim-Addo, J. (1995). *Longest Journey: A History of Black Lewisham*. Deptford Forum Publishing.

Anim-Addo, J. (1998a). Another doorway? Black women writing the museum experience. *Journal of Museum Ethnography* (10), 93–104.

Anim-Addo, J. (ed.) (1998b). *Another Doorway: Visible Inside the Museum*. Mango Publishing.

Bell, D., Caplan, P. and Karim, W. (eds) (1993). *Gendered Fields: Women, Men and Ethnography*. Routledge.

Caplan, P. (1988). Engendering knowledge: the politics of ethnography (Part 2). *Anthropology Today*, **4** (6) 14–17.

Clifford, J. and Marcus, G. E. (eds) (1989). *Writing Culture: The Poetics and Politics of Ethnography*. University of California Press.

Coombes, A. E. (1994). *Re-inventing Africa: Museums, Material Culture and Popular Imagination*. Yale University Press.

Corradi, G. F. (1995). *The Other Side of Language: A Philosophy of Listening*. Routledge.

Crimp, D. (1985). On the museum's ruins. In Foster, H. (ed.) *Postmodern Culture*. Pluto Press, pp. 43–56.

Foucault, M. (1980). *Power/Knowledge: Selected Interviews and Other Writings 1972–1977*. The Harvester Press.

Freire, P. (1996). *Pedagogy of the Oppressed*. Penguin.

Gadamer, H. G. (1981). *Truth and Method*. Sheed and Ward.

Gardner, H. (1993a). *Frames of Mind: The Theory of Multiple Intelligences*. Fontana.

Gardner, H. (1993b). *Multiple Intelligences: The Theory in Practice*. Basic Books.

Golding, V. (1995). Puppets. In Yorath, J. (ed.) *Learning about Science and Technology in Museums*. South Eastern Museums Service, p. 18.

Golding, V. (1997). Meaning and truth in multicultural education. In Hooper-Greenhill, E. (ed.) *Cultural Diversity: Developing Museum Audiences in Britain*. Leicester University Press, pp. 203–25.

Hall, S. (1994). Cultural identity and diaspora. In Williams, P. and Chrisman. L. (eds) *Colonial Discourse and Post-colonial theory: A Reader*. Harvester-Wheatsheaf, pp. 392–403.

Haraway, D. J. (1991a). A cyborg manifesto: science, technology and socialist feminism in the late twentieth century. In Haraway, D. J. *Simians, Cyborgs and Women: The Reinvention of Nature*. Free Association Books, pp. 149–81.

Haraway, D. J. (1991b). Situated knowledges: the science question in feminism and the privilege of partial perspective. In Haraway, D. J.

Simians, Cyborgs and Women: The Reinvention of Nature. Free Association Books, pp. 183–201.

Hein, G. (1998). *Learning in the Museum.* Routledge.

Lorde, A. (1996). *The Audrey Lorde Compendium: Essays, Speeches and Journals; The Cancer Journals; Sister Outsider; A Burst of Light.* Pandora.

Morrison, T. (1984). Rootedness: the ancestor as foundation. In Evans, E. (ed.) *Black Women Writers (1950–1980): A Critical Evaluation.* Doubleday, pp. 339–45.

Morrison, T. (1988). *Beloved,* Picador.

Philip, M. N. (1992). *Frontiers: Essays and Writings on Racism and Culture.* The Mercury Press.

Plasa, C. (1998). *Toni Morrison's Beloved.* Icon.

Trinh T. M-ha. (1989). *Woman, Native, Other: Writing Post Coloniality and Feminism.* Indiana University Press.

Vygotsky, L. S. (1986). *Thought and Language.* MIT Press.

Walker, K. (1997). *Application for Designation.* Horniman Museum.

CASE STUDY 3

Kaija Kaitavuori
Education officer,
Kiasma Museum of
Contemporary Art,
Helsinki

Reaching diverse audiences: a case study from Finland

Kiasma, the new building in the heart of Helsinki for the Museum of Contemporary Art, was opened to the public at the beginning of June 1998. It was founded in 1990, as a separate entity from the Museum of Finnish Art, and became an autonomous part of the Finnish National Gallery which now has three museums: the Museum of Finnish Art, the Museum of Foreign Art and the Kiasma Museum of Contemporary Art. The Museum of Contemporary Art's move to its own site meant increased space for exhibitions and other activities. This required a whole new organisational structure and additional staff, including an education department of three.

The museum education department was the first in Kiasma, as it started work while the building was still under construction. The project, set up in the autumn of 1997, consisted of a study circle on contemporary art for the museum's builders. This group of about 20 people met on five occasions in one of the site huts during extended coffee breaks. The course dealt with questions such as:

- Why are ventilation pipes used by an artist thought of as art, but not those used by builders?
- Why do artists produce such work?
- Works of art need not look like words of art. Why not?
- What is the role of an everyday object in art?
- Is contemporary art just a joke?

Just before the opening of Kiasma, the group met in the completed museum to look at the collections.

The impulse to arrange a study group of this sort arose from a number of discussions with the builders and the realisation that we had different perceptions of what was happening inside the building. What significance would contemporary art have for those who were actually building the facilities in which it would be viewed and who were unknowingly influencing the conditions for its existence?

The act of spreading the gospel of contemporary art among builders sounds as if it belongs to the cultural ideology of the 1970s, when Finland's cultural life was strongly influenced by the leftist political agenda. In fact, it ultimately follows the ideology of enlightenment that first gave birth to the public museum institution: open up artistic treasures and culture to the people.

For an observer from within the field of art, it was a real challenge to talk to the builders about contemporary art. How could I justify the artistic solutions and actions that make up contemporary art and which, from the layman's point of view, can be obscure? How would the audience be convinced of the significance of these curiosities – without being denied the opportunity to express a critical attitude? Moreover, it felt artificial and patronising to think that the museum would be 'educating' others. I preferred to think of the study group as an opportunity for the two parties to have a look in to each other's world.

That everyone should have equal access to art and civilisation is a beautiful thought. But there is a downside to this democratic educational ideal. Education also means discipline. In the 19th century, when the public museum emerged, museums were places where – to put it bluntly – the upper classes felt at home and to which the working classes could be introduced and elevated to their standards. Society has changed enormously since those days, and so have museums. Even so, it is valid to ask whose world view today's museums respond to and reflect. Who will be comfortable there and who will find it easy to step inside?

Changes in the concepts of education and museums are reflected in the way museums name their educational departments. In the 1960s and 1970s the Finnish National Gallery had an 'enlightenment department', which in 1990 was changed into the 'unit of museum education'. Even the word 'education' is beginning to sound patronising and ideological, so the department has been renamed 'cultural services'. Instead of teaching art history or how to produce art, the aim of these services is to activate the viewing process, make room for sensations and help people make interpretations.

Kiasma has expressed a wish to be a 'meeting place for artists and audiences alike' and stated that it 'aims to expand and deepen understanding of contemporary art through the high-quality national and international programme, with an emphasis on varied ways of serving the public'. Since the launch Kiasma has been frequently called 'a

common living room' and this leads to the inevitable question: Who will feel 'at home' there? Will it be the kind of living room where, despite the host's invitation to 'make oneself comfortable', one never really knows how to relax?

The museum's aim, to target its programme to the 'general public', is meaningless unless it also considers the role in which the visitor is cast. What kind of world will the visitors step into and how are they supposed to behave in it? In the Louisiana Museum in Denmark, the words 'viewer' or 'visitor' have been abandoned and the term now used is 'guest'. A 'guest' could also be understood as a 'customer', to whom it would be natural to offer 'services'. So, using different interpretations of 'the public' we may be talking about looking after guests or engaging in the rhetoric of consumption. Furthermore, in Finnish, the word *vieras* can mean not only a 'guest' but also a 'stranger'. True hospitality would be to welcome those who feel 'strangers' in the museum.

Lately, there have been discussions about the level of access to art. For people with disabilities, this means getting rid of physical obstacles such as thresholds. But the real challenge is to get rid of invisible thresholds as well; the kind of inherent practices and evaluations that steer us towards certain predetermined environments and away from alternatives.

We all know what it is like to be in the wrong place at the wrong time: to be at a cocktail party wearing a tracksuit or drawn into a conversation where you understand nothing. If the museum visitor feels excluded and finds it difficult to join in the discussion, whose fault is it – the visitor's or the museum's? I would argue both. The museum should be much more conscious of its inbuilt assumptions and become more flexible in that respect, while the visitor has some responsibility to be open to art and to what the museum has to offer.

It is hoped that the pilot project with Kiasma's builders will become an integral part of the museum's work, reaching out to those who might not spontaneously come to the Museum of Contemporary Art, and providing an example of how the museum can be open to different views and lifestyles. The builders – who probably would not be considered as a primary audience for contemporary art – proved to be willing and interested viewers when given the opportunity to become acquainted with the art.

But the potential audience for contemporary art, which could be said to be the whole of society, is too heterogeneous to be addressed in only one way. The needs and – if I dare to use the word – the *problems* of

those who already visit museums frequently are different and need different solutions. This is not to mention the different types of art professionals who form an important part of the audience. This variety is the real challenge that museum education has to deal with.

Learning the different 'languages' of different audiences and developing the education programme accordingly – be it a historical approach, providing the visitor with information, encouraging the variety of interpretations and experiences, or offering an opportunity for questions – will need a lot of listening. I feel that we are only at the beginning.

CASE STUDY 4
Ruth Malul-Zadka
General director,
Artists House,
Jerusalem

Reaching diverse audiences: *Status Quo Vadis?* at the Jerusalem Artists House

The Jerusalem Artists House (Beit Ha-Omanim) is in a building dating from 1890, when the Ottoman Empire ruled in Palestine, and which became part of the old Bezalel Art Academy campus (founded 1906). Later, the Israel Museum was housed in the building and in 1964, when that Museum moved to new premises, it was given to the Jerusalem Artists Association. Today the Artists House, which is neither a museum nor a private gallery, serves as one of the main showcases for contemporary art in Israel and plays host to international exhibitions. Some 40 exhibitions are mounted annually, drawing large numbers of visitors.

The Artists House is a secular institute in a city of unique religious significance. Its ideology is therefore one of commitment to the immediate surroundings – Jerusalem – through an ongoing, artistic dialogue. As part of this social and cultural concept, a special project was initiated in 1992 to encourage young artists by giving them a venue in which to exhibit their first solo shows. The institute is also actively engaged in arousing public debate, through art, on controversial issues of religious and social significance. Issues such as gender, sexuality and the role of women were dealt with in the *Femina Sapiens, Gender Bents* and *Hair* exhibitions (Nelson 1996; Nelson and Segev 1995). Other exhibitions raised issues such as the Israeli–Palestinian conflict and Ethiopian immigration.

The *Status Quo Vadis?* exhibition, held during February and March 1998, was a direct continuation of this trend and dealt with the conflict between the religious and the secular sectors of Israeli society, a central issue of public debate in Israel. In 1948, when the State of Israel was established, it was clearly on the non-religious basis of Zionism. The religious and secular sectors established a mode of co-existence that enabled social pluralism and kept friction to a limit. But this status quo eroded rapidly during the 1990s, as a direct result of a surge in religious awakening and the growth of political power held by religious parties. Mutual prejudices and ignorance often become a source of fear, where individuals from both sectors feel their way of life directly threatened by the 'other'.

The *Status QuoVadis?* exhibition started as an initiative by a small number of non-religious artists who felt the need to take an active stand in this conflict. Throughout the eight months of preparation, more people joined the original nucleus, including poets, photographers and painters. After long deliberation, it was decided that religious and more orthodox artists should be invited to join as well. Thus, the dynamic process of producing the exhibition became as significant as the final event itself.

The aims of the exhibition were to:

- reach as wide an audience as possible, especially those who were not regular gallery-visitors
- run the exhibition as a dynamic event for seven weeks, allowing for spontaneous encounters in and around the exhibition space
- bring together the many different sectors within Israeli society
- raise public awareness of possible solutions and options (A reference room was made available as an integral part of the exhibition. In addition to the Holy Scripture known as the 'Jewish bookcase', Israeli poetry and novels and international works of literature were included to create an alternative view of Judaism. An extra 'trigger' was provided by pre-prepared manuals to facilitate discussions.)
- organise discussion panels around a range of opinions, from ultra-orthodox to atheism – these events were run on a voluntary basis, with academics, rabbis, writers and poets invited to voice their opinions
- allow free expression of all opinions, even if problematic to certain participants.

While preparing the exhibition, many interesting and exciting situations occurred as a result of the interaction between secular and religious artists. Even the issue of setting the time for the opening turned out to be a complicated issue. The Artists House conducts all its exhibition openings at midday on Saturday. The religious artists asked for the opening to be shifted to the evening, after the Sabbath was over. This created a long and highly charged debate, which ended in a consent to their request. Furthermore, the offer of sponsorship from a non-Kosher meat factory was rejected so that religious feelings would not be hurt. However, certain works of art which were problematic to religious sensitivities were not removed from the exhibition. These included a poem written in the form of the cross and a photograph of an orthodox crowd in Jerusalem which carried a possible Fascist connotation.

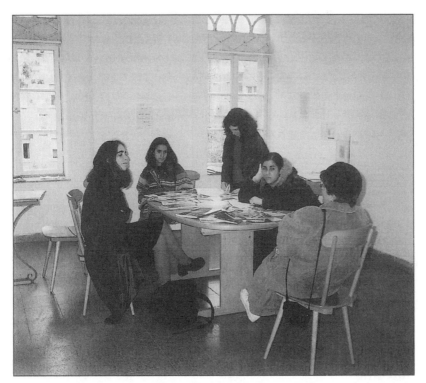

A reference room was provided as an integral part of the Status Quo Vadis? *exhibition.*
Photograph courtesy of the Artists House Museum, Jerusalem.

The catalogue, which was first conceived to include no articles or explanations, was later supplemented with a narration of the personal experiences of a secular man married to a religious woman. It was decided that all works would be processed by computer and enlarged to billboard size (6 x 4 metres). This resulted in the design of the exhibition as a 150-metre-long succession of huge posters hung with no intervals. Jerusalem billboards are often dominated by political, religious or marginal groups who illegally fill these spaces with their own notices. Thus, the billboards are seldom used for their original purpose as sources of information for cultural events, but are turned into constant channels of local communication, often very political.

The exhibition was conceptualised as an event. It was decided to relate to the exhibition in the same way as a political campaign and to use aggressive state-of-the-art marketing methods, otherwise seldom used in the local art scene. Ten days before the opening, black posters with only the exhibition's name on it, and no additional information, were pasted on billboards throughout the city as 'teasers', raising a high level of curiosity and expectation. These were followed by articles and

General view of the Status Quo Vadis? *exhibition in the Artists House.*
Photograph courtesy of the Artists House Museum, Jerusalem

reports in all local and national weekend newspapers, including a long report on Israeli TV a day before the opening.

Outcome

- The exhibition surpassed all expectations in reaching a wide and varied audience, including members of the public who would not normally attend this kind of art event, such as the ultra-orthodox and high school students, both religious and non-religious.
- The exhibition space became the focus of a seven-week event, with dialogue taking place between groups and individuals who had never met before.
- Throughout this period, the discussion panels drew a high number of participants and audiences to the galleries and media coverage raised much discussion.
- Although art is generally considered a secular vehicle, the *Status Quo Vadis?* exhibition created a significant dialogue between religious and secular members of society, which continued to reverberate beyond the limited scope of an art exhibition.

Bibliography

Artists House Publishing (1998). *Status Quo Vadis?*

Nelson, N. (1996). *Femina Sapiens.* Artists House Publishing.

Nelson, N. and Segev, H. (1995). *Gender Bents – Shades of Sexual Identity.* Artists House Publishing.

Chapter 6 WORKING WITH CHILDREN AND YOUNG PEOPLE

Hagit Allon
Curator of public
programmes,
Ruth Youth Wing,
Israel Museum,
Jerusalem

The Israel Museum is the country's largest museum. It contains four wings:

- archaeology
- Judaica and ethnography
- art
- youth – this wing is known as the Ruth Youth Wing.

The museum is run by four head curators together with the director.

The Ruth Youth Wing was established at the same time as the museum and hence differs from children's museums, art schools and education departments attached to museums. It fulfils all these functions and more. The Ruth Youth Wing's size, scope, variety of activities and social influence contribute to the children's life experiences. The wing spans 3500 square metres (10% of the entire area of the museum) and its budget is $2 million (10% of the museum's budget). It is staffed by 100 people, 40 of whom are employed in full-time positions (they comprise 25% of the museum's staff). Each year, about 300,000 people visit the Ruth Youth Wing (the total number of visitors to the museum in 1997 was 700,000). The wing now receives increasing support from the museum's management, publicity and marketing departments and, slowly, from the curators responsible for exhibitions. This support, not due to museum policy, has grown from the success of the programmes and their popularity.

The Ruth Youth Wing is made up of nine departments:

- department for guiding school parties
- department of art classes for children, young people and adults
- department for the general public (adults and families)
- special education department
- centre for teacher training courses
- multimedia and education unit
- exhibition department
- Arab education department
- administration.

It also publishes the museum's art magazine, Mishkafaim (glasses), for young people and adults.

What image is conjured up when we think of children and museums? Museum visitors might envisage a group of children accompanied by several chaperones, sitting in a corner or marching through the museum, directed by a guide who tries to arouse their interest in the exhibits or the art works. Some will view this group as hampering the cultural atmosphere they expected to enjoy during their stay in the museum, others will smile at the sight of young people immersing themselves in culture. Museum staff are also divided into two groups. Some view youth groups as superfluous and to be ignored, as long as they do not bother the 'real' visitors. Others, usually the staff of the museum's education department, view these groups as the future generation – the most important members of the public – and the justification for their position in the museum.

The museum is usually packed with children throughout the school year. During the summer vacation season when museum visits peak, many parents try to interest their children in what they consider a 'must' for the child's transformation into a cultured person. But most families in Israel never visit a museum. They consider them élitist, boring or intimidating institutions. Unfortunately, the masses of children who visit museums within the school framework do not return either. Only a small minority will come back to the museum with their families or friends, and most will not pay a visit on their own initiative.

This kind of situation used to exist for the Israel Museum. Although Jerusalem's municipal authorities decided to give every child who lives in Jerusalem a free membership card to the Israel Museum, visiting children did not inundate the museum, except within the school framework. Today, we are proud that a growing number of families and children view the Israel Museum as the preferred place in which to spend their free time; they return to us over and over again. All those who deal with museum activities understand that every exhibit or educational programme must be measured not only by its content, but also by its approachability and whether or not it reflects and enhances the interests of people visiting the museum. Children and young people are the future generation of museum lovers. The more we expand and vary the programmes that the museum offers, the more we shall succeed in reaching additional groups and encourage return visits from regular visitors and new members of the public.

Six years ago I set up the department of programmes for the public in the Ruth Youth Wing, with the support and encouragement of the Ruth Youth Wing's management. This support increased, in terms of budget, staff and freedom of activity, as the activities expanded, although several

years passed before the museum's management realised the potential importance of these target audiences.

Previously, the Israel Museum had addressed itself to the adult, usually well-educated population. Traditionally, children were considered the education department's domain. They were handled as school groups or as participants in the Ruth Youth Wing's yearly art lessons. My urge to focus upon families and children during their leisure time grew out of spending 12 years as a guide and programme designer in the Israel Museum's education department. In my view, the museum's most important role is that of a cultural signpost, one that can enrich experience and help bridge cultural gaps (and perhaps others too), and foster the establishment of social tolerance. But there are two key obstacles in the way of any museum fulfilling this role for children when it focuses on school groups:

- a guided tour is almost always a one-time 'show' that is not followed up by return visits by the schoolchildren alone or the family after school hours
- children and young people often consider the museum to be something connected with school, and the majority are consequently unwilling to go to the museum during their free time.

The museum as a formal learning environment

Museum visits tend to be viewed by schools as part of a programme to enrich formal education and as a way of touching upon subjects that formal education misses. As these visits are additional to the main curriculum, they are often seen as part of 'informal' education, taking place off the school premises in a building where the code of conduct is perhaps different. Children experience real exhibits or realistic depictions and the guide is not a teacher, but a new person whose theatrical or artistic talents sometimes succeed in engaging them in different or additional ways. And the children are encouraged to participate actively, through additional media such as drama or art (see box on learning activities for school visits). All of these things tend to reinforce the view that the museum provides an 'informal' method of education. This, I believe, is a mistaken view, however, and one that deserves to be looked at more closely.

For example, when the museum visit has a defined topic (usually connected to the curriculum) and the pupils are accompanied by the class teacher working within the class framework with its inherent restrictions, then these very elements can work against the child's view of the museum. This happens despite favourable opportunities being

LEARNING ACTIVITIES FOR SCHOOL VISITS

The following activities can be used to make school visits more stimulating and memorable. The examples can take place in education rooms or in the galleries and all relate to some aspect of the school curriculum.

- Allow children to handle original objects so that they can identify specific features such as how they were used and made (technology).
- Enact 'Living History', enabling pupils to adopt roles from periods in the past to increase their understanding of how people lived (history).
- Provide problem-solving activities such as choosing items in a display for a specific purpose, e.g. the most appropriate lighting system for a particular situation (science and design and technology).
- Develop oral response and encourage creative writing as a result of describing narrative paintings or individual objects (language).
- For older pupils, allow them to study the way in which the museum or gallery is a business within the leisure industry (tourism).
- Enable pupils to study one painting (whether a portrait or landscape) and then encourage them to create their own interpretation and display this alongside the original (art).
- Encourage pupils to study poses in paintings and sculptures and then develop their own mime/drama/dance (performing arts).

All the activities depend on careful planning on the teacher's part, and liaison with the museum and gallery educators to ensure that the work is appropriately pitched and that the pupils are clear about the purpose of the visit.

presented for children to express themselves in the museum environment. So, even though children will almost always choose a museum visit over classroom studies, simply because it is a break from the routine, they will still associate the museum with formal learning.

Museums depend on schools for their survival, in order to justify the budgets they receive from the authorities. Often museums are asked to put on exhibitions or displays to correspond with the Ministry of Education's annual theme or the school curriculum, thereby ensuring financial support and a greater number of school visits. Important exhibitions can also be problematic, whether they deal with innovative trends, thought-provoking topics or controversial works of art. The decision to mount an exhibition often hinges not only upon obtaining funding but also upon its attractiveness for schools or the undoubted controversy that it could spark.

The authorities, from their standpoint, tend to view museums as means of enriching the school curriculum. The visit takes place in an aesthetic, cultural and stimulating setting, with a trained and professional staff. From a social standpoint too, museum education brings a cultural medium to a broader cross-section of the child population, who would otherwise not have the opportunity to visit a museum with their families. However, we cannot forget that this audience is a captive one, brought to the museum with no possibility of choice. They view the museum as a part of the formal education system.

This fact is not so terrible. The exposure to stimuli that they will never receive on their own is an important goal. However for us, the museum staff, the cultural-societal message is the one of primary importance, and the one we desire to promote in order to create and expand our future public. Unfortunately, children's visits within the school frame-work do not necessarily achieve this aim.

The museum as an informal learning environment

Nowadays, an increasing number of families look for extra-curricular enrichment for their children. Parents wish to take advantage of the free time they have with their children in a qualitative and unifying fashion. Museums have much to offer in this area beyond the conventional visit.

At the Ruth Youth Wing, we felt that offering families open visits to an exhibition was insufficient since most parents feel that they do not possess the required knowledge or confidence to make the museum an enjoyable experience for their children. Many also find that their children become bored, perhaps because they are unable to understand what the museum is presenting to them. While we wished to find innovative ways of approaching these problems, we considered that plays, films or musical performances for children that had no connection to the exhibitions would be irrelevant to fulfilling our goals.

In recent years we have developed an increasing number of leisure-time programmes that are offered in the afternoon and during vacations. Some are geared only to children, some are geared to parents and children and some to the entire family. These programmes have been very successful. In the early stages, they were perhaps attended mainly by people who were regular museum visitors, but we now encounter a wider and broader audience for these activities. There is a growing demand for them and many are booked up well before the day of the event.

Out of a desire to appeal to members of the public who cannot afford a museum visit but who wish to participate in activities, we offer services at a minimal cost to those with limited means. This has included women and children in sheltered accommodation who are taking refuge from violent families. Their integration is important to the museum.

It should be noted that the Ruth Youth Wing's staff provide all the activities for the general public, and for all children and families. The staff include guides who are university graduates and experienced artists, all of whom have much experience of working with children in the museum. Most of the staff matured and gained their teaching expertise at the Israel Museum and did not come from the field of formal education.

Young people aged between 15 and 18 serve as assistant guides to the experienced staff. The majority of these young people are pupils themselves in the Ruth Youth Wing's annual art classes and provide a wonderful service to the guides. Their presence and the ease with which they relate to children are highly valued. These young people are outstanding ambassadors for the museum both in the present and for its future.

The following programmes have been developed in the Ruth Youth Wing and can be divided into two main groups. Each one has a different character and addresses different goals.

Programmes for families
The basis for these programmes is to organise activities for parents and children to enjoy together.

One approach was to produce Active Family Guides for Exhibitions, such as the guide to the archaeological exhibit The Sultan's Palace and another to the Middle Age and Renaissance art exhibit The Enigma of the Human Body. These exhibitions were chosen as subjects for the guides as we felt they were most likely to be appreciated by parents and children together. The

guides are written in simple language, appropriate for adults explaining the exhibition to the children. They are laid out attractively, provide explanations of terms and concepts and include photographs of objects or parts of objects that are being described. A number of directed activities are suggested which adults can do with the child while visiting the exhibition or at home following the visit.

Another approach for involving parents and children was to develop activities attached to a specific topic. One of these topics was 'Art and Food: Their Cultural Connection' and two of the related activities – which have proved very popular – are explained below.

'An Impressionist Breakfast' was developed for 8–12-year-olds and their parents in groups of up to 35. The activity is based on three interconnected stages:

- The group meet their guide who takes them to the museum's Impressionist gallery and tells them about the Impressionists' special treatment of scenery, light and colour.
- The group is then led to the museum's gardens where a 'breakfast' of light wine, baguettes and cheese awaits them. While they eat, the guide – now dressed in artist's work clothes and a broad-brimmed hat – describes the preparations that an Impressionist artist would make before going outdoors to paint. The guide makes use of reproductions of several different versions of *Déjeuner sur l'herbe* to help with the explanation.
- Following their light meal, the children experiment with colour, using typical Impressionist brushstrokes. At the end of the activity they take their paintings home with them.

This activity has been very successful for some years now. In its wake, we have developed 'A Stone-Age Breakfast' and 'A Roman Breakfast'. This activity has also been requested by adult groups. Popular demand confirms its success.

Another activity for parents and children is 'Eating Art'. One of the museum's workshops is turned into a makeshift kitchen where a well-known chef and a Ruth Youth Wing guide who specialises in either archaeology, ancient cultures or art (depending on the exhibition chosen) lead participants through the activity. The chef tells the group about the food they are going to cook and relates it to the topic that is the subject of the visit. The chef's discussion includes different types of food, customs, utensils and the connection between a society and its food. Together, the children and parents prepare the meal and the food is then left to cook under the chef's supervision while the families go

for a guided tour of the exhibition. At the end of the tour, they return to the workshop. Children and their parents continue cooking as a team and then eat the meal together. There is much shared gratification.

The integration of art, culture and culinary customs, along with the shared work of parents and children in the cooking workshop and their joint tour of the exhibition, with an emphasis on the cultural aspects connected to the topic, create a satisfying experience. Visitors often return.

Programmes for children only

These programmes accommodate parents who wish to leave their children where the activity takes place and then either visit one of the museum's exhibitions or run errands. This kind of programme includes:

- art and craft workshops connected to the museum's exhibitions
- activities that integrate a visit to an exhibit and an arts and crafts activity
- story time
- meetings with artists.

Two examples of these activities are described below, and both are partially based upon the annual Ruth Youth Wing exhibition. The Ruth Youth Wing contains its own exhibition area and the exhibits presented usually focus upon a theme for the entire family, including original art works alongside installations and activities connected to the theme. The activities held for children aim to further promote the view that the museum is not an élitist establishment and that it can be a fun place for children to visit in their free time.

Birthday celebrations in the museum

We invited parents to celebrate their child's birthday in the museum, as an alternative to having it take place in an amusement park, zoo or park. The invitations, birthday surprises, activities and even the gifts are all made by the museum staff and connected to the birthday. The parents only have to bring refreshments.

The party takes place after the museum is closed in a selected gallery or in the Ruth Youth Wing exhibition so that the location is at the complete disposal of the young guests, who will be made up of neighbourhood children, classmates, friends and family – as at any birthday party. The programme is made up of activities that are connected to the exhibition and, for any child who has had a unique birthday celebration in the museum or has participated in a friend's, the

museum will always remain a special place to which he or she will want to return. And the children really do return at their own request and by their own initiative.

It should be emphasised that, from the start, we planned the parties to be offered at a reasonable price so that anyone could afford them. The success of this strategy has been confirmed by the number of bookings.

A pyjama party in the Israel Museum

Anyone who has children between 8 and 12 years old is likely to be familiar with the phenomenon of the pyjama party. So why not have one in the museum? We had our reservations at first as there were several questions to be answered before we could go ahead.

- Who, among the museum staff, would be suitable to work with children for a whole night full of adventures and without being too didactic?
- What sort of programme would maintain interest and curiosity for twelve hours between 8.00 in the evening and 8.00 in the morning?
- How could we create an adventure while also safeguarding the museum's special contents?
- What would we do if one or more of the children wanted to go home in the middle of the night, or if anyone was ill?
- How would the Security Department react to the idea of an overnight children's party?
- How could we create good group dynamics among 35 children who may not know each other or the staff?

Several staff members laboured long on this task, but the programme was eventually completed. It integrates a visit to an exhibition (usually that of the Ruth Youth Wing), two art workshops, the joint preparation of a night-time meal, and a night adventure in the museum's Sculpture Garden that combines sights, voices, a search for sculptures and more. The activity in the Sculpture Garden takes place between 11.00 in the evening and 2.00 in the morning and is the highlight of the programme. Many children come back to us for another party, sometimes with friends who also wanted to take part.

The museum's teenage helpers (mentioned above on page 82) are invaluable in making this activity work well.

Practicalities

There are currently five staff members in the department for the general public. As well as me, there are two organisational and creative assistants responsible for running the programmes, and the department secretary

who is responsible for registration and payment. There is also a temporary assistant who works with the department secretary during peak times, due to the fact that registration and payment for activities is done in our department and not by the museum's general cashier. Guides are engaged for each separate activity or programme.

Most of our activities are planned for periods of one and a half to three hours, excluding the pyjama party which lasts twelve hours. None of the activities require advance preparation by participants.

Payment is required for almost all of the activities and is determined by the cost of each individual project. From a budgetary standpoint, most activities cover their own costs. The department's budget is independent and comprises part of the entire Ruth Youth Wing's budget. All the department's expenses, including salaries, are part of the budget and funded by the revenue generated by programmes.

The museum's entrance fee is about equal to the cost of a movie ticket; a child is half price. Activities cost extra and this means that the expense for an entire family can be relatively high. To address this, the museum administration solicits donations to subsidise families with children who wish to visit the museum during holidays. This makes possible free entrance to the museum for children during vacations, except during the summer, and has proved to be worthwhile for the museum as a whole and for the Ruth Youth Wing in particular. More families with children are visiting, and parents are more willing to invest in paid activities for children during the visit.

Our reviews have showed that over the summer, a large number of parents come with their children specifically for the activities. Recently, we also offered a discount to parents on the entrance fee. Since the department's budget is built upon the real expenses of and income from the activities, we are negotiating with the museum's financial department in order to receive part of the entrance fees paid by our audiences (these can be precisely measured). This will allow us to increase the scope of our activities and respond to the increasing demand. Added to that, we will be able to lower the price for activities so that they will be accessible to more people.

Evaluation

A number of years ago we composed an evaluation form for participants in our activities. For each visiting family, we wished to discover:

- the children's ages
- the number of annual family visits to the museum
- how the family heard of the programme

- whether they wished to receive written material about the museum's activities regularly by mail
- their suggestions for additional activities.

Several hundred families filled in the forms. An analysis of the results revealed the following:

- there was a need for a programme for younger children (most of our programmes are for children aged between 5 and 13)
- the majority of families had previously visited the museum between one and three times
- a large number of participants came from outside Jerusalem
- almost all the families were interested in receiving written material
- over 50% had read about the programmes in the newspapers
- most were satisfied or very satisfied with the programme
- most suggestions were for more activities, workshops and programmes with music.

Negative comments made on the evaluation forms mainly concerned the fact that participants were required to pay an entrance fee to the museum in addition to a fee for the activities, and that the cost was quite high for a family with several children. One of the practical steps resulting from the evaluation were tickets granting a 20% discount on all Ruth Youth Wing activities for an entire year. The majority of those who purchased them were families with several children or those who visit the museum more than once a year.

Key points
- The attention paid to children and young people within the school framework is important; however, in the long run, the results in the Israel Museum were minimal.
- Leisure-time activities proved to be more effective in terms of enjoyment and creating a desire to return to the museum.
- The more that we succeed in expanding the programmes offered and their themes, the more we will succeed in reaching a broader and more diverse public of new museum consumers.
- Personal experiences, such as birthdays, pyjama parties and so forth, engender a personal connection to the museum for children. They relate to it as 'their' place; it is always an interesting and fun place to spend time. The museum ceases to be an educational institution and becomes a cultural and

enjoyable place. I believe that this feeling will also remain with the children as they grow up.
- When the entire family or a parent and child share the museum experience, it becomes a positive mutual experience. The desire to repeat it spurs additional visits to museums in general.
- The public's growing interest in our leisure-time programmes, and the thousands of children and families that attend them, leads me to believe that this is the right direction for the museum cultural 'education' of the future.

Key texts

Durbin, G., Morris, S. and Wilkinson, S. (1990). *A Teacher's Guide to Learning from Objects*. English Heritage.

Where visits to museums are arranged by schools, this publication provides much practical help for teachers in showing children how they can enjoy finding out from objects by learning to pose questions and look for clues to answer them.

Israel Museum (1991). *Stork, Stork How is our Land?*

This collection of children's art shows how museum staff can react rapidly to extraordinary circumstances in their community and help children at sites away from the museum as part of outreach work. The children and their families were among the 14,600 Ethiopian Jews brought to Israel in 1991. The Ruth Youth Wing teachers at first set up spaces in the lobbies of hotels, where the immigrants were initially housed, and encouraged the children to draw and paint. Their work reflected their story from the homes they left behind to their arrival in Israel.

Chapter 7 WORKING WITH FAMILIES

Nico Halbertsma
Senior lecturer in
museum studies,
Reinwardt
Acadamie,
Amsterdam

Families as target groups

Quite often museums announce special family activities: for just a weekend, during holidays or on special occasions. Often, 'families' are mentioned as a specific group of visitors at the museum entrance desk – on the price list families may be charged differently from other groups.[1] The increasing responsiveness of museums to families has three aspects:

* marketing
* social and political factors
* how families learn.

Are museums following a trend, like theme parks, McDonalds, some large shops and swimming pools? The answer is yes, and why shouldn't they? From the marketing point of view it is a good thing to focus on such a large group which may have money to spend and is willing to do so. Museums are being helped by families' changing attitudes towards this kind of trip. They increasingly wish to spend their leisure time in a 'cultural' way and are not only looking for pleasure and fun. Their visit needs to be interesting, so that they can 'learn' something from it (though fun should be part of it too).

Apart from following a marketing trend, museums are changing from traditional and rather scientific institutions with an emphasis on 'learning' to places where education is still present but in an informal way. Entertainment is part of the experience. 'Edutainment' they call it (Mintz 1994). This movement has to do with the growing awareness among museum staff that museums are not just places to be visited by the dedicated few. Museums have a responsibility towards society in not only collecting and taking care of our cultural heritage, but also presenting it so it is accessible to everyone.

In many countries the fact that museums should play an active role in their communities is seen as a political issue. Sometimes the pressure from government can be considerable and museums are actively encouraged to attract people living in deprived areas to take part in programmes. Although political pressure of this kind may not be

attractive to museum managers, it can lead to well-thought-out activities for people who would never have dreamed of visiting a museum, often adding something to their lives. In addition to political pressure, long-established education programmes help museums to attract families. When schoolchildren have visited a museum with their class they often talk about their experience at home and ask parents or carers to go back with them to the museum, where they can show them what they have seen and done (Harris Qualitative 1997: 24).

In developing new exhibitions, museums now use ideas about how people learn, how their attention can be drawn and held and how they can learn in an informal way, using all their senses. The fact that there is a lot to do not only increases the learning effect of the visit, but gives people of all ages a sense of being active in their learning. They are challenged. They become curious. They want to solve the problem and find a solution.[2] This has led museums to develop what we can call an 'exhibition language'. New insights about two- and three-dimensional design, coupled with theories of learning and perception (as summarised in Hein and Alexander 1998), are leading to a new way of presenting objects and to a new way of telling stories. Learning can also be enhanced if it is presented as a social activity. From this point of view, the family can be a good 'learning' unit.

Before continuing, it will be useful to look at what the word 'family' means. The traditional family is made up of a father, a mother and one or more of their children. In some cultures, the grandparents are automatically part of it. But that is too rigid. A 'family' can be all sorts of things. One or both of the parents may be step-parents to one or more of the children. There may be only one parent, or there may be two parents of the same sex. Added to these possibilities, when a 'family' is out visiting a museum, the children might have brought along some of their friends and the adults may be carers instead of parents – the au-pair, next-door neighbours, relatives or friends who take the children for a day out. In terms of marketing and public relations, the simple-sounding target group of 'families' becomes a complex one.

What is meant by 'family friendly'?

There are many things to consider when developing a museum that will appeal to the whole family. Being family friendly involves publicising facilities so that families are aware of them, but also giving good warning of any restrictions that may be encountered. These may include not being allowed to use pushchairs or back carriers in some historic house museums for example. Family-friendly facilities include:

- Easy access by car or public transport. There should be good parking facilities nearby.
- In museums with entrance charges, a reasonable entrance fee at a special family rate. Unlike theme parks where you know exactly what you will get for your money, the visit to any museum has something of the unknown, of the unexpected. People hesitate if they have to pay too much for something they are not sure if they will like.
- Exhibitions and displays with a physical and intellectual approach for both children and adults and which take into account the special needs of people with disabilities. For example, children who use wheelchairs should have access to and be able to operate interactive exhibits.
- Friendly, helpful attendants who are used to dealing with children.
- Toilets with extra facilities, for example nappy changing bays, low basins, a toilet for visitors with disabilities with space and fittings to allow carers to change children's pads.
- A restaurant with lots of choice and chairs for young children.
- A picnic area, such as the facilities which are provided for schools. Some families find prices in museum cafeterias and restaurants too expensive and might prefer to consume refreshments they have brought from home.
- A cloakroom where prams, bags, coats and shoes can be left, with easy access for children if there is no attendant.
- Slings to help support the weight of babies where pushchairs or back carriers may not be taken round the museum.
- Doors to galleries and toilets that children can open themselves.
- Safe stairways and balconies.
- A play area inside or outside the museum.
- A shop with small, cheap items for children and educational materials related to the collection for both children and parents or carers.

Some museums are known to be aimed at families, but they may not be family friendly in the way they exhibit their objects and through the kind of educational activities they arrange. When parents or carers want to visit a museum with their children, the first type that comes to mind is often a children's museum. Everything these museums have and do is focused on children, so parents can be certain that they will be very attractive for their children. They will be addressed at their own level. Themes will be presented from their point of view and interest, and parents can just walk behind and let the children discover for themselves what interests them most. They don't have to be lifted by coat-laden arms to see things that have been displayed too high. Text labels are

clearly printed in large script and there is plenty to touch. The children can run, and they are allowed to speak loudly.

But what about the adults? Are they really part of the visit? Is there anything in the exhibition which really appeals to them and aims at their level of knowledge? Seldom is this the case in a children's museum. More often than not, they are not even allowed to enter or to join in the activities. Only in exhibitions for the under-fives are they really invited to be part of the experience and to play a role. (Yes, to play, not to act as a teacher.) Generally speaking, children's museums are for children and are not typically family-oriented.[3]

A second type of museum thought to be aimed at families is the one with a children's department. This may be a children's museum inside a 'large' museum, or a special area with education rooms which organise courses, workshops and Wednesday afternoon, weekend or holiday activities. These activities might range from music to painting, from dance and drama to filming and photography, and from working with textiles to pond dipping. In some countries these kinds of activities for children are also organised by special institutions (like music schools or youth theatre schools), but it is a very good opportunity for museums to have these things programmed too. However the activities need to have a clear link to and make use of the museum's collection. A visit to part or all of a gallery each time children join in an activity should be compulsory. The collection acts as a resource for the children, as a point of information and inspiration.

But, again, what is the role of parents or carers in this kind of children's department? They can, of course, have a look at the galleries by themselves. More likely, and certainly when the children join in a regular, weekly course, they will leave the museum and go shopping. In the Netherlands, children who are taken for lots of activities are called back-seat children. They belong to upper-middle-class families, in which the mother has her own car and chases around town to fetch the children from school, take them to the museum, then on to a swimming lesson and back home for dinner, after which it's time for the children's violin or flute practice. There isn't much in it for the parents.

An example of a truly family-friendly exhibit is the 'children's trail' that some museums have as part of their exhibition(s). On the child's eye level there are special text labels, special questions, special holes to look through or even displays where they have to discover things inside, crawling on their hands and knees. This is part of a larger exhibition that would appeal more to adults. The exhibition can be experienced by both child and parent or carer, allowing them both to say to each other:

'Hey, look here, this is something special.' It is not only the adult who 'teaches' the child, but also the child who can show accompanying adults things they discovered themselves. In this way, all members of the family are exploring the exhibition on an equal level.

There now exist a wide variety of museums that deal with specific subjects, and houses where famous people once lived and which call themselves museums. Other heritage sites such as castles, palaces, workers' homes, factories and coal mines are open to families too. Even parts of a city, such as docks or a whole village, might be open, with or without 'living history' presentations.[4] Are any of them specially attractive for families? They are, of course, all worth visiting and can be suitable for an entertaining family visit as long as they provide the facilities listed earlier and, more importantly, tell their stories and show their objects in a way that all family members can discover for themselves, at their own pace, on their own level and using all their senses.

A child operates a 'ferry' in the play house of the Nordiska Museum, Stockholm. Photograph by Hazel Moffat.

The use of actors and role players or people who give demonstrations of old crafts and trades and, where possible, let visitors try to do things themselves can increase the impact of any museum visit enormously. There might be one exception, mentioned with great restraint: art museums. There are many good examples of art museums having very

good programmes for families, so there is no doubt that such museums can develop activities for this target group. However, mainly because of the way objects are presented in art museums, which in some cases has not changed over a long period of time, people might have the impression that an art museum is 'not for us'.[5] The situation is changing where education departments exist in art museums, especially through the addition of programmes aimed at families.[6]

Some ideas for good practice when working with families:

- One of the best ideas has been mentioned above: children's trails in an 'ordinary' exhibition for adults.
- A cart or trolley containing handling activities inside the galleries or at a particular exhibition is very effective. In some science centres, carts have been used with all kinds of problem-solving mathematical games for adults and children. The cart can be used at crowded times when visitors have to wait before they can explore a display. In museums for applied arts, young and old visitors have been encouraged to practise the same techniques used by designers and artists in the exhibition.
- The family backpack loaded with puzzles, tasks and games to explore in one of the galleries. These specially designed rucksacks are loved by children, who nearly always fight over who may carry it to the gallery.
- Special (monthly) Sundays for a family visit with, for example 'Adrian the Attendant'. At the entrance desk the children receive a nicely designed booklet with a themed tour through the museum featuring an attendant as a cartoon character. There are questions to answer and problems to be solved; it is a kind of activity sheet made into a very attractive type of comic. Although designed for children, accompanying adults can follow the activities.
- Special text labels provide an alternative to the children's trail. These might be children's texts in an exhibition for the general visitor (so the children can understand what it is all about) or adult text labels in an exhibition for children. In the latter case, the adults' text contains more information than the children's texts, on a higher level. This makes it more interesting for parents or carers to join the visit to the children's exhibition and they are better able to explain some difficult words or concepts than can be done by simply having access to the children's text label. This is sometimes called 'co-education'.
- Play and rest areas. For example, in a clearly marked corner easy chairs can be arranged alongside soft and large play objects for the under-fives. These allow one or more of the parents or carers to sit and wait with very young children while older children explore the gallery

with another parent or by themselves. The use of these areas is greater when the seated adult can see the others walking round the gallery, as this creates a greater sense of safety.

- In some of the more technically oriented museums there are playgrounds outside the building with inflatable versions of some of the displays inside. Children love to play in these huge constructions and experience movement and balance.

Helping families to have a successful visit

Having attracted families to the museum, it is important to help them get the most out of their visit in terms of informal learning. What counts is that, in the course of an enjoyable, exciting and fascinating experience together, family members come across new facts and new ideas, master new skills and have new feelings and emotions.[7] Only then will a family say next time, 'Come on let's visit a museum'. A large part of this is in the hands of museum staff: the way they design exhibitions, the kind of activities they develop, the attitude of

Notice for adults accompanying children in the Boston Children's Museum. Photograph by Hazel Moffat.

front-of-house staff. But the way the family acts also plays a significant part in whether or not the museum visit is a success. Parents or carers will adapt their approaches according to the ages and personalities of the children they bring. Here are some ideas to help parents make a success of their visit:

- Let the visit be a surprise for the children.
- Let the children decide which museum to visit (this can be carefully managed by giving the children two or three options that parents feel will be most enjoyable for the children and for themselves).
- Do not stay too long. An adult's capacity for concentration should not determine the length of time children are expected to enjoy a visit before they start to wilt.

- Always visit the shop, if only to buy a small gift. It is useful to announce before entering the shop, or even the museum, that only something small will be bought. Choosing the nicest postcard on display will normally do (although looking for a postcard of the children's favourite object in the museum is not always a good idea, as it may not feature on a postcard).
- Bring refreshments, as the café or restaurant might be expensive, especially with a large family. Food and drink are not usually allowed in the museum, so ask if there is a special picnic area. If not, tell the children they will get something to eat after the visit. A small sweet can help a lot in overcoming the time until they are outside again.
- Never force children to find something cute or fascinating, interesting or splendid. They can decide for themselves and might disagree with you. This does not mean that parents or carers should not express thoughts and feelings about an object or display. It is very important to share these views, but this should never be in the form of a 'lesson'. If visiting a special museum as a once-in-a-lifetime experience, parents or carers can choose a few items to illustrate why the collection is special.
- Do not tear children away from a spot they like very much, where there is something they find fascinating or that attracts them. It is their choice to stay longer, to discover more about it or just enjoy the beauty of it. This need not stop parents or carers from encouraging children to have a look at other displays and to discover new ideas.
- Avoid very crowded exhibitions where there is no space for the children to explore for themselves.
- Parents can guide children's research skills by wondering aloud how something works, asking questions about the items on display or posing problems that can be solved through the exhibition. Let children express wonder about things, including the vastness of the building or the smallest detail.
- Do not pretend to be the all-knowing scientist. If parents or carers do not know the answer to something, ask the staff or try to find the answer in a multimedia application in the gallery.

This list is not exhaustive, but it promotes the role of parent or carer as a responsive supporter and encourager, with the children as central figures during the visit. Museum and gallery educators can encourage parents or carers to have confidence in adapting the strategies by producing a leaflet for them or holding workshops for them, if applicable, as part of a parenting course.[8] Other strategies tried by museums include providing older children with booklets so that they

can 'show their parents a good time in the museum'.

These ideas could be trialled with parents or carers in a focus group or, perhaps with the help of students on placement, through interviews with parents waiting in line at a clinic (with the clinic's permission), to see what their preferences would be for support in taking children to museums and galleries.

Conclusion

Families represent one of the largest groups of visitors to museums. These cross-generation groups can derive much pleasure from sharing the experience of museum visiting. However, museums do not always take their needs into account, particularly where permanent exhibitions are aimed at one age group. Both the design of exhibitions and associated programmes could consider the learning needs of children and adults. Where this has been done, whether through texts dedicated to children in an exhibition for general visitors or through family art activities, the quality of the visit is considerably increased. Adults and children can interact with each other as well as with the exhibitions to create very enjoyable experiences where learning is fun and future visits to museums are anticipated with pleasure.

Key points

- Families visiting museums come in many guises. Museums need to respond to their various needs in terms of adequate marketing, recognising the range of political and social factors that impact on and interest them, and enabling them to learn through all their senses.
- Apart from adapting exhibitions and programmes to take families' informal learning styles into account, a range of suitable facilities is necessary to cater for families' needs whether or not the use of the museum is designed specifically for children.
- Key roles in making museum visits enjoyable for children are played by parents or carers, museum exhibition designers, front-of-house staff and educators. Parents can be helped to participate in their children's informal learning.

Notes

1. The significance of family visitor groups as a substantial proportion of all visitors is discussed in Falk (1998).

2. The impact of interactive exhibits on families is reviewed in Knopf (1992).

3. However, children's museums may see themselves as places which offer opportunities for family learning as a key characteristic, as in Pearce (1998: 20).

4. Ways in which parents or carers can help their children learn from these sites are outlined in David (1996).

5. Parents' negative perceptions of art museums can be seen, for example, in Harris Qualitative (1997: 31).

6. An example of how educators in Copenhagen worked with children and adults at a contemporary art venue is given by Grethe Nymark (1995).

7. The informal nature of family learning is discussed in Wood (1996). For a focus on the role of conversations during visits see Pontin (1997), Vengopal (1995) and McManus (1994).

8. Other types of workshops and courses can also help parents make the most of museums. A basic skills course for parents included a session in a museum which led parents to take their children there (see Moffat 1995: 140–1).

Key texts

David, R. (1996). *History at Home.* English Heritage.
Waterfall, M. and Grusin, S. (1989). *Where's the ME in Museum? Going to Museums with Children.* Vandamere Press.
Both these books are designed to help parents help their children learn in informal ways. The first concentrates on the environment around the family home and shows parents how to encourage children's observation and sense of enquiry. The second selects different museum venues, such as an art museum and a science museum, and gives parents examples of how to engage their children's interest, even in something which might not at first appeal, such as a landscape painting.

Harris Qualitative (1997). *Children as an Audience for Museums and Galleries.* Arts Council and Museum and Galleries Commission.
Prepared for the Arts Council and the Museums and Galleries Commission in the UK, this report is based on research into the needs and attitudes of children and their parents in order to understand how to increase informal visits by children to museums. The research involved discussions with attenders and non-attenders at museums. It identifies key attitudes of children and their parents which lead to their deciding to visit or not to visit museums and galleries, and lists what will maximise the children's experience.

Wood, R. (1995). Museums, means and motivation: adult learning in a family context. In Chadwick, A. and Stannett, A. (eds) *Museums and the Education of Adults*. National Institute of Adult and Continuing Education, pp. 97–102.

This paper gives a concise review of the theory and practice of enabling adults to learn informally with their children in museum exhibitions. It discusses practicalities and gives examples of how a museum creates opportunities for family learning through social interaction.

Bibliography

Falk, J. H. (1998). Visitors: towards a better understanding of why people go to museums. *Museum News*, March/April, 38–43.

Hein, G. E. and Alexander, M. (1998). *Museums: Places of Learning*. American Association of Museums.

Knopf, M. B. (1992). The family museum experience. In Museum Education Roundtable, *Patterns in Practice*. Museum Education Roundtable.

McManus, P. (1994). Families in museums. In Miles, R. and Zavola, L. (eds) *Towards the Museums of the Future*. Routledge, pp. 81–97.

Mintz, A. (1994). That's edutainment. *Museum News*, November/December, 32–5.

Moffat, H. (1995). Prospects for future collaboration. In Chadwick, A. and Stannett, A. (eds) *Museums and the Education of Adults*. National Institute of Adult and Continuing Education.

Nymark, G. (1995). *Children Should be Seen and Not Heard*. Conference papers, Walsall Museum and Art Gallery.

Pearce, J. (1998). *Centres for Curiosity and Imagination: When is a Museum not a Museum?* Calouste Gulbenkian Foundation.

Pontin, K. (1997). Talking to each other: conversations between carers and children in an exhibition. *Journal of Education in Museums* (18), 19–20.

Vengopal, B. (1995). Family groups in museums. In Hooper-Greenhill, E. (ed.) *Museum, Media, Message*. Routledge, pp. 276–80.

Wood, R. (1996). Families. In Durbin, G. (ed.) *Developing Museums for Lifelong Learning*. The Stationery Office, pp. 77–82.

Chapter 8 ESTABLISHING OUTREACH
Daniel Castro **PROJECTS**
Benitez
Head of education,
National Museum
of Colombia

The National Museum of Colombia, the oldest museum in the country and one of the oldest in the Americas, was founded in 1823 as a scientific institution. One hundred and seventy-five years later the collection of the National Museum has more than 28,000 pieces showing the nation's history and heritage. This heritage includes vestiges of the first inhabitants and material of the pre-Hispanic societies, objects gathered from the current indigenous and Afro-Colombian groups, evidence of the different periods of national history and a collection of fine arts created by artists from colonial times to the present.

Supported by the Ministry of Culture, the museum's administrators started a process of restoration in 1989 because the site is also an architectural heritage monument; it is the former prison of Bogotá, built in the second half of the 19th century. After many decades of moving the collections from one part of the city to another, all the collections have been reunited here and the building is being enlarged in an end-of-millennium project to cater for the increase in the collections and to offer a wide variety of services worthy of the central museum of Colombia.

As head of education at the National Museum of Colombia, I am in charge of defining the museum's mission and education policies in relation to current international pedagogical developments in museums. I am responsible for the planning, management, evaluation and co-ordination of the division's programmes and their staffing. I also establish links related to education and cultural action with other divisions and departments of the museum, as well as with other cultural and educational institutions locally and internationally.

Before analysing one specific example of an outreach project in Bogotá, this chapter will outline important general concepts and ideas about the cultural and educational policies in Colombia and Latin America in recent years, policies that in many cases make possible the successful implementation of outreach programmes and projects in museums and cultural institutions.

Theory of public culture in Colombia and Latin America

The concept of what a museum is has varied significantly in recent decades. Many publications have theorised about the museum's *raison*

d'etre and also about its mission and functions. One of the most interesting publications in Spanish on the theme was written in 1992. The following extract from that book closely reflects the National Museum of Colombia's cultural and educational aims through outreach projects and programmes.

> *From its minority-orientated origins, the museum has changed its role radically to become a much more community-orientated institution. This change of orientation began with a new social attitude on the part of museums, which started to be perceived by the general public no longer as inaccessible places removed from every day life. Furthermore, increased social and economic demands from the general public were an impetus making the museum more concerned not only with school groups but also other social and cultural institutions ... These demands were shown in the increased number of visitors to exhibitions. At the same time, new approaches towards the museum's educational role and function emerged (Pastor Homs 1992: 7).*

The cultural and educational projects begun by the National Museum of Colombia are based not only on the general definition of a museum given by the International Council of Museums as 'a non profit-making, permanent institution in the service of society and of its development, and open to the public, which acquires, conserves, researches, communicates and exhibits, for purposes of study, education and enjoyment', but are linked simultaneously with the government's cultural and education policies and related to various private and public development plans and programmes.

Following independence in 1810, Colombia developed strongly centrist policies, a process that weakened the capacity of the provinces to rule themselves. Dissatisfaction with this situation eventually led to the important process of decentralisation in the second half of the 20th century. In 1991, Colombia adopted a new constitution founded on the desire for peace (even if it seems difficult to attain in reality), solidarity, collaboration and participation. In essence it enshrined a more collective understanding of the nation. The constitution recognises and protects the ethnic and cultural diversity of the country through various strategies. For example, it includes special laws for education and culture which, for the first time, mention museums as places with specific functions and missions within society. Education in museums acquired a fundamental role in fulfilling this mission.

This shift in perception of culture in general, and museums in particular, began with the idea that history and culture are not only about the role of institutions, but also about individuals within society. The one aim is to enable society to remain alive through communication and exchanging ideas. This approach accepts that the visitor to our museums is no longer simply a recipient of cultural information but plays a more dynamic role. Latin America as a whole has experienced similar cultural processes and there are many theorists who have reflected on the problem of culture, communities and identity.

One of the most important of these theorists is Nestor García Canclini. Canclini argues that cultural action in Latin America shifted from liberal patronage, where large enterprises sponsored cultural activities, moved through different concepts such as traditionalist heritage and neoliberal privatisation, to the latest tendencies of cultural democratisation and participative democracy (García Canclini 1990). In this phase of popular participation and self-management, the objectives are the plural development of every group in relation to their own needs.

The first outreach programmes in Colombian museums were designed and programmed in most cases as a balance between governmental, institutional and public policies, and sociological and cultural studies. Now, the main emphasis is the concept of identity within multicultural diversity.

The new role of the museum as communicator

The mission and education policies of the National Museum of Colombia reflect very closely the ideas expressed by Ivan Karp and his colleagues:

> The museum experience is supposed to be intensely private and personally transforming. Communities are the setting in which the skills for appreciating museums are acquired, but museums' audiences belong to many communities, often simultaneously. Part of the politics of museum community relations involves the politics of asserting and legitimating claims to identity (Karp et al. 1992: 12).

As integral parts of civil society, museums often justify their existence on the grounds that they play a major role in expressing, understanding, developing and preserving the objects, values and knowledge that civil society values and on which it depends. The National Museum of

Colombia's education policy states that the institution should enable everyone to recognise the museum as a place of encounter and communication, and should design new strategies to attract new kinds of audiences.

As repositories of knowledge, values and taste, museums educate, redefine or produce social commitments beyond those that can be produced in ordinary educational and civic institutions. This role forms part of the objectives and mission of the National Museum of Colombia. These objectives are linked with the government's cultural and educational policies through strategies where people define and debate their identities, and reflect on their living conditions, beliefs, values and ultimately their social order.

These concepts and theories are related not only to the idea of the museum as an educational institution, but are integral to the institution's new role as a communicator. They underpin the reorientation of the educational functions and services in the museum, developed in 1997 and implemented formally in 1998 through a new structure and organisation of job assignments. This reflects the specific functions of planning, execution and evaluation in seven different programmes aimed at better communication with the public:

- research
- teaching
- cultural diversity
- publications
- teacher training
- training for staff who have responsibility within the museum for contact with the public
- audience research and development, including the outreach projects.

Daily Life Museums

This background was the starting point for the museum's first outreach project, in which the interpretations of Colombian heritage were as diverse as the people with whom we wanted to work. Whereas art museums may offer a somewhat narrow visual experience and museums of cultural history produce exhibitions with more narrative content, the National Museum of Colombia offers broader possibilities for sharing Colombian cultural heritage with all citizens due to its mixture of artistic, historic and scientific collections.

Many people in Colombia and in Latin America still have in their minds the old vision of museum institutions: old and dark places where a lot of strange objects are exhibited; places where only privileged

people can enter and visit the galleries. Before embarking on the outreach project, one of the aims of the education department was to share with different types of visitors the specific functions of the museum as a place that collects, preserves, studies, interprets and exhibits, to overcome the idea that museum exhibitions were only places for the élite. Through dialogue, visits, workshops and guided tours we began to see a change of attitude and a deeper understanding of the museum's function in children, young people, older people and even professionals and university professors.

The theoretical justification for the outreach project was based on the ideas of many people inside the museum. It was also in keeping with national and local legislation on education and culture. The reflections of Fernando Savater (1997), Spanish philosopher and writer, and Nestor García Canclini showed us the way to produce a document which was offered to local authorities to help them implement the project in their communities. García Canclini (1990: 186) states:

> *The majority of visitors and spectators make no link with tradition through a ritual relationship, from a devotion to unique works or objects in a fixed sense, but through an unstable contact with messages that are widespread in multiple scenarios ... The museums that solemnise objects which were once everyday objects are divulging the national heritage packaged in a fatuous rhetoric. But at the same time the multiplication of 'noble' images such as the museums of daily life constructed in the corner of every room and made by everyone who sticks a poster on the wall with a photograph of a cultural site or a famous painting, souvenirs of travel, newspaper cuttings, a drawing by a friend, creates a personal heritage that renews itself as life goes on. This example is not intended to suggest that museums become insignificant places and are not worth visiting, but it gives us the possibility of introducing more liberty and creativity in relationships with the cultural heritage.*

These ideas were crucial for writing a working document, the basis of the first outreach programme of the National Museum of Colombia called Los museos cotidianos: espacios de acción y reflexión sobre ciudad y patrimonio cultural, convivencia y comunicación ('Daily Life Museums: spaces for action and reflection on the city and cultural heritage, collaboration and communication'). The main idea was centred on changing the old, hackneyed concept of culture to a new and significantly different one: the collective capacity to reassure values, share practices, innovate and

create a world without destroying the living environment (Brunner 1994).

The project was dependent on funding offered by the local borough authorities in Bogotá. These financial resources gave the museum the opportunity to work during a period of three months (from February to May 1997) and the project was designed in three phases of implementation within this time span.

Phase 1

This was divided into two sections:

- a research phase
- communication workshops, where the aim was to review the personal history of every participant.

We worked with a team of nine people, including two museum staff members, to reach approximately 210 people, with 30 people in each key group in each community. The workshops took place at times when each group could meet easily, for example children's workshops were held in school time or at weekends, those for teenagers happened in the evening and for older people they were during the day. Every workshop lasted between two and three hours and sometimes the work with teenagers lasted an entire evening.

Workshops were held in different places such as the streets, community houses and schools. Through dialogue we learned about the inhabitants' individual and collective experiences and about their particular localities. Items like heritage, memory, the past and collecting were discussed by the different groups before the next step started.

Phase 2

Heritage and conservation workshops were held. These gave people an opportunity to recognise their physical and architectural environment and the material heritage that surrounds everyone, not only in their own homes but also in the neighbourhood. These workshops aimed to give everyone in the key groups (children, young people and older people) the chance to make sense of this heritage through developing curiosity and spontaneity about material culture.

Several strategies were used in these workshops. There were painting activities in which children planned the city of the future, and others in which they investigated objects by finding 40 different ways to look at them. There were tours through the neighbourhood where teenagers pointed out the spaces of their daily activities and which inspired their

rap compositions. Individual interviews were held with older people in which they reflected upon their own life histories, followed by planned visits to the museum where they could confront concepts and reflections about daily life.

Phase 3

This involved the design of exhibitions, intended to reflect that everyone involved is a citizen and inhabitant of the city. The museum displays were designed by the three groups in every community as living museums where not only the objects displayed but also concepts about culture and heritage were linked through an educational and communicative process. Everybody had the opportunity to consider values, share practices, innovate and create a new world of meanings.

The outreach programme, through the Daily Life Museums, harnessed a sense of ownership and respect for the common heritage through respecting personal heritage and identifying the groups' own values.

What the Daily Life Museums achieved

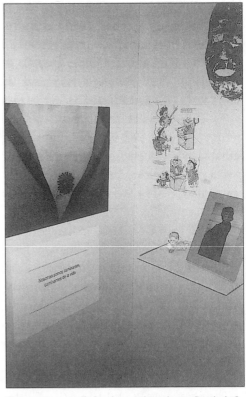

Being able to observe and reflect about themselves, the environment, objects and collections allowed the groups to react differently to the idea and functions of the National Museum of Colombia. It gave them an opportunity to recognise this 'sacred institution' not as a remote place that conserves and keeps objects and works of art, but as a space that interacts with elements of daily life.

Oral history, based on the neighbourhoods which had been represented by the inhabitants who worked on the project, gave significance

Tattoo on a girl's body exhibited in a Daily Life Museum, to express her unique heritage. Photograph courtesy of the National Museum of Colombia.

to the lives of individuals and groups who never before had the option to visit the museum. Through the writing of personal histories, the project also gave people the opportunity, otherwise denied them, to express themselves.

The exhibitions were built and designed in community houses, recognised by the inhabitants as meeting places in the neighbourhood. The final event was planned to coincide with the celebration of International Museums Day and to link with an 'open doors' day in the National Museum. In the community exhibitions, the history of the children, young people and older people were retold by showing objects from one part of the community to different communities. The objects

Daily Life Museums provide spaces for different generations to communicate with each other about daily objects.
Photograph courtesy of the National Museum of Colombia.

included flat irons, sewing artefacts, traditional games and old photographs of places in the city that are now unrecognisable.

The groups had a substantial change of attitude about the nature of the National Museum and also about the policy of the previous city administration as expressed in the former Action Plan of Santafé de Bogotá. In this plan and in the practice of our outreach programmes, the concepts of culture such as conservation and reflection of cultural heritage are common elements that are linked in practical actions of civic participation.

Rise and fall of a successful project

The National Museum of Colombia's education programmes are designed, planned and evaluated through different strategies. However, cultural action in Colombia has not had a tradition of being evaluated

qualitatively, but has used quantitative evaluation instead. Museum education staff wished to evaluate the first outreach project and recorded all the activities on videos and photographs, and tape recorded the participants expressing views about the project's impact on themselves and their own communities. Because the local administration gave funds to develop the programme, they also required a written report and a videotape of the experience, and these were given to them when the project concluded. One older woman was recorded as saying: 'I never expected that the visit to the museum would be so nice. I felt as though I was with a relative, chatting and remembering old stories.' A teenager said that, through the words of one of the songs they recorded on video: 'We are here to preach for everybody how evil the world is as it nears the end. We feel death, we feel rap, that is the sublime expression of this city. We sing against violence, we sing for peace.'

The outreach project was a great success, as was its impact on the city, the communities and the museum itself, but the fact that it was funded by the local boroughs has limited the programme's continuity. The museum's general budget, which depends on the Ministry of Culture, has so many other priorities that even a successful project like the Daily Life Museums may not continue. Many people recognise the importance of these projects but financing projects of this kind on a regular basis cannot be guaranteed.

The way that local policies are designed allows outreach programmes like the Daily Life Museums to flourish and succeed, but can also cause them to be terminated. The Daily Life Museums programme was made possible because the previous city administration based many of its actions and policies on the ideas of dialogue, collaboration and civic culture, and saw how the interpretation of personal, local and city heritage could be linked with the museum's aims. The present administration, with a new democratically elected mayor leading city government, has designed a very different action plan for the city for 1998–2001, which emphasises theories of market forces and a more individual participation in consumerism. This may initially divert funding to other projects.

It is now necessary to find other like-minded institutions to finance and support the National Museum's educational outreach programmes. We are starting to develop different activities with other members of the public, such as people with disabilities, especially those with visual impairments. The National Museum is one of the few museums in Colombia to have implemented display strategies for visually impaired

people, using funds from the Ministry of Culture and private sponsorship. This project is naturally linked with the Ministry of Education's policies and the new legislation about accessibility and the need to provide improved access to the museum for very different types of communities.

Cultural managers in Latin American countries are constantly debating theory and practice. Sometimes theories change so fast that a practice becomes obsolete, or they have to theorise again to provide new justifications for their actions and plans. Literature enables us to reflect on this, as the following extract from a short story entitled *Utopia for a Married Man* by the Argentinian writer, Jorge Luis Borges (1997) demonstrates. The dialogue between two people summarises ideas of change, perception, identity and autonomy, all of which education departments in our museums would like to implement, now and in the future:

> '*What about the great adventure of our time, space exploration? ... every trip is space exploration. Flying from one planet to another is like going to the next farm. When you came into this room you were exploring space.*'
> '*There are still museums and libraries?*'
> '*No. We like to forget the past, unless for the composition of elegies. We don't have celebrations, jubilees, effigies of dead men any more. Everybody should produce by themselves the sciences and arts that they need.*'

Key points
- Museums have radically changed their role, becoming more community-oriented institutions. As repositories of knowledge, values and taste, museums educate, redefine or make social commitments beyond those that can be made by other educational and civic institutions.
- Museum visitors are no longer simply recipients of cultural information. They play a more dynamic role.
- Outreach programmes have to be linked with governments' educational and cultural policies, and with private and public development plans and programmes in various contexts.
- Museums have the opportunity, through outreach programmes, to introduce more liberty and creativity in the public's relationship with cultural heritage.

Key texts

Delors, J. (1996). *Learning: The Treasure Within*. UNESCO.
These proceedings of the UNESCO International Commission, directed by Jacques Delors, present a comprehensive vision of the value and importance of education in the 21st century, through life, politics, economy and democracy.

García Canclini, N. (1990). *Culturas híbridas: estrategias para entrar y salir de la modernidad*. Grijalbo.
This text is central to the theme of the chapter because it reflects on communities, identities and heritage. It confronts the theoretical debates about modernism and post-modernism with studies about the popular uses of cult art and mass media. In this study the author analyses how museums, politics and economics ritualise the traditions and behaviours of individuals and groups. He defines museums as 'hybrid cultures' where a combined and inter-related use of disciplines can give us routes for understanding and action.

Hooper-Greenhill, E. (ed.) (1994). *Museums and their Visitors*. Routledge.
This helps towards an understanding of museums' social mission and com-municative role by referring to the public in general and different types of visitors in particular.

Hooper-Greenhill, E. (ed.) (1999). *The Educational Role of the Museum* (2nd edition). Routledge.
This is an 'up-to-date bible' for planning and implementing education in museums. It is very useful in helping to 'convince' other departments of the museum to comprehend the role of education in everyday activities.

Karp, I. and Lavine, S. (eds) (1991). *Exhibiting Cultures. The Poetics and Politics of Museum Exhibition*. Smithsonian Institution Press; **Karp, I., Mullen, C. and Lavine, S.** (eds) (1992). *Museums and Communities: The Politics of Public Culture*. Smithsonian Institution Press.
These two publications present a good balance between theory and practice through different kinds of experiences all over the world, related to museums' different strategies towards their communities.

Pastor Homs, M. (1992). *El museo y la educación en la comunidad*. CEAC.
In this publication, the author presents an extensive review of much of the English and Spanish specialised literature devoted to museums, introducing the reader to the nature of museums and their effect in the contemporary world. This is a useful compendium of the ways in which a museum can work with communities through educational processes.

Programma de naciones unidas para el desarrollo (PNUD) (1998). *Educación: La agenda del siglio XXI: hacia un desarrrollo humano.* Tercer Mundo Editores.

This has almost the same objectives as the Delors publication, but with a more concise and particular point of view about how education can be involved in the changes in Latin America and the Caribbean in the 21st century. This text provides a general context for education in museums and galleries in Latin America.

Savater, F. (1997). *El valor de educar.* Ariel.

This publication challenges conventional views of education, stressing the importance of dialogue and the need to learn from each other rather than relying on a concrete body of knowledge transmitted through formal education.

Bibliography

Borges, J. L. (1997). *El libro de arena.* Plaza y Janés, pp. 86–7.

Brunner, J. J. (1994). Preguntas del Futuro (Questions to the Future). *Revista Cultura. Número especial: La cultura chilena en transición.* Secretary of Communication and Culture, Santiago, Chile.

CASE STUDY 5
Phodiso Tube
Senior curator
of education,
National Museum,
Monuments and
Art Gallery,
Botswana

Museum-in-a-Box: a school and community project

The National Museum is a cultural and environmental public institution through which sustainable use of both cultural and natural heritage can be achieved while generating income at the same time (National Development Plan 8). Intrinsically, this approach to heritage management facilitates a thriving culture and environment for all.

The Museum-in-a-Box programme is a museum education project for the improvement of the quality of education for children in remote areas, who form the majority of the 17% of children who do not attend school. The programme is aimed at improving their enrolment and increasing the retention rates at primary school level. It does this by providing a culturally rich stimulus in the school, which is one of the essential attributes for better educational achievement.

The role of education for development and the world of work in a culturally rich environment is stressed in the 1977 *Report of the National Commission on Education.* It states that education must

> inculcate in every Motswana a sense of pride in identification with his cultural heritage. The education system should orient young people toward the social, cultural and artistic life of their unique society and prepare them to participate proudly in it (Government of Botswana 1977: 12).

In the Museum-in-a-Box programme, children make artefacts with the help of local experts. The crafts involved are leather tanning and leather working, wood carving, painting and drawing, ostrich-eggshell decoration, necklace, bracelet and earring making, and papier maché. The products, the children's own crafted items made from natural or recycled materials, are housed in a large box, the size of a tea chest. Different subject teachers use the contents of the box as teaching aides in the classroom by linking, for example, art and technology to geography, natural history and social and economic history. Each school

has its own box which displays the items made according to local traditional methods. Thus the range and style of items differs from area to area. Each box is circulated to other schools, providing a very efficient method of spreading culture and environmental knowledge to neighbouring communities. Involving children in the crafts programme encourages environmental awareness, notwithstanding the fact that environmental education is already familiar to the different ethnic communities in the country.

Curriculum links

The Museum-in-a-Box concept is relevant to the revised national policy on education (RNPE) (Government of Botswana 1994). The following are some of the aims of the RNPE.

- *Effective preparation of students for life, citizenship and the world of work.* As a result: 'A strategy of pre-vocational preparation in the general education system and a curriculum that is orientated to the world of work will be emphasised' (p. 3).
- *Improvement and maintenance of the quality of the education system.* It was realised that 'although not by design, the success in quantitative development of the school system has not been matched by qualitative improvements. Levels of academic achievement are a cause for concern' (p. 3). Activities in the Museum-in-a-Box programme are designed so that children are engaged in structured play for their cognitive and affective development towards better educational attainment.
- *Effective management of the education system.* The Museum-in-a-Box uses local expertise for children to tap into and to develop their creative and artistic potential. As stated in the RNPE: 'participation by the community in the development of education is important for the purpose of its democratisation, quality assurance and relevance' (p. 4).
- *Cost-effectiveness/cost-sharing in the financing of education.* Materials for the artefacts for the Museum-in-a-Box are largely available locally and a sizeable portion of the materials come from what is generally regarded as waste. Some costs are borne by the National Museum.

Activities in the programme

The programme was launched in April 1998 in Motokwe Kweneng West. The sessions, which took place over four days, were carried out by local experts. They began teaching children about the importance of using the natural resources in a sustainable manner for the continued

survival of the different crafts.

Two of the activities are wood carving and ostrich-eggshell decoration. With wood carving, the experts impress upon the children that when harvesting wood for carving, one does not cut down the whole tree but only a branch or two to allow the tree continued growth. Care has to be taken not to deliver a cut which could kill the tree. Branches are mostly cut during the dry season when they contain less water. Before cutting a tree, it is important to know the finished object's purpose and function in order to discourage waste. The wood carvers may advise that as this craft has the potential to develop into a large commercial undertaking, new planting may be necessary so as not to deplete the trees that grow naturally. In this craft children produced the following artefacts: small mortars and pestles, *lefetlho* (kitchen whisks), wooden spoons, knives and small herding sticks with a knob at the top.

Local experts in ostrich-eggshell decoration teach the children to harvest the eggs in such a way that the ostrich population is not harmed. The eggs are harvested in August. If there are 40 eggs only 15 are taken, leaving the remainder for natural incubation. If incubation has started no eggs are removed as the shell becomes thin and fragile. To work on the shell the egg is carefully broken open in the centre of the tapering end

Children watch an expert prepare an ostrich egg for decoration.
Photograph courtesy of the National Museum, Botswana.

and the contents are shaken out. Traditionally, charcoal, ochre and animal fat are used for the decoration, while a knife is used for etching. To decorate, water is applied, then colour, followed by a smearing of animal fat to stop the colour running. When finished, the shell can be used as a drinking vessel or for storing water. Shells which break are used for making beads.

Girls and the Museum-in-a-Box programme

When it was time for the children to participate, the older girls were very excited at the prospect of engaging in what has usually been regarded as a man's world. It is the programme's intention to involve girls in traditional male activities, as it is important for them in the contemporary world to acquire the same skills and knowledge. Perhaps of even more importance is the cultural aspect, as girls are expected to be nurturing, accepting and timid. This, more often than not, leads to a sustained decline in independence. Boys, on the other hand, are brought up to be adventurous and dominant.

The effects of these different sorts of upbringing in today's world of the global village, cyberspace and the information superhighway become apparent in the workplace. Such an obvious gap in experiences necessitates concerted efforts to uplift and empower females to be on a par with males, increasing, if not maximising, the use of Botswana's human resources and thus reducing poverty in the process. In December 1993, almost three-quarters of female-headed households in rural areas were below the poverty line. By comparison, between a third and a half of male-headed households were equally disadvantaged (Government of Botswana and Unicef 1993: 36).

Bibliography

Government of Botswana (1977). *Education for Kagisano: Report of the National Commission on Education 1977.* Government Printer, Gaborone.

Government of Botswana (1994). *The Revised National Policy on Education Government, Paper No. 2 of 1994.* Government Printer, Gabarone.

Government of Botswana (1995). *Investing in Today's Joy Tomorrow's Wealth: A National Programme of Action for Children of Botswana (1993–2003).* Government Printer, Gabarone.

Government of Botswana Ministry of Education (1992). *Primary School Syllabuses for all Subjects: Standard One to Four.* Government Printer, Gaborone.

Government of Botswana Ministry of Education (1993). *Primary School Syllabuses for all Subjects: Standard Five to Seven.* Government Printer, Gabarone.

Government of Botswana and Unicef (1993). *Situation Analysis of Children and Women in Botswana.* Quick Print, Gabarone.

ICOM (1991). *What Museums for Africa? Heritage in the Future.* The International Council of Museums, Paris.

ICOM–CECA Annual Conference (1991). *The Museum and Needs of People.* The International Council of Museums, Jerusalem.

Presidential Taskforce for a Long-term Vision for Botswana (1997). *A Framework for a Long-term Vision for Botswana.* Government Printer, Gabarone.

CASE STUDY 6
Chris Nobbs and
Simon Langsford
Education officers,
South Australian
Museum

The South Australian Museum goes bush

The South Australian Museum, which is located in the heart of the city of Adelaide, is a scientific institution with extensive collections of natural history specimens and cultural artefacts from Australia and around the world. The museum is committed to the interpretation and communication of its knowledge through education programmes. About 500,000 people visit the museum each year; most are local South Australians but there is also a significant proportion of interstate and overseas visitors.

The museum education service includes two education officers seconded from the Department for Education, Training and Employment (DETE). They develop and implement a broad range of resource-based teaching and learning programmes linked to the school curriculum, and play an important role in museum exhibition design and development. Over 43,000 students from metropolitan schools and tertiary institutions were booked in for museum education programmes during the 1997/8 financial year and another 8000 accessed the museum travelling education service for country schools.

The South Australian Museum travelling education service was established in 1976, in response to a demonstrated need to provide country schools in South Australia with access to the museum's knowledge, expertise and collections. It was initiated by the museum education service and begun with an education officer driving to country schools, towing a trailer with boxes of artefacts and specimens. The education officer provided students with stimulating lessons which utilised artefacts, specimens and models specially selected for their durability and handling by students.

The exercise proved too labour-intensive and, in 1984, evolved into the first unstaffed travelling exhibition, *Fur and Feathers,* which focused on animals and their coverings. It was mounted on free-standing panels which could be configured to fit any space and included large perspex-covered boxes of specimens arranged in typical habitats, as well as physical and electronic interactive displays. The specially designed display system enabled the exhibition to be packed up quickly and

loaded into a light truck for transport to the next school by an education officer. A package of teaching materials, with background information and teaching strategies, was sent to all the schools in an area before the exhibition arrived.

This exhibition was so popular that it was quickly followed by *Australia's Life of the Past* (1986). This exhibition traced the fossil record of Australia, with particular emphasis on South Australia. It used a series of interconnected panels with text, images and 'hands-on' real and cast specimens to unlock the evolution of life in Australia. Education officers developed a comprehensive, curriculum-linked resource pack for teachers to send out to schools for use by staff and students in association with the exhibition. Both of these exhibitions were financed by the museum and designed by museum exhibition staff in association with museum education officers and curators.

The next in the series of travelling exhibitions, *Life and Lands: Three Aboriginal Cultures of South Australia* (1991), spent three years in production and cost approximately A$95,000, excluding salaries. It was sponsored by Foundation SA (a government organisation). For this exhibition, curators and education officers consulted widely with Aboriginal community groups and the design of the exhibition and the delivery system were improved. Again, there was an emphasis on various types of interactive and real artefacts. Digital sound delivery of oral histories, and 'hands-on' activities such as fire-making and seed-grinding were significant innovations. Since then, this exhibition has travelled around South Australia twice and, like the other travelling exhibitions, it is set up in a host school, usually in a gymnasium, library or double classroom. Smaller schools within easy commuting distance visit the host school.

The most recent travelling exhibition, *Life and Adaptations to Water* (1997), which includes 50 panels and free-standing dioramas, is perhaps the most ambitious and spent approximately two years in production. It is certainly the most innovative exhibition of the series and includes state-of the-art technology and display techniques. The total cost of this exhibition was approximately A$120,000, excluding salaries, but a very generous sponsorship from Living Health (an organisation set up by the state government to dispense funds to the arts), in partnership with the museum and the DETE, enabled it to go ahead. It was an initiative driven by the museum education service and the project was managed by an education officer who worked in collaboration with museum exhibition

designers, curators in natural science and staff of the Botanic Gardens and State Herbarium. The exhibition was assembled in the museum's workshop and the display system included some significant design changes to improve handling.

Students examine a flying fox; part of the travelling exhibition Life and Adaptations to Water.
Photograph by Trevor Peters, South Australian Museum.

A group of teachers was consulted about the layout and suitability of text and images for students. They recommended the use of bullet-point summaries of important information on the bottom half of each panel and this proved very accessible to younger primary school students. The display includes interconnecting panels incorporating text, photographs and attached specimens, as well as free-standing dioramas depicting habitats. Electronic and 'hands-on' interactives encourage students to engage with the displays and discover how animals and plants across Australia have adapted to diverse habitats from the tropical rainforests of Irian Jaya, through the deserts of Central Australia to the southern oceans around Antarctica.

A comprehensive, integrated package of education materials, including a teachers' resource kit video, CD-ROM and online access to the Internet via the museum's website, were developed by an education officer in collaboration with museum curators, exhibition and web designers, teacher reference groups, DETE curriculum officers and the Open

Access College materials unit. The teaching resources are provided free to schools and are sent out ahead of the exhibition arriving in the area, allowing teachers ample time to incorporate them into their programmes. The whole package has been evaluated in the field using questionnaires and it has been extremely well received by teachers, students and local communities in country areas. Over 9000 students have had access to the exhibition since it went on the road in October 1997. It is anticipated that it will be set up in 90 schools, visited by over 300 schools across South Australia and will have travelled approximately 12,000 kilometres in 1999.

The exhibition proved a great success, but there are always new problems to overcome. We are currently investigating ways to:

- reduce the weight of portable dioramas
- ensure teachers are more aware of the arrival of the exhibition and its potential
- get sponsorship for the next exhibition.

The South Australian Museum travelling education service is now a juggling act, with the last three exhibitions all on the move. *Life and Adaptations to Water* is visiting country schools for the first time, while *Life and Lands* is making return visits and *Life of the Past* is about to visit metropolitan schools for the first time.

Chapter 9
Katrina M. Stamp
Curator of
education and
head of inter-
pretive services,
Auckland Museum

PLANNING AND IMPLEMENTING EVALUATION

Auckland Museum was founded in 1852. Since 1929 it has occupied the Auckland War Memorial Museum building in the Auckland Domain. This is New Zealand's largest museum and enjoys 1.2 million visitors annually (the highest in Australasia). The collections of Maori and Pacific art and material culture, natural history and the decorative arts are of national and international significance. The museum's library is one of the country's major historical and scientific reference libraries, with important primary-source manuscript and archival holdings. As the Auckland Provincial War Memorial Museum, the museum provides a wide-ranging service to the northern half of the North Island. A trust board of ten members (five from the territorial local authorities, four from the Auckland Institute and one representing Maori interests) governs museum activities. Approximately 60% of the museum's operational funding comes from local authorities of the Auckland region. The remaining 40% comes from the museum's trading operations, grants, bequests and investments.

In 1996, Katrina Stamp was instrumental in establishing an education policy for the Auckland Museum, which provides a guiding document for its core educative role. It outlines its interpretive objective in the following way: 'To support the Museum in its mission by using the Museum's collections and exhibitions as a basis for creating a dynamic centre for public learning and enjoyment.'

The interpretive services department is responsible for four main areas:

- *interpretive input for all displays, written material and responsibility for all programming,*
- *provision of services to schools*
- *recruitment, management and training of museum volunteers*
- *management and development of the children's discovery centres.*

> *If collections are the heart of museums ... the commitment to present objects and ideas in an informative and stimulating way ... is the spirit (AAM 1984: 55).*

Until recently Auckland Museum invested only limited time in evaluation work, and visitor studies have centred more on visitor profiling as opposed to evaluating programmes or exhibits. In the

southern hemisphere, some museums are taking a progressive step by establishing evaluation and visitor studies units. Throughout New Zealand and Australia there are now five posts dedicated to evaluation, four of which have additional staff allocated to ensure a working unit (Scott 1998). We do not enjoy that luxury at Auckland Museum so the studies outlined here are those of a non-specialist, attempting to add to our body of knowledge with regard to programme and exhibit efficacy. While the studies are conducted scientifically I must emphasise that we are continually learning on the job.

Over the past few years, the interpretive services department has evaluated a number of areas and I would like to outline a particular case of programme delivery to schools. In this case, performance targets were set prior to delivery and contained quantitative as well as qualitative expected outcomes. Our evaluation looked at the total package, so we were involved in organisational assessment as well as the visitor experience. Carol Scott describes programme evaluation as:

> a total function, activity or event and when we undertake programme evaluation we are assessing the progress and outcomes of all its features (cost/benefit, objectives and targets met, critical acclaim received, visitor experience, work structure required, etc). Programme evaluation leads us beyond assessing exhibitions, educational service and public events into, for example, assessing a museum customer service approach, its outreach services, its collection management and its volunteer programmes (Scott 1998).

In 1994, the New Zealand government established a contestable funding base for what it described as Learning Experiences Outside the Classroom and issued contracts to provide opportunities for students to undertake specific learning experiences outside the classroom, particularly in museums, zoos, art galleries and science centres. Programmes were required to enhance and enrich the curriculum in keeping with the New Zealand curriculum framework and the national curriculum statements. The Ministry of Education administers the funding and Auckland Museum's current contract enables us to concentrate staff, time and resources into providing curriculum-linked object-based programmes that are tailored specifically for school students and teachers.

In consultation with contracted providers the ministry established a rigorous outline of performance criteria and a reporting timetable. The Auckland Museum contract took the form of a programme entitled 'In

Touch with Auckland Museum' and, from the very beginning, we implemented an evaluative process so that we were able to report effectively to the ministry. The development of an evaluation process challenged us to ensure the programme achieved what it set out to do and to ensure that all components contributing to the whole were constantly monitored. Prior to putting a programme into operation an assessment of needs was conducted in which schools were asked to provide ideas and suggest subject areas that they wished to cover in a programme. The next step was to establish an advisory group to guide museum staff in developing and monitoring the programme, its staff, resources and evaluation materials. Both the needs assessment and the advisory group proved extremely valuable to our long-term success, helping us constantly to adapt and refine our programme and process.

The development of the evaluation process was not just a response to the performance-target data required by the contract, it was essential for assessing the quality and relevance of what we were offering. The museum also wanted to know how efficient the programme was in terms of cost, administration and advertising. The evaluative process needed to ensure quality management systems for staff to be more aware of:

- professional training needs
- the relevance of resources
- efficiency of the booking system.

On a political level, the evaluation made it possible for staff to ensure that information regarding all visits and activities was recorded so that statistical information, such as the number of school visits from a particular council area, could be disseminated to stakeholders.

Booking, administration and the collection and collation of statistical information were implemented from day one, with clear guidelines and procedures so that every school visit was documented along with the requirements for that visit. Every school in the Auckland region (some 1300 schools) was entered into the database, then their frequency of visits and subject areas covered (for example) were recorded. This allowed us to target schools that did not have a pattern of museum attendance. The computer system provided daily visit sheets for use within the museum, generated all booking confirmations for schools and gave statistical details to meet all internal and external requirements. It has been an invaluable tool in meeting all quantitative requirements, and particularly in allowing us to project workloads and gallery visitor distribution.

The most important aspect for staff was to come to grips with the idea of using information for constant improvement and modification; to see lack of success or criticism not as an inhibitor but as a building block to help meet the needs of the museum and its clients. To achieve these goals it was necessary to set up a number of checks and balances for each component of our programme and it quickly became evident that each part of our five-point plan needed its own focus.

I want now to outline the five-point plan and indicate some of the areas evaluated and some of the planning changes that resulted from it. The plan outlines the services that schools are able to access and a year's programme of topics, related activities and materials available. This proactive move has helped bring about a high standard of both presentation and resource materials. The work in developing and producing the programme was extremely time consuming and demanding. However, our assessment shows that we have become more efficient and better prepared to meet our clients' needs.

In Touch with Auckland Museum

The five-point plan

1 Teacher workshops

Our aim was to develop a programme of active and dynamic teacher-training workshops designed to empower teachers in using the museum's resources and therefore enable schools to access museum collections and programmes. Teacher workshops provided:

- expert familiarisation with the collections, galleries and exhibitions with the help of curators and specialists
- details of curriculum objectives and learning achievements
- in-depth training from museum interpretation staff on how to use resources
- introduction to 'hands-on' opportunities with activities and materials which are available for students' visits
- exploration and assessment of prepared written resource materials.

2 Direct delivery teaching

This involved the provision of a range of programmes to enhance museum-based learning for all students, irrespective of ability, culture or gender (Auckland is the largest Polynesian city in the South Pacific and services offered must support the bicultural and multicultural needs and aspirations of our students). We are committed to supporting

teachers and students through Levels 1–8 and across the curriculum. Direct delivery includes:

- gallery introductions provided by educators
- 'hands-on' object-based activities facilitated by educators
- in-gallery creative sessions
- drama and craft sessions facilitated by educators (topic dependent).

3 Resource development

Written resource materials for all galleries and exhibitions were provided, which clearly stated cross-curricular links for teachers at all levels and thereby contributed to the concept of seamless education. All written resource kits provided teachers with rich sources of information about Auckland Museum and followed the basic format:

- collections, displays, exhibitions and background information
- curriculum links and achievement objectives
- pre- and post-visit activities
- evaluation sheets.

4 Museum-in-a-Trunk outreach service

This is an outreach service that provides access to the museum collections for Auckland schools who are disadvantaged geographically and economically. The museum educator delivers a 'hands-on' session for pupils and provides classroom resource materials to support the teachers' programme. Each Auckland Museum-in-a-Trunk unit contains the following:

- resource kit (with information as previously stated)
- 'hands-on' collections
- classroom display materials and activities.

5 Secondary student service scheme

This scheme provides an opportunity for secondary school students to develop leadership and communication skills. Students have the chance to work as facilitators in the museum discovery centres, and this work goes towards fulfilling the Duke of Edinburgh Award service obligations. The programme aims to:

- provide secondary school students with the opportunity to develop leadership and communication skills
- foster science education
- draw the 'lost generation' of teenagers into the museum to act as role models for other children and teenagers.

Implementing the evaluation regime

The following evaluations took place:

- student evaluations at two levels (lower primary and intermediate/secondary)
- teacher evaluations of student programmes
- Museum-in-a-Trunk teacher evaluations
- teacher workshop evaluations.

Each area of the five-point plan generated an evaluation and these were conducted primarily through the use of evaluation sheets, which were seen as the most feasible way to assess the value and accuracy of all programmes delivered by museum interpreters. Following guidance from our advisory board, a format was developed to ascertain the information required and a consistent form of questioning was devised to produce valid analysis, although slight modifications were needed in some subject areas, particularly in the case of teacher workshops. Sample areas of evaluation for the teacher workshop included questions that would help us to:

- measure how closely the programmes supported different achievement objectives
- ascertain the level of satisfaction with relevant education kits and written resources
- ascertain the level of satisfaction with 'hands-on' activities
- determine whether the museum has provided learning opportunities not available in the classroom
- determine whether the workshop has changed teacher understanding about availability and usefulness of museum resources
- determine whether the workshop has changed teacher understanding about the role of museum educators
- determine whether the presentation has changed teacher ideas of how the museum can be used.

The museum uses an employee performance management system under which all staff operate. Further evaluation measures assessing the staff and the programme have been implemented to ensure quality provision and a basis for continuing modification. These include written and oral evaluation by teachers and students and peer reviews by educational professionals up to three times a year, focusing on:

- delivery (knowledge, style, rapport)
- teacher workshops (relevance, delivery, communication objectives)

- resource development (curriculum relevance, appropriateness of student activities, communication).

Lessons learned

Much of what is here is common sense. However, the difference between what we think is happening and what actually happens is important to us. These studies certainly indicated weaknesses and exposed issues to which we had not paid sufficient attention. The following lessons were learned through evaluation.

- The return rate of evaluation sheets was poor. Wherever possible evaluations are requested on-site or stamped addressed envelopes are provided to ensure return. A greater emphasis on the importance of feedback is now part of every teacher workshop. Class evaluations have been found to be more effective for the younger pupils. Collation and response to open-ended questions are the most valuable in providing useful ideas for modification.

- For all evaluations, the educational experience rated a satisfaction level of 98%, which I have interpreted as an endorsement of all the evaluative work done prior to implementation. Identification of incidental aspects of the visits that created discontent was important. The focus of teacher and pupil dissatisfaction centred mainly on issues such as access to toilets, storage of school bags, unexpected closures, unexpected noise, a glitch in bookings and, sometimes, other visitors. These results heightened our awareness of the need to manage such problems and to improve the customer service attitudes of all staff. Most of the problems were ones that could have been managed better. The results guided us into a more client-focused approach and towards some simple modifications. For example, the initial meet-and-greet experience was improved so that, in some way, every arriving school is now welcomed by a member of staff who has full details of their programme. This change of focus has led to a smoother operation.

- The Museum-in-a-Trunk programme is not cost-effective in the short term. The programme development and delivery of the trunks are staff-intensive. In the long term this will change. Experience has indicated that we must find more effective ways to reduce development costs and modify gallery material to be used in the classroom. The very essence of this programme is to take collections to schools. In terms of travel it was cost-effective in that three class levels would often participate at one site and schools could take full

advantage of the museum educators' involvement. Needless to say, the political and social imperatives associated with this programme are still significant motivators. In terms of public relations and educational value, this component is invaluable and the true and long-term benefit difficult to assess.

- The secondary student service scheme has grown considerably and has assessments that are both internal and external. Museum staff regularly give presentations to schools and educators detailing the embracing nature of the programme. From the students' point of view they meet their requirements for the Duke of Edinburgh Award and develop social skills, and our younger visitors benefit from the opportunity to learn from them. A spin-off has been that many students continue to be involved with the museum in a range of voluntary and paid roles after they have completed their community service.

- Teachers are not always eager to experience change. Those who have not been frequent users of the museum and facilities respond in two ways. Either they are extremely positive and eager to the utilise what is offered to the fullest extent, or they experience disappointment because, for example, the museum programme and layout is not the same as it was five years ago, or different resources are being used. This latter response prompted us to become more proactive in extending our work in teacher workshops and finding ways to encourage teachers to visit the museum before the class trip. In addition, it was decided that a museum educator would contact teachers by telephone prior to every visit. This is time-consuming but profitable.

- In the past, some museum teacher workshops have not been well attended and assessment showed that this was often because our advertising did not reaching the appropriate people. From such assessments, new advertising was initiated through association newsletters, the Education Gazette, generic advertising and our own website. As a consequence numbers increased. We also discovered that workshops for school librarians can be one of the most effective ways of ensuring those museum resource materials and programme opportunities are circulated and made available to teachers.

- It became clear that it would be helpful to rebrand and reinforce the museum message and image. Basic marketing principles ensure that customers will become aware that excellence and access are

fundamental in everything we do, and make all materials and advertising instantly recognisable to client groups.

- The format for workshops has evolved as a result of constant monitoring and evaluation of all components. Especially well received by teachers is the opportunity to experience what the students will actually experience. Specialist speakers and the opportunity to become familiar with collections and resource materials have generated a 98% success rate. Invited experts and practical activities are always well received, although we have yet to achieve the ideal balance in time allocation for teachers to complete all tasks and activities.

- A break for refreshments is an absolutely necessity. Funding and teacher timetabling in New Zealand have meant that many more teachers pursue professional training opportunities in their own time. Apart from presenting workshops at staff meetings and during teacher-only days, the majority of workshops are held at the museum after school hours when teachers may be tired. We have also experimented with the type of refreshment most suited to sustaining teachers after school and discovered that white wine with snacks during a break is not a good idea as teachers are prone to nod off!

- The advisory board was not always easy to convene and its members were therefore given a new role as individual focus advisors. In this role they provided evaluations of materials and became mentors in respect to curriculum links. This modification became much more manageable and guaranteed the museum almost immediate response to queries and planning direction.

- Information revealed that enquiries and requests from early childhood educators skyrocketed. This had not traditionally been a target group for the department and has resulted in the preparation of early childhood kits, teacher workshops and designated gallery time.

- An effective and efficient booking service is critical. The department facilitates programmes for approximately 65,000 schoolchildren per year and good organisation is essential. Following identification of cracks in the system a new procedural format was developed, with a checklist so that problem issues could be minimised. It is sometimes very difficult to make contact with teachers, resulting in a heavy use of the fax machine. Our ideal is to have booking availability on e-mail so those teachers can programme themselves in at suitable times.

- The single most useful tool for teachers is the resource kit, so free distribution for all schools became a target. The original intention was to generate income from the kits but it became far more effective to seek sponsorship so that production and postage were covered.

- Cost factors cannot go ignored and the biggest cost is staffing. Changes were made to the way that the programme was staffed, so that we often brought in short-term contractors to cover specific subject areas, especially during special exhibitions. Close monitoring of staff costs was necessary in order to report accurately to our funders and to museum management. Good statistical information allowed us to see the breakdown of costs but also to assess the actual sums generated for the museum by school groups, especially for special exhibitions. This sum is not inconsequential and generated during the less popular times of the day. In terms of cost-efficiency, every component was evaluated and modifications made to achieve the same effect at less cost. The establishment of a set term programme certainly resulted in better use of resources and more focused staff time in the development stage of unit preparation.

Conclusion

The learning curve since embarking on this process has been enormous. Becoming familiar with different methodologies and applying rigour in the analytical process is critical and time-consuming. Anyone wishing to set out on this path must do so with clear aims in mind.

The study was valuable because it made this department, as a staff team, much more aware of the many daily operations that affect the total museum experience. It has caused us to move from a purely educational approach to one that is more holistic and organisation-wide. It made us much more aware of the many levels of accountability and, in my view, produced a more worthwhile product with total client focus.

All content and resource areas were fully evaluated, trialled and tested before being implemented, and teachers and pupils evaluated them further while using them. The philosophy behind the approach was based on the belief that the museum visit and experience is made up of a number of components, all of which should meet the visitor's needs. Those needs are educational, emotional, physical and social and it is the interplay of all these that will result in a positive experience. By looking thoroughly at all the ways in which the individual and group visitor needs were being met we were able to identify weak links. This work has been educative and empowering to us as staff.

Key points

- Programmes need to be evaluated before they are implemented and during their operation. It is important that evaluation looks at the total package, the overall organisation as well as the visitors' experience. It must ensure that all components of a given programme contribute to the whole.
- The results of evaluation can be useful in providing feedback to the external funders of an education programme as well as to museum colleagues who need to know the quality of what is on offer and its efficiency in terms of cost, administration and advertising. Evaluation can also provide evidence of the quality of management systems and any staff training needs.
- Evaluation should not be a one-off, rather a process which facilitates constant improvement and modification. This regular feedback can result in improvement in a variety of areas, such as the content of teacher preparation prior to a visit and the way in which the museum education department is staffed.

Key texts

Durbin, G. (ed.) (1996). *Developing Museum Exhibitions for Lifelong Learning.* The Stationery Office.

Section 8 of this publication helpfully summarises a range of evaluative techniques particularly related to informal learning in exhibitions.

Hooper-Greenhill, E. (ed.) (1996). *Improving Museum Learning.* East Midlands Museum Service.

Based on a three-year project in a number of museums, this booklet provides good basic advice on how to start a process of evaluation, giving various examples such as running evaluation workshops and generating support material. It stresses that the objectives of any evaluation have to be clear before an appropriate form of evaluation can be chosen.

Bibliography

AAM (1984). *Museums for a New Century.* American Association of Museums.

Dufresne-Tassé, C. (ed.) (1998). *Evaluation and Museum Education: New Trends.* University of Montreal/ICOM.

Scott, C. (1998). The long winding road: evaluation and visitor research in Australia and New Zealand. Presented to the 1998 *Visitor Centre Stage: Action for the Future* conference, Powerhouse Museum.

CASE STUDY 7 Evaluation of teachers' courses

Eva M. Lauritzen
Head of education,
Natural History
Museums and the
Botanical Garden,
University of Oslo

These are the biggest natural history museums in Norway. In 1960 a joint education department was initiated, which aims at increasing knowledge in biology and geology among teachers and students at all levels. This is done by producing educational resources, by direct teaching, and also by arranging teachers' in-service courses and courses for student teachers.

In common with most museums, our education department arranges short courses for teachers on how to use the museums. We also arrange courses extending the museums into the environment. These usually last three days. Our philosophy is that, after studying nature in the museums, students should go out into the environment, study it and learn from direct experience. All units at the university are expected to arrange further education courses. Courses for teachers are subsidised by the Ministry of Education's section for continued training. They demand that all courses are evaluated.

Teachers examine their finds during a field course on freshwater ecology. Photograph by Eva M. Lauritzen.

A new curriculum was introduced in 1997 for primary and secondary schools in Norway. This has been adopted gradually over a three-year period, and the process has involved many challenges for the teachers. The curriculum states the importance of fieldwork and experiences in individual environmental projects. For many teachers this is a new and demanding way of teaching. They are often unfamiliar with the measuring and recording equipment used in natural sciences and have a limited knowledge of flora and fauna. When we arrange a teachers' course about nature excursions and fieldwork we aim to prepare participants so that they will be able to carry out an effective excursion with their own pupils. By the end of the course, they should know how to record environmental data, identify the most ecologically important plants and animals and how to draw conclusions about the status of the area. Evaluation is a tool to ascertain that we reach this goal.

Formative evaluation

When planning the programme for a teachers' course, we consider several factors. We choose equipment that is affordable for schools, not expensive research tools. We find or produce printed materials for the excursion that are of a good quality, in terms of both biological information and educational level. We list a limited number of plants and animals for the participants to learn and these are carefully selected to be the most common and the most important environmental indicator species. We also design the material for the course so that it is possible for teachers to use them in other, similar, areas afterwards. The printed materials also include pupil activity sheets for recording, measuring and observation.

When a draft programme is ready, it is time to discuss with the participants what they need the most or consider most important. Each participant receives a list of topics and is asked to prioritise them. We ask about their educational background and their experience as teachers. We also ask teachers whether they prefer several short days or fewer, very long days. This is a formative evaluation for the course.

Formative evaluation is often used for commercial products in order to secure success. When using it to design teachers' courses it has several advantages. First, it is possible to modify the content of the course to meet the expectations and needs of the participants. Our experience is that more than 80% place the same three topics as the most important. Second, it provides important knowledge about the participants, which is crucial when deciding the level at which to pitch the course. At the

same time, participants get an extra motivation from having been given influence over the content.

Knowledge about the background of each participant allows us to put together groups of teachers who are teaching at the same level and who can work with each other throughout the course. In each group there will be teachers with considerable experience and some whose experience is more limited; there will be those with a fairly good background in the actual subject and others with hardly any. This is to ensure that the group will be able to co-operate effectively as a team. The course itself consists of lectures on environmental studies and teaching methods, practical fieldwork, demonstrations, discussions and reports.

Pre- and post-course testing for knowledge of species

Many teachers have been overwhelmed by the vast number of plants and animals in nature that they are unable to identify, and appreciate a limited list of species. This method enables them to learn the most important plants and animals in a short time, and to temporarily close their eyes to the more insignificant species. On some courses we have given the participants a test of their knowledge of species before starting the course and after it has ended. The results are handed in anonymously with an identification mark that only the participants themselves are able to recognise. It is very interesting for us to compare the results from the two tests, and stimulating for the participants to get proof of what they have learned.

Summative evaluation

For the final evaluation of the teachers' course a questionnaire is handed out, sometimes at the start of the course. At the end, time is left to go through it, fill it in and discuss the course. Participants answer questions about their experiences of the course, they give ratings on a five-point scale as to the quality and level, and suggest in plain words what should be done differently. The most important questions are:

- Do you feel able to plan and arrange a good environmental excursion with your class?
- Are you able to teach about how to interpret and draw conclusions from the measuring, observation and recording?
- Will you be taking your class on an excursion this term?

We usually get very encouraging feedback. Participants often mention as

a positive experience that their opinions and demands were considered when planning the course. Occasionally, some answers identify problems shared by a number of participants. Whenever criticisms are made it is a challenge for the organisers to make improvements before the next course.

Conclusion

These methods of evaluation make it easier to plan courses and save us needless work. Participants get what they expect, are content and feel able to master the theme after finishing the course. We get no complaints about long, intensive days; participants have themselves voted for this format. Occasionally we get postcards from teachers telling us that they have been out on a nature excursion, that they coped and that their pupils enjoyed the fieldwork. The ultimate aim of all our courses is to make students fond of nature and willing to take responsibility for it. By encouraging teachers to get out of the classroom, we hope that our courses contribute to this aim.

Chapter 10
Vicky Woollard
Lecturer,
Department of
Arts Policy and
Management,
City University,
London

DEVELOPING MUSEUM AND GALLERY EDUCATION STAFF

Britain, along with the rest of Europe, has taken up the challenge of creating learning societies and putting learning into the workplace. With this ambitious vision come new initiatives, such as personal action plans, which aim to encourage each individual to take a lifelong interest in their own professional development. In the context of museums and galleries, encouraging such development in staff on museum educational matters, be they educators or not, will help to place education at the centre of the organisation. This chapter looks at a number of aspects of professional development for museum and gallery educators. It also looks into the role of the museum or gallery educator as a trainer of other staff (permanent or freelance) and of volunteers in areas such as teaching, guiding, working with people with special educational needs and compiling programmes based on the theory and practice of museology.

As we have seen in previous chapters, the education work carried out by museum and gallery staff requires a wide range of skills and knowledge if it is to be carried out to a high standard. Staff members need expertise in pedagogical theory and practice, and should be able to relate these to the various learning patterns, styles and needs of the public. They also need to develop and maintain a wide network of contacts in the museum education sector and among agencies and individuals whose work is linked to different visitor groups, for example teachers, lecturers, social workers, community leaders. Staff require an understanding and knowledge of the collections that they are interpreting, along with an overview of the various functions of the museum and its place in the wider context of society. Finally, a wide range of management skills are necessary if programmes are to be delivered to specified standards with the available resources. These include an understanding and involvement with staffing issues, managing budgets, forward planning and evaluation.

No one person can acquire all these skills, knowledge and expertise at the beginning of their career. These are constantly accumulated

throughout a working life through specified training, informal coaching and academic reading.

The sections below look at a range of methods for personal professional development and for transforming the museum or gallery into 'an environment in which all members are encouraged to develop' (Peel 1993: 87). They include informal and formal schemes for education and training which take place both within and outside the workplace. The aim is to highlight the variety of opportunities for museum and gallery educators to raise their standards and expectations in order to have fulfilling and enjoyable careers. Rewards are equally high for the organisation itself, which becomes richer professionally and more adaptable to the increasing demands made by funders and the public.

When embarking upon a career in museum and gallery education it is helpful to have gained experience, knowledge and skills in a number of areas. For example, it is helpful to have:

- first-hand experience of working with the public, in either a formal or informal education context
- participated in the planning, delivery and development of programmes that have educational aims and objectives for a target group
- knowledge and experience of setting up, developing and maintaining contacts with different outside agencies related to formal and informal education
- the ability to work with people and resources in an efficient and effective way
- the ability to communicate with a wide range of the public
- a sensitivity to others' learning needs and an ability to support and develop an interest for learning
- an interest in and knowledge of museums and galleries, their historical and political context, role in society and aspects of their collections.

Most museums and galleries welcome volunteers and this is the often the first opportunity for people to experience museum work.

Self-assessment and appraisal
On gaining a position as a volunteer or as a freelance, part-time or full-time worker, it is vital for you to maintain a long-term view of your work and development. Before embarking on any form of professional development, be it a day's conference, training scheme or academic

course, it is useful to reflect on the roles and responsibilities of the post by asking questions such as:

- What do I do well?
- What am I recognised for?
- What have colleagues praised me for?
- What do I think are my strengths and weaknesses?
- In what areas of my work do I feel less confident?
- When do I automatically turn to others for support, and is it appropriate to do so?

This can be followed by a second set of questions which are linked to the future:

- How do I want my career to progress?
- What would I like to be doing in three years' time?
- What additional skills, knowledge and experience will I need to accomplish my ambitions?

This self-assessment can be done informally with colleagues in the museum and within the museum education sector. It concerns your own needs and aspirations and requires you to plan ahead.

Many museums have an appraisal scheme in place, where all members of staff are individually interviewed by a senior colleague or line manager. The appraisal reviews the past year in order to inform the coming year's objectives. This more formal assessment allows for training needs to be noted by the museum or gallery management, but the principal aim is to help members of staff achieve the goals that the museum or gallery has set itself in terms of staff development. This kind of audit is often referred to as 'training needs analysis' (Kilgour and Martin 1997). This analysis becomes very useful in times of change, when the museum or gallery is having to or wishing to go in a new direction. For example, when a gallery loses its statutory grant and has to generate income from a variety of sources, education staff will need advice and training in marketing their programmes to a range of audiences, applying for grants and reassessing their budget planning. An existing training needs analysis will show if any members of staff already have useful skills that can be applied in the new situation, and will indicate who needs extra training. It is to everyone's advantage when the ambitions of the individual correspond with the those of the museum, as there will be a positive response and financial support for professional development.

Visiting and shadowing

One easy and informal way of broadening your outlook is to visit another gallery or museum which has some similar features to your own organisation but has developed different strategies. Although this might seem casual, you will need to be thoroughly prepared for the visit; it is impossible to look at every aspect of other colleagues' work, especially if you wish to take away particular pieces of information. So, focus on a particular aspect of the education work and think of relevant questions which will draw out the details. You also need to bear in mind what is appropriate to transfer across and to adapt to your own practice, and what elements are site-specific. For example, it is not appropriate to embark on a range of activities that are based on a type of collection which your gallery or museum does not have, but it could be helpful to extract the techniques and materials used and the overall learning goals.

Shadowing has a different emphasis and is more appropriate when you wish to have an understanding of an individual's role within the organisation, rather than of the programme itself. Perhaps you are interested in looking at the role of the head of an education department in a large organisation. What are the day-to-day issues they are involved in? How do they organise and monitor their team's work? Or you may wish to shadow an outreach officer while they make their visits into the community. What skills are used? What are the types of relationships which are built up between the individual and the groups? What influence has the location on the type of project the officer sets up?

With shadowing, it is important to plan well ahead with the host to co-ordinate the day and timetable which best highlights the specific areas you are interested in. You also need to think carefully about your own role during the day. Are you there to observe or will there be times when your own expertise may be called upon, and is this understood by everyone?

Attachments and secondments

These are circumstances where an individual spends a period of time, for example from three months to a year, at a particular organisation in order to gain an in-depth view of its activities. These tend to be carried out early in your career and could be organised by universities as parts of their courses.

In the European Union, the Erasmus scheme enables EU students to take a part of their course at a partnership university. Students are matched to a museum or gallery and are expected to write a report on the attachment to form part of their overall assessment. In the UK, the

Millennium Commission (a part of the National Lottery in Britain) has granted awards for employees in museums and galleries to spend six weeks in another heritage-related organisation. Applicants must have had at least four years' experience of working in museums or galleries. The aim of the secondment is for the individual to return to their own museum or gallery with new skills and knowledge that will directly benefit the public's experience. The individual will be expected to contribute ideas and practices to the host organisation as well as offering staff time and expertise. The importance of exchange, and particularly of international exchange, is dealt with in Chapter 12.

Mentoring

This is a recognised informal relationship between two professionals. The mentor in this partnership has more experience and, through encouragement and discussion, nurtures the other's interest and progress. The mentor is generally based outside the mentee's own workplace, thus enabling both to look objectively at the context in which the mentee is situated. Mentors can

> pass on practical insights derived from experience and can pick up on new ideas and attitudes. They can help their protégés to set themselves realistic expectations and steer them in the right direction as far as their career aspirations are concerned (Thomson 1993:111).

The relationship should allow mentees to sound out ideas about their future professional life, while mentors challenge and stretch mentees' horizons through asking pertinent questions.

In the UK, the Museums Association, the professional body for those working in museums, has set up a more formal mentoring scheme for its members. The initial stage has been to introduce mentoring as a component in the development of an individual as an Associate of the Museums Association, which is recognition of an individual's status within the profession. The mentoring relationship is set up for two years, during which the mentee produces a plan for continuing professional development which includes the activities they intend to complete in order to achieve their goals. The mentor and mentee meet throughout the two years using the plan as a basis for their discussions, noting where changes have been made and, more importantly, recognising development. At the time of writing, the scheme is for younger members of the profession who, following a successful interview and the presentation of their plan, are made Associates. This can upgrade

their salary and position within an organisation. It is intended that older members will take part in a similar scheme that will maintain high standards and an awareness of current issues.

Partnership in research

One way of developing your skills and knowledge is to collaborate with others in a project, particularly one which contributes to the profession's understanding as a whole. Here are three possible routes for collaborative research.

- Write a paper with a number of colleagues about some shared professional experience. This is a welcome opportunity for those who wish to conduct research, but who perhaps do not enjoy writing, to spread the burden.
- Join a book research group, such as the one the Group for Education in Museums set up to bring together a collection of existing papers on the theme of exhibitions for lifelong learning. Teams of readers around the country commented on the suitability of articles for inclusion under a range of headings, such as 'visitor studies'. The outcome of the project was a very successful book (Durbin 1996).
- Join or set up a project run by a group of individuals who work in different museums and galleries. Project members contribute information gathered from their own practice and, together, this helps to demonstrate trends across all or part of the country, or within a specific range of collections. For example, in the East Midlands in the UK, a group of museum education staff based in various museums worked in partnership with the Museum Studies Department at Leicester University. They spent three years examining their own practice, from which they produced a booklet on aspects of evaluation titled *Improving Museum Learning* (Hooper-Greenhill 1996). More importantly, the project helped the individuals involved develop and improve their own practice.

Workplace competencies

It is highly desirable that learning occurs in the workplace, although it is much harder to gain official external recognition for this kind of professional development. During the 1990s the museum profession in the UK aimed to improve this situation by creating initiatives that could measure standards of competency. Competency is defined as 'the ability to apply knowledge, understanding and skills in performing to standards required in employment. This includes solving problems and meeting changing demands' (Beaumont 1996: 12). Individuals have

to find evidence and demonstrate to colleagues that they are competent at work, according to the agreed standards. In England and Wales these standards are called National Vocational Qualifications (NVQs) and there is a set of standards for the museum sector which include planning and delivering educational programmes to the public. In Scotland, the qualifications are the Scottish Vocational Qualifications (SVQs).

There are many advantages to this form of qualification. You, the candidate, are totally in control of the procedure. Your portfolio of evidence is made up of material created by you in the day-to-day activities of your job and you judge when you are ready to present yourself to your assessor. The development of the individual comes with ensuring that work done matches the quality expected for that level of responsibility and displaying competency in a range of situations. For example, candidates need to demonstrate that they can prepare support materials that will be suitable for a range of ages, abilities and interests.

It is often thought that this form of accreditation is concerned with skills only. However, knowledge that 'underpins' those skills is equally important as it determines 'what should be done, how it should be done, why it should be done and what should be done if circumstances change' (NCVQ 1997: 5). The overall aim of these standards is to show recognition to those people, such as volunteers, who may not take the more formal and traditional route to scholarship. They enable more people within museums to make a significant contribution to the profession as a whole.

University courses

Universities have provided the main form of education and training for most museum staff. Until recently most professional staff in museum and gallery education have obtained a first degree in an academic subject such as art history, geology or archaeology, followed by a teaching certificate. Some have a pedagogical degree, others have a second higher degree or a diploma in museology or heritage studies. Many courses offer secondment (see above) and require a piece of research to be written (10,000–20,000 words). This form of professional development has a different premise from that of the workplace competence model. It looks at models, theoretical and practical, and places more emphasis on the analysis of theory and practice and on arguing beliefs about the current and future roles and responsibilities of museums and galleries.

Courses may include education as an integral part of the core curriculum for all students, looking at policymaking and types of

practice alongside communication theory and interpretation. Others offer a separate module, which looks in more depth at the issues of museum and gallery education and audience development. At the time of writing there are around 50 museum or heritage graduate and postgraduate courses offered by universities in the UK, but only five of these offer education as a key element of the degree.

The university environment provides the opportunity to rehearse points for debate and helps the individual develop research skills and a broader view of the subject than could be found in a single working situation. Universities have also become much more accessible in relation to the scheduling of courses, offering part-time, weekend and evening sessions. A more recent addition has been the introduction of distance-learning packages, which students complete in the comfort of their own home and in the workplace. These courses help to bring theory and practice together into the student's everyday life.

Distance learning

This extension of the university course has been developed over the years with the forward-looking Open University set up in Britain in the 1960s. The intention of distance learning is that the student is able to learn and study at home or at a distance from the university. Through assignments and the reading of material sent through the post or transmitted on radio or television, the student completes the degree and diploma. There are often special residential weeks arranged to provide group discussion, and tutors are allocated to groups of students for encouragement and also to offer academic advice.

Recently, a number of universities have offered a museum degree in this form, for example the Department of Museum Studies at Leicester University. This option at Leicester delivers a package of material and, with additional readers and study guides, the student embarks on six modules. Each module is assessed by a piece of coursework which must pass the appropriate grade before the student can move on to the next module.

Professional groups and agencies

Many countries have a museum or gallery education group which brings together individuals working within the same sector to discuss their practices, and organises meetings and conferences, thus providing a supportive network. This network is particularly important for those who are working in small museums and galleries, which are geographically some distance away from other colleagues. The

Committee for Education and Cultural Action of the International Council of Museums (ICOM-CECA) has national committees set up in a number of countries. Some countries also have their own national organisation such as the Group for Education in Museums (GEM) in the UK, which publishes journals and bibliographies, and offers travel and research bursaries to its members. The advantage of such groups is that the courses and seminars are tailor-made for members of the profession, by members of the profession. At a number of conferences there are open sessions where participants can share ideas and practices about an aspect of their work.

If you become involved with areas which are on the fringe of the museum and gallery education world, for example management, child psychology, healthcare or leisure, it is best to seek training and development which is provided by the relevant professional agencies. This provides an opportunity to network with a wide variety of individuals and organisations, and this positively enhances the museum or gallery's work. In recent years, many museums and galleries have worked successfully with staff from organisations set up to help and support people with disabilities. In the UK, the Royal National Institute for the Blind has given advice to museums and helped promote and support a number of museum and gallery projects across the country. Museum and gallery staff have benefited from this collaboration in terms of their professional development, as some have been involved in setting up 'hands-on' exhibitions and developing Braille or sound guides. These projects will have given those individuals specific knowledge and skills that will remain with them throughout their careers.

Educators training others

Many museums rely on volunteers to deliver activities and services to the public, as they are often very well informed and enthusiastic about their own particular subject area. However, running educational activities demands a range of specific skills and knowledge. Museum educators can offer excellent advice and training in this area for volunteers and staff who are not trained educators.

The UK's South Eastern Museums Education Unit (SEMEU) offers advice and expertise to all museums in the area (see Chapter 2). In collaboration with the Hampshire Museums Service, SEMEU has developed a manual called *Going Interactive*, which explains to non-educators how to prepare and deliver education workshops with museum collections (Search 1996). This manual was created to

overcome the problem of not being able to recruit experienced staff to support the schools attending the local museums. The manual contains information on, for example, listening and presentation skills, and session management.

In recent years, a number of museums have embarked on the training of gallery attendants, to maximise their abilities and increase the number of staff members who can offer a broad service to the public. Attendant staff are given training which includes detailed information about the exhibition displays, methods of working with the public and the opportunity to work with a range of audiences. Education staff have been pivotal in organising and delivering this training. The museums that have provided this kind of training have found their staff are more involved in their work and the public are more enriched by their visit. It is, of course, essential to set realistic objectives, to consider the interests and capabilities of attendant staff and reinforce the information given through a good-quality training scheme.

Key points

As a museum and gallery educator or intending educator you need to:

- take every opportunity to reflect on your recent and current work to assess the skills or knowledge you need to accomplish future professional goals
- carefully assess the range of training providers offer and choose those that are most appropriate for your particular circumstances
- collect evidence and support materials from any training sessions you have run on museum education practice, for example training volunteers to work with objects, in order to create a handbook which can be used by other colleagues
- collaborate with colleagues in similar circumstances on practical research dealing with an aspect of the group's work, which can be published or used for the basis of discussion with a larger professional group
- develop links with a range of professionals outside the museum sector who can be called upon at key times to extend the practice of your own work (for example, contact with child psychologists can be very useful when planning an exhibition for under-fives)

- take the opportunity to 'shadow' a colleague for a day – someone who works in a different type of museum or a colleague who works in a different department (conservation or documentation, perhaps) – to broaden your view of the profession as a whole.

Key texts

AAM (1992). *Excellence and Equity: Education and the Public Dimension of Museums*. American Association of Museums.
This booklet contains ten recommendations for furthering the role of museums in our culturally diverse societies. The ninth recommendation looks at professional development and comments on the need to employ and train a range of staff in order to ensure that programmes raise awareness of the value of cultural diversity.

Glasser, J. and Zenetou, A. (1996). *A Place to Work: Planning Museum Careers*. Routledge/Smithsonian.
This book provides a comprehensive description of the employment hierarchy in the museum sector, with a listing of recommended experience and education that an individual would need for each type of post and the responsibilities that are to be expected.

Kilgour, E. and Martin, B. (1997). *Managing Training and Development in Museums: A Guide*. The Stationery Office/Scottish Museum Council.
This is a practical tool for looking at staff training and development in the museum context, with the particular emphasis on training needs analysis. There are exercises and easily referenced themes running through the text.

Bibliography

Beaumont, G. (1996). *Review of 100 NVQs and SVQs*. Department for Education and Employment.
Durbin, G. (ed.) (1996). *Developing Exhibitions for Lifelong Learning*. The Stationery Office.
Hooper-Greenhill, E. (ed.) (1996). *Improving Museum Learning*. East Midlands Museum Service.
Kavanagh, G. (1995). *Museum Provision and Professionalism*. Routledge.
Museums and Galleries Commission (1987). *Museum Professional Training and Career Structure: Report by a Working Party*. HMSO.
NCVQ (1997). *Assessment of NVQs and SVQs*. National Council for Vocational Qualifications, Scot VEC.

Peel, M. (1993). *Introduction to Management: A Guide to Better Business Performance*. Pitman Publishing.

SEARCH (1996). *Going Interactive: A Trainers' Manual for Preparing Staff to Work in a Hands-on Centre or Museum*. Hampshire County Museum Services.

Thomson, R. (1993). *Managing People*. Butterworth-Heinemann.

Useful website

International Committee for Training of Personnel (ICTOP): a part of the International Council of Museums.

ICTOP's mission is to encourage and promote relevant training to appropriate standards for all people working in museums, throughout their careers, including students in museum-related pre-entry training programmes. See <http://www.icom.org.ictop>.

Chapter 11 INFLUENCING AND IMPLEMENTING NATIONAL STRATEGIES

Alison Coles
Museum development officer, Museums and Galleries Commission

The Museums and Galleries Commission (MGC) is the national advisory body for museums (including galleries with permanent collections) in the UK and is funded by central government. It promotes the interests of museums, undertakes strategic work to raise museum standards, provides expert and impartial advice to museums and others, and advises the government on museum policy. Through its work the MGC aims to encourage as many people as possible to visit and enjoy the nation's museums, and it 'places a high priority on the development of museum education services within the wider context of lifelong learning and audience development' (MGC 1998a). The MGC keeps in touch with government-funded and other initiatives and disseminates information about them to the museum community. In 1994, the MGC created a three-year full-time post to deal with education and other public services issues, and the post was subsequently made permanent. This post aims to increase and improve opportunities for lifelong learning through museums.

The MGC collaborates with other national organisations including the Museums Association (the professional body for museum staff) and specialist groups within the sector, such as the Group for Education in Museums, the National Association for Gallery Education (engage) and the Association of Independent Museums. It also works closely with the ten UK Area Museum Councils, membership bodies for museums which receive most of their funding from government.

In 1997, the UK government department with responsibility for museums published *A Common Wealth: Museums and Learning in the United Kingdom* (Anderson 1997). This was commissioned by the government as a contribution to the debate on the nature, extent, importance and development of museum education and marked a significant step forwards for museum education in the UK. The report reflects the gathering tide of interest in the role of museums in lifelong learning. Beyond that, it argues that museums' long-term survival depends, in part, on whether or not they rise to meet the challenge of 'the learning society' and develop their educational role. The report makes recommendations for museums, museum organisations, the government and other bodies whose policies impact on museums,

aimed at enabling the museum sector to fulfil its educational potential.

The bulk of its recommendations fall into three broad categories:

- advocacy
- standards
- resources.

Together, they contribute to a vision of a future where the educational role of museums is integrated into government and other national policy developments in education, culture and the arts, and social welfare; where museums deliver a high standard of education, and where funding is stable and sufficient, with access to a specialist museum educator for every museum.

Needless to say, this vision is not yet reality. However, at the time of writing the recommendations are being addressed seriously by the relevant parties. The aim of this chapter is to explore how the MGC and the rest of the museum sector are trying to foster an environment in which museum education flourishes through national strategies in the three areas of advocacy, standards and resources.

Advocacy

The UK government has made education one of its greatest priorities since 1997, as symbolised in the prime minister's commitment to 'Education, education, education'. [1] This is reflected in the government's statement on cultural policy, which has 'the nurturing of educational opportunity' as one of its cornerstones (DCMS 1998). Such endorsement is helping to raise the profile of museum education and supports the MGC's view of education as a core function of museums.

However, there are other national policies which impact on museum education. Most significant, of course, are government education policies. A particularly important one for the museum sector has been the introduction of statutory national curricula in England, Wales and Northern Ireland, which stress learning from first-hand experiences and enable museums to match services closely to schools' needs. Indeed, the government's curriculum authority for England produced a guide to the English and Welsh National Curriculum for museums, with suggestions for activities and resources (SCAA 1995). More recently, however, the requirements of the primary National Curriculum were modified to allow schools to focus on literacy and numeracy, leading to concerns that the role for museums would be reduced and pupils' school experiences impoverished. The MGC called for the government to stress the contribution of museums in its guidance on how to

maintain 'breadth and balance' in the newly flexible curriculum. As a result, examples of work involving visits to a museum and historic site were included in the guidance and should help reduce any detrimental effects of the curriculum changes.[2]

This illustrates the importance of active involvement in policy developments in the wider educational field. Through participation in advisory groups and written submissions, museums are now contributing towards the development of a revised National Curriculum to take effect from 2000, with the aim of ensuring that the curriculum encourages the use of museums. To this end, the MGC has worked closely with national organisations in the wider heritage field who share many of the same concerns. This helps to strengthen the message.

Another area of national education policy which has great impact on the ability of museums to contribute fully to schools' education is teacher training. It is vital that teachers develop skills in using museums effectively. Through responses to various consultations, the MGC and others – such as the Group for Education in Museums – have been calling for compulsory teacher training in the use of museums, and also for the use of museums to be evaluated in school inspection reports (as happened in the past). MGC press releases about these responses have resulted in a good deal of publicity about this stance. In the meantime, the MGC is part of an advisory group set up by the government's body for the curriculum in England – now known as the Qualifications and Curriculum Authority (QCA) – to produce professional development materials for teachers and museum staff on using museums with schools.

The UK government's policies on lifelong learning have profound implications for museums. The government's consultation paper on its lifelong learning strategy sets out its vision for a nation of learners, recognising the many benefits of learning for individuals, communities and the nation (DfEE 1998). Museums have a significant role to play in the various initiatives proposed to fulfil this ambition. However, the specific proposals in the document focus on the development of skills and knowledge for work, and museums receive very little mention. The MGC and other organisations within the museum sector have stressed the importance of a wider view of the role of learning and of the contribution museums can make to learning for its own sake as well as work-related learning. How this lifelong learning strategy is now taken forward will be an important factor in the development of museums as providers of mainstream education. For example, the government

proposes that each individual will have a 'learning account', with a contribution from the government. It is important that these accounts should be valid for museum learning which might not be primarily work-oriented.

Government policies other than those aimed at education can also have an impact on museum education. A key issue for the UK government is tackling social exclusion: overcoming the barriers to full participation in the life of the community and the nation which can result from problems such as unemployment, poor skills, low income, poor housing, high crime environments, bad health and family breakdown. Museums already undertake valuable educational work with people who are socially excluded, including prisoners and disaffected young people, and people with a range of disabilities. There is a need to promote the role of museums in this sphere. Research into the social impact of museums, and high-profile dissemination of such research, would be one way of doing this.

Looking outside government initiatives, it is important to try to encourage museums to become involved in well-publicised education projects, thus raising their profile as educational providers. For example, museums in the UK are contributing towards the BBC's 'Millennium History Project', the National Institute of Adult and Continuing Education's 'Adult Learners' Week' and the Campaign for Learning's 'Family Learning Weekend'. In the latter case, the Campaign for Learning was encouraged to send out information about participating in the family learning events via museum networks. Museum contributions include free opening, special family activities, and temporary exhibitions and object handling sessions in shopping centres, railway stations and leisure centres. It is possible that media coverage of exciting museum education work can have far more impact than responses to consultation papers.

National agencies can play a key role in influencing government and other education policies and initiatives, and in making sure that museums feature strongly in them. Success in advocacy demands a proactive approach and anticipation of future developments. For example, when the government consulted on proposals for a National Grid for Learning, a network of learning resources on the Internet, the sector responded enthusiastically. The MGC and others pointed out the opportunities for museums to provide 'virtual' access to their collections and teaching resources based on them, and through this to encourage more and better-focused visits. By this time, however, the Library and Information Commission had already undertaken research

into the provision of learning opportunities using new information technologies in libraries. This culminated in the publication of a major report (LIC 1997) which is likely to have contributed to the central role given to libraries in the development and delivery of the National Grid for Learning. For example, the library sector has access to funding for the training of librarians in information technology, whereas similar funding has not been allocated to museums. This illustrates the importance of trying to lay the ground which will enable museums to play a key role in developments. Simply responding to initiatives is not sufficient.

The example of the National Grid for Learning illustrates another point about advocacy. It is not only national agencies which need to provide advocacy for museum education, however much they may represent the whole sector's views; regional organisations and museums themselves have to play a part. For example, few individual museums responded to the National Grid for Learning consultation, whereas there were many library responses, and this is likely to have influenced the outcome. In addition, museums need to promote their role in education at a local level, for example within their local authority, which will feed into national policies. Indeed, some national policy initiatives grow from what is taking place on the ground. For example, the government's plans for vastly expanded opportunities for out-of-school educational provision developed out of work which was already going on around the country. Because museums were not involved in this to any great extent, they were not considered during the early stages of the initiative. However, following approaches by representatives from the museum sector, the government is now funding museum pilot projects with the intention that museums will become increasingly involved. By forming partnerships with other educational organisations, museums can help to ensure that they are viewed as being part of mainstream lifelong learning provision.

One of the most significant factors affecting the extent to which the museum sector can influence government education policies is the structure for liaison between the government's cultural and education departments. Ideally, there would be liaison at ministerial level, along with civil servants within the government education department who would be responsible for alerting the museum community to education initiatives and acting as champions for museums within the department. It is only relatively recently that the UK government's education ministers and civil servants have given greater emphasis to the role of museums for lifelong learning. This came about largely as a

result of the publication of *A Common Wealth* (Anderson 1997) and subsequent advocacy work.

Much is still to be done before, in the words of the MGC's director, 'Education, education, education – museums, museums, museums' becomes a widely accepted vision (Mason 1997: 2). In recognition of this, various national museum organisations, including the MGC, the Museums Association and the Group for Education in Museums, have collaborated to develop a Campaign for Learning Through Museums, the key role of which is to promote the contribution that museums can make to wider education initiatives. At the same time, it is essential that museums are capable of providing high-quality educational experiences as no amount of advocacy will change views if the product is poor. Raising standards of provision is therefore a key part of a national strategy for museum education.

Some forms of advocacy that any organisation or museum can get involved in include:

- responding to consultations and issuing press releases
- approaching key decision-makers
- contributing to education sector advisory groups and conferences
- inviting involvement of the wider education sector in museum advisory groups and conferences
- undertaking research, producing papers or holding conferences which anticipate or reflect key government priorities
- working in partnership with other organisations with similar concerns
- setting up a campaign group.

Standards

Helping to increase and improve the educational opportunities offered by museums is a key MGC activity, and a natural and necessary partner to advocacy work. The MGC's publication *Managing Museum and Gallery Education* sets out guidelines for good practice in the areas of policy, planning, staffing and resources (MGC 1996), and the first key recommendation in *A CommonWealth* is that museums should adopt these guidelines (Anderson 1997). In key points to the guidelines, 'the MGC urges every museum and gallery to:

- recognise education as a core function of museums and galleries
- support the role of museums and galleries in providing education for all

- have a written policy on education, which is endorsed by the governing body and is an integral part of the forward plan
- have a written action plan with long- and short-term objectives
- give responsibility for education to a senior member of staff, who should ideally be a specialist
- ensure that staff receive training, advice and other support to enable them to fulfil their educational responsibilities
- ensure that the governing body supports the educational role of the museum or gallery' (MGC 1996: 10).

The guidelines were developed through consultation with the sector and represent a consensus about good practice which is achievable by all museums, whatever their size or resources. In order to improve standards, the guidelines stress the importance of each museum assessing what it can achieve in its own particular circumstances; museums need to view themselves as inherently educational organisations and seek to fulfil their full educational potential through all their activities. Following the MGC's lead, the Association of Independent Museums produced *Education for Smaller Museums* for its members (Moffat 1997).

The museum community welcomed the MGC's guidelines as a checklist for action. However, it is not compulsory for museums to follow the guidelines and the actual effect which they will have on standards remains to be seen. Through annual questionnaires to museums, the MGC monitors the existence of education policies and action plans, and the results are published (MGC 1998b). The MGC will be interested to see if there is any increase in the percentage of museums with policies and plans over the next few years.[3] A qualitative evaluation of the specific impact of the guidelines is planned.

The nearest to compulsory standards in any area of museum work is the MGC's highly successful registration scheme, which offers museums a basic 'seal of approval'. This brings eligibility for grant aid from a range of sources, as well as for certain awards and for participation in various initiatives. There are now over 1700 registered museums across the UK (which is the vast majority of museums). Although museums are required to supply details of their education provision when applying for registration, the scheme concentrates on issues of constitution, collection care and documentation, and does not include specific education criteria. There is currently much debate about the place of education within the registration scheme (Bott 1998). The use of education criteria would be an effective tool for raising standards, and the guidelines could be used as a basis for these criteria. However,

some museums, particularly smaller ones, are already stretched by the existing criteria and feel that they could not cope with the introduction of education requirements. The danger is that the scheme would no longer embrace museums of all sizes and types, which would lessen its impact on the museum world.

How far should the MGC risk leaving some museums behind in a desire to raise standards of education provision? It is beginning to consult widely about this issue. In the meantime, the MGC's work continues to help museums to raise standards through training, information and advice. For example, the MGC has organised the training of a group of museum education specialists to deliver training to other museums on writing education policies, working through Area Museum Councils.

Another important influence on whether museums take account of national standards for museum education is the criteria used by funders. It is important that charitable trusts, sponsors and other grant-giving bodies are encouraged to consider such standards when assessing applications. For example, museums seeking Lottery funding for education projects are asked for details of their education policies, and assessment of applications takes into account the availability of museum education expertise, both of which echo key points in the MGC's guidelines. On a more fundamental level, funding and standards are inextricably linked, as increased and improved education provision can only come about if sufficient resources are available.

Resources

Museums need human and financial resources in order to fulfil their ongoing core functions as well as for specific new projects. In the survey undertaken for A CommonWealth, museums cited lack of funds as the main reason for not providing education services (Anderson 1997). Indeed, the report suggested that education funding is more likely to be cut in response to financial pressures than funding for other museum functions.

To some extent, resources for education programmes within museums depend on how much of their budget museums choose to spend on such work, and the way they prioritise their various functions. Core funding for education work is the only way to ensure a stable basis for developing long-term provision, and a core-funded post for a permanent education officer can be hugely beneficial. The value of core funding is illustrated by the situation which has arisen where museum education services are funded out of local authority schools' budgets.

This funding is increasingly being delegated to schools themselves, who can then choose whether or not to spend it on museum education services. This threatens the stability of these services and the essential developmental work which underpins museum education, as well as work with non-school audiences. Separate funding for education work can also result in museum education being divorced from the rest of the museum's functions. The ideal situation is where the museum itself has core funding for its education services. Through its discussions with central and local government, one of the MGC's key aims is to argue for core funding of education in all types of museums and to help to encourage museums to allocate core funding to museum education. The guidelines state that 'the time, effort and resources that you put into education will indicate your level of commitment to education as a core function' (MGC 1996: 9).

It is also important to try to create additional resources for specific projects, which can help in the long-term development of services. For example, innovative pilot projects can demonstrate new ways of working, and initial funding of education posts often results in the creation of a permanent core-funded post. The MGC's liaison with the Department for Education and Employment (DfEE), the government's education department in England, over 'demonstration' projects linking schools and museums is an example of this kind of work. For some time, the MGC has been calling for the education sector to contribute towards developing the educational role of museums, and this is a welcome example of the DfEE giving money directly to museums for education work. The Campaign for Learning Through Museums is working to persuade charitable trusts of the value of funding museum education, and the availability of Lottery funding for museum education projects, which was recommended in *A Common Wealth* (Anderson 1997), is also a welcome development. Area Museum Councils can also fund education projects in museums, but vary in the priority they give to such projects, and Regional Arts Boards support projects in galleries showing contemporary visual arts and crafts.

It is not only museums that need resources for education work. The infrastructure which supports museums needs resourcing too, to enable it to facilitate museum education activity. Some Area Museum Councils have appointed education specialists from their core budgets and these people can work with museums that do not yet have their own education officers. Other Councils are seeking Lottery funding to establish such posts. This will have a profound effect on those museums' access to museum education expertise. The MGC's investment of money

in a permanent museum development officer post has been important in supporting museums to increase and improve provision. Indeed, it is probably true to say that, with limited resources, investment in such infrastructure is the best use of money, and the MGC has called for additional government money for Area Museum Council education specialists.

Conclusion

The areas of advocacy, standards and resources are interlinked parts of an overall approach to influence and implement national strategies for museum education, as indicated in the flow diagram. All three elements are needed to enable museums to take their place at the centre of 'the learning society'. In the UK, this work is undertaken by a variety of bodies and the MGC, as the UK's official government advisory body, plays a key role. In other countries, national committees of the International Council of Museums (ICOM) and the ICOM Committee for Education and Cultural Action are likely to be important contributors to these activities.

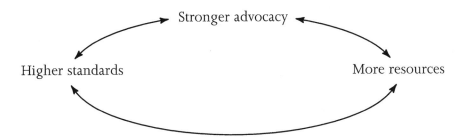

Stronger advocacy

Higher standards

More resources

Key points

Making advocacy effective involves:

- anticipation of future policies and initiatives in the education field, and involvement throughout their development
- involvement of museums in high-profile education projects, with good media coverage
- advocacy and partnerships at a regional and local level, which will then feed up into national policies.

Raising standards involves:

- setting clear standards

- helping people to achieve these standards through training, information and advice
- promoting use of standards by funders and others in their assessment criteria.

Improving resources involves:

- promoting the importance of core funding for museum education
- creating additional resources for specific projects from government, trusts and sponsors
- ensuring resources for the national and regional infrastructure which supports museum education.

Notes

1. Tony Blair, speaking at the Labour Party Conference on 30 September 1997.
2. 'Combine aspects of history, art and design and technology. For instance, on a visit to a museum to find out about everyday life in the past, record observations of the shape and form of kitchen utensils and talk about what they look like, what they are made of and how they were used' (QCA 1998: 10).

 'Combine the teaching of skills common to history and geography. For instance, develop children's skills and understanding of history and geography during a visit to a site, such as a Roman villa' (QCA 1998: 11).
3. In 1997, 34% of museums had education policies.

Key texts

Anderson, D. (1997). *A Common Wealth: Museums and Learning in the United Kingdom*. Department of National Heritage.
A comprehensive report which reviews the activities of museums in the UK as centres for formal and informal learning, and identifies how this function can be effectively developed.

DCMS (1998). *The Comprehensive Spending Review: A New Approach to Investment in Culture*. Department for Culture, Media and Sport.
Outlines the government's priorities for the development of the cultural sector, including museums.

MGC (1996). *Managing Museum and Gallery Education*. Museums and Galleries Commission.
An outline of good practice for the management of education in museums, aimed at helping museums to fulfil their educational potential.

Bibliography

Bott, V. (1998). MGC education pledge. *Museums Journal*, September 1998, 21.

DfEE (1998). *The Learning Age: A Renaissance for a New Britain*. Department for Education and Employment.

LIC (1997). *New Library: The People's Network*. Library and Information Commission.

Mason, T. (1997). New opportunities and new expectations. *Museumatters* (11), July 1997, 1–2.

Moffat, H. (1997). *Education for Smaller Museums*. Association of Independent Museums.

MGC (1998a). *Annual Report 1997/98*. Museums and Galleries Commission.

MGC (1998b). *Museum Focus* (1). Museums and Galleries Commission.

QCA (1998). *Maintaining Breadth and Balance at Key Stages 1 and 2*. Qualifications and Curriculum Authority.

SCAA (1995). *A Guide to the National Curriculum for Staff of Museums, Galleries, Historic Houses and Sites*. School Curriculum and Assessment Authority.

Chapter 12 DEVELOPING
Hazel Moffat **INTERNATIONAL LINKS**

Museum education
consultant

Learning about museum and gallery education in other countries is a long-established practice. The Committee for Education and Cultural Action of the International Council of Museums (ICOM-CECA) has been a key vehicle in fostering such learning through its conferences and publications since 1963,[1] but some initiatives predate the foundation of ICOM itself in 1946. For example, a government review of museums' work with educational institutions in England and Wales in 1931 included comparisons illustrating educational programmes and resources in American, Dutch, German and Scandinavian museums (Board of Education 1931).

As with any form of education, learning by comparison has a fundamental value. It has been described as integral to the process of cognition and a means of enabling us 'to make choices, engage in debate, better understand ourselves, our lives and environment. Comparison can help us to understand, to extend our insights and sharpen our perspectives' (Heisen and Adams 1990: 277). Museum and gallery educators, like any education professionals, can gain enormous personal benefit from seeing comparisons at first hand by travelling abroad; this becomes all the more valuable for people working in a museum or gallery context where collections may originate in many diverse societies. Experiencing different contemporary societies, albeit briefly, and their attitudes towards museum and gallery education, can bring new perspectives and a greater understanding. The importance of comparative studies specifically for museum and gallery education has been expressed as: 'Exposure to the work of overseas museums provides staff with fresh insights and new ideas, and encourages them to question their own methodologies and consider a wide range of approaches before embarking on new initiatives' (Anderson 1997).[2]

This chapter considers a range of international links in museum and gallery education, and assesses their value. This assessment is based primarily on research consisting of interviews, both face-to-face and by telephone, with staff from some 60 museums and galleries in the UK.[3] All the interviews, except for one, were held during July and August 1998. They focused on:

- visits to the UK made by educators and student interns from abroad
- use of the Internet

- membership of international associations
- visits abroad made by UK museum and gallery education staff
- evaluation of international links.

This chapter also refers to the annual conference of the UK's Group for Education in Museums (GEM) held in 1998, in co-operation with the European group of ICOM-CECA, and reference is also made to selected publications which have drawn on international comparisons in various ways.

Table 1. International links by types of museum, expressed as percentages

	Local authority	Independent	University	National
Visits made by educators and student interns from abroad	73	72	100	100
Use of Internet	41	17	87	66
Membership of ICOM	41	27	0	83
Visits abroad made by education staff	59	50	50	83

Visits made by educators and student interns from abroad

While most museums and galleries received visits by museum and gallery professionals and students from outside the UK who wished to see and work with educational services, there are some variations. All of the national and university museums received such visitors, while just under three-quarters of the local authority and independent museums did so (see Table 1). Most of the visits were made by individual educators and curators for discussions and observation of work in progress. Some examples of groups visiting include those arising from a series of individual initiatives and those sponsored by the British Council.[4] National museums were more likely than others to have individuals and groups making contact under the auspices of the British Council. The university museums in the sample have had no visits arranged in this way. Other agencies which have arranged or facilitated visits to the UK include Area Museum Councils, local arts boards and twinning associations as well as overseas higher education institutions.

The second most common type of international visitor in all four types of museum and gallery was made up of students on placement with education services. Just over a third of local authority and national museums and galleries had such placements, while a quarter of

university institutions and a ninth of the independents had them. Most of the students were on postgraduate museum studies courses in the Netherlands, Germany and the USA, and stayed in UK museums and galleries for up to three months. A few other placements were linked to business studies, history and teacher training courses. All types of museums and galleries had examples of educators who come to the UK to attend conferences, in some cases arranged by the museums and galleries. There were also a few examples of secondments, artists and teachers in residence and an exchange visit, all of which brought international staff to UK museums and galleries.

The value of these visits for host museums and galleries is wide ranging. First, the many questions asked by visitors help to crystallise thinking as policies and actions are explained and justified. Visitors also inform UK staff of good quality work in their own countries, sometimes bringing examples of material with them.[5] Where visitors are able to work with staff, whether they are on placements or other forms of attachment, benefits from their shared knowledge and skills can be considerable. Examples include learning from the skills of an African potter; having an Inuit teacher explain his way of life; and interns carrying out research, translating from their mother tongue into English and generating ideas for use of the Internet.

Some constraints are also apparent in dealing with international visitors. Occasionally, very short notice was given of an intended visit. Even with carefully planned visits, time can be pressing and allow little opportunity for an exchange of views. These constraints were less in evidence when educators attended an international conference in the UK, where the time available for formal and informal contacts gave opportunities to learn about museum education in other countries.

Use of the Internet

This form of international communication has been used by about two-thirds of the museums and galleries in the sample (see Table 1), but only a quarter of them overall used the Internet for both e-mail and access to the websites of similar institutions outside the UK. All but one of the university museums and galleries made use of the Internet in these ways. However, education officers in a third of the national museums made little or no use of the Internet, either because access was difficult or they chose not to use it. Education staff in a minority of local authority and independent museums and galleries had international links through the Internet. Reasons for other museums and galleries not using the Internet included having few or old

computers, having no time and access not being seen as a priority, especially by local authority managers.

Where Internet links have been established, educators have used e-mail to keep in touch with overseas colleagues, prepare for overseas visits and respond to enquiries. Websites have been browsed to help staff prepare their own websites, to look at learning materials, conference proceedings and recent research, to select contributors to conferences and to plan visits. One university museum has used a student and one national museum has employed someone to assist in Internet searches. General benefits derived from using the Internet are:

- discussions with fellow professionals in museums, galleries and other educational institutions
- news of current developments, conferences, exchange visits and scholarships
- opportunities to carry out surveys
- virtual exhibitions
- catalogues
- information about teaching and learning materials
- feedback from schools
- directories
- lists of books, journals and reference documents
- booking services
- software packages
- visibility and publicity.[6]

Some examples of international co-operation are beginning to extend the possibilities for joint planning of websites. A UK–Japan initiative has led to the preparation of a website on the Ancient Egyptian collection at the British Museum aimed at primary school pupils. The website will be available in English and Japanese. The Natural History Museum has received European funding to work with several overseas museums, including ones in Sweden and Germany, on ways of devising material for the Internet (Hawkey 1998). *Quest*, the Internet program that was developed in London, gives access to illustrations of and information about a number of specimens. It also enables dialogue about the specimens to be exchanged by Internet users. This program and examples of material developed in Sweden were shared during a seminar at the GEM annual conference. The session was appreciated for showing how overseas museums use the Internet and enabling participants to see the benefits of electronic links. Other projects have been assisted through the Museum Computer Network.[7]

Membership of international organisations

An indicator of the extent to which museum and gallery education services maintain international links is their membership of international organisations. Less than half of the education services in the sample were members of ICOM. National museums and galleries were most likely to be members, while university and independent museums were least likely (see Table 1). Reasons given for not being members of ICOM included the cost of membership and lack of awareness about the organisation. In contrast, university and independent museums and galleries were more likely to belong to international organisations that are particularly linked to the nature of their collections and interests. Such organisations included:

- Association of European Migration Institutions
- Association of European Open Air Museums
- European Network for Children's and Youth Museums
- International Institute for Art and the Environment
- International Standing Conference for the History of Education.

All of these organisations have provided useful networks for education staff who attend their conferences and meetings, although the contacts made have largely been confined to Europe. Where education staff have been members of ICOM-CECA, useful contacts have been made beyond Europe. Learning how museums and galleries develop education work in very diverse societies has provided new perspectives for reflecting on practice at home.

Visits abroad by education staff

Two-thirds of the museum and gallery staff in the sample have made visits abroad, in most cases either for individual study visits or to attend conferences. About a tenth of the staff in the sample made the visits during their holidays, sometimes with a few days added to their leave allocation. The great majority of visits were between two and fifteen days' duration. Three people were involved in longer visits, one as an intern for ten months, another on a three-month attachment and the third on a travelling fellowship for six weeks. One senior education officer, who is project leader for a new interactive museum exhibition, confirmed the importance of overseas visits by saying that 'you could not do your job if you had not been on overseas study visits'. Another head of education has a job description which requires research to be done, including comparative work abroad. Educators in the first year or two of their careers in museums or galleries were less likely to have

attached importance to overseas visits. However, awareness of the value of overseas visits needs to be encouraged and incorporated into future plans for professional development.

Study visits in the sample were of three types:

- focus on a specific theme, for example investigating an approach to learning
- visiting a particular type of museum
- a wide-ranging search for good ideas.

Most of the visits were made by individuals, although a few local authority and national museums and galleries funded visits by small teams, sometimes of educators alone and sometimes of educators with designers and architects who were part of the same project teams. This latter approach had the added advantage of clarifying aspirations and encouraging a united approach to the educational implications of new exhibitions and gallery spaces. Another group visit that included gallery educators made a two-week tour of Japanese art museums.[8] Features of successful study visits are given in Checklist 1 and ideas for making initial contact for study visits are given in Checklist 2. Staff from mainly national museums have also travelled abroad to give lectures, and in two instances staff from independent and local authority museums have either lectured or been involved in an artist's residency abroad.

For education staff who have not made work-related overseas visits (nearly half of the staff surveyed from local authority and half from university and independent museums and galleries), the two main reasons outlined were lack of funding and lack of time due to other professional and family priorities. In some local authorities there was the anomaly of a commitment to the promotion of international links but no support to museum and gallery staff wishing to make study visits or attend conferences abroad. Several educators noted that their museum or gallery sent exhibitions abroad accompanied only by directors or curators. In only two cases did educators travel abroad with an exhibition.[9] For smaller institutions, the reason given for not making overseas study visits was (in five cases) insufficient staffing to permit any one person to take time to go abroad.

Several sources of funding for international travel are available in the UK.[10] For example, the Museum and Gallery Commission's (MGC) International Travel Grants Scheme aims to 'promote longer-term contacts and mutual co-operation between UK and overseas museums and to enable museum and conservation professionals to maintain and develop their skill and knowledge'. However, since 1991 fewer than 5%

Checklist 1. Criteria for making the most of study visits

- Have clear aims about the purpose of a study visit, e.g. relate it to a particular issue or type of museum/gallery.
- Ensure that the visit reflects education policy objectives.
- Decide whether the purpose of the study visit is best served by going alone or with one or more colleagues.
- Identify the most useful contacts and places to visit (see 'Making initial contacts for study visits', Checklist 2).
- Secure funding. This may come in total or in part from your institution, through a travel grant or via self-funding (for example, a short study visit could be added to the end of a holiday).
- Decide how ideas, evidence and impressions will be recorded during the visit (for example by taking slides, photographs, taping your impressions or making notes).
- Allow time to hold discussions and observe work in progress.
- Generate ideas for future contacts with the people met during the visit. For example, they might be invited back to the museum or gallery. Otherwise, an exchange of educational resources or publications could be arranged or a joint project organised, such as the writing of an article or an exchange of children's work generated by an exhibition.
- Take examples of your institution's learning materials or evidence of programmes to share with hosts.
- Allow a little time to be a museum visitor and to enjoy other museums.
- Decide the most effective ways of sharing your findings, perhaps by giving a presentation to colleagues, circulating your report or writing a shorter version for publication.
- Plan how you will adapt and implement any ideas or practices seen during the visit.
- Decide how you will build on the contacts made.

of the people awarded MGC travel grants have been educators and only one of these educators is based in an independent museum. This reflects a lack of applications by museum educators rather than any trend for applications from educators to be unsuccessful. Travel awards offered by the Madeleine Mainstone Trust for study visits by museum and gallery educators to the Netherlands have similarly not attracted many

Checklist 2. Making initial contacts for study visits

Linking up with professionals in other countries might seem daunting initially, but there are many simple ways of finding the right contacts and getting in touch with them.

- Talk to colleagues who have been on visits to museums or galleries abroad.
- Check through journals or websites for good practice in the area which interests you.
- Access Internet networks.
- Meet overseas colleagues at conferences in your own country.
- If your museum or gallery does not already have its own linked institutions, contact colleagues in towns twinned with yours.
- Use ICOM-CECA networks.
- Ask the British Council for advice through their networks.
- Use agencies to arrange all or part of your visit according to your specifications. (Visits to the UK for educators outside the UK may be planned by the British Council. For visits to the USA, the Center for Museum Studies at the Smithsonian Institution or the US Information Service may offer similar help.)
- Visit museums or galleries when on holiday as this can sometimes identify places to which you want to return.

applications, even though the full cost of the visit is met. Unlike the MGC and Mainstone travel grants, the travel bursaries offered by GEM for the first time in 1998 attracted a good number of applicants. (See Appendix 2 for details of these and other travel awards.) Enterprising education departments whose own budgets did not cover the costs of overseas travel sought funding from a variety of sources including charitable trusts. Four main types of value were ascribed to the first-hand opportunities provided by international visits:

- widening horizons in general
- learning about different national outlooks and attitudes to education
- sharing problems and successes
- learning about good quality programmes, planning, research, buildings, facilities and materials in other national contexts.

A further spin-off in some cases was to promote the home museum or gallery and enhance its prestige abroad. Less quantifiable, but

nevertheless of considerable benefit, is the stimulation generated by meeting like-minded people and the challenge of absorbing new ideas. This is summed up by comments such as the following reflection on the value of a study visit abroad that was:

> *a rich source of information, fresh ideas and new perspectives; moreover it was a rare opportunity to stand back from day-to-day work and to provide time to experience, think and to be the recipient of ideas rather than the provider ... the inspiration and motivation engendered by the visit should not be underestimated, nor the importance of the visit as a reinvigorating experience (Dodd 1998).*

Evaluating international links in museum and gallery education

None of the institutions in the sample has evaluated its overall international links in terms of their purpose and value for museum and gallery education. However, in about a quarter of cases staff have evaluated, for example, particular projects with international links, and the international use of their collections or specific study visits. In some other instances institutions are aware of the importance of developing an international profile for their education services. The result of having little formal evaluation is that international links are not usually part of a consistent, overall vision for the institution as a whole or for the education service in particular. They are often spasmodic, ad hoc and undervalued.

In order to ensure that institutions make the most of opportunities for international contact, international links need to be incorporated into policies, forward plans and job descriptions, and then regularly evaluated. An evaluation of the use of a variety of international links can enable museums and galleries to increase the effectiveness of their education services by checking that:

- the expectation to develop international links is applied consistently across educational as well as curatorial aspects of museum and gallery services
- short- and long-term objectives for the education service enable international links to be fostered
- the full range of international links is being developed
- financial support for international links is obtained either from the museum or gallery's own budget or from an external agency
- the outcome of international links benefits both individual museum or gallery educators and the museum or gallery as a whole.

Here are some questions for starting an evaluation:

1. How does the museum or gallery incorporate the need for international links in its policies for exhibitions, education, publications, research, staff training and marketing?
2. Are these policies consistent across the different services?
3. Are the current short- and long-term objectives of the education service likely to promote international links?
4. Do job descriptions make clear the need to develop international links?
5. Which of the following international links are (a) well established, (b) in the process of being established or (c) not yet established by the education service:
 - creating and updating a website with details of the education service
 - accessing websites of overseas museums or galleries to see what types of education programmes and materials are offered
 - using e-mail to correspond with education staff in overseas museums and galleries
 - hosting visits by overseas museum and gallery educators
 - hosting overseas students as interns in the education service
 - exchanging publications with one or several overseas museum and gallery education services on a regular basis
 - attending conferences in the UK where speakers and/or other participants are from overseas
 - attending conferences overseas
 - arranging study visits overseas
 - arranging staff exchanges
 - undertaking lectures or consultancy work overseas
 - publishing articles or papers in overseas journals and books
 - maintaining a network of overseas contacts
 - being a member of ICOM-CECA.
6. How have international links been extended year-by-year?
7. How is funding arranged to support overseas contacts? Are staff aware of all the sources of funding locally, regionally, nationally and internationally?
8. Is sufficient time allocated for the development of international links?
9. How are the results of international links shared among education staff and the rest of the museum?
10. Are the countries with whom the museum or gallery is linked targeted specifically or the result of chance contacts?

Conclusion

Many successful museum and gallery education projects have been developed by educators who have learned from the experience of work in other countries. This learning has, in some cases, led to the adaptation of ideas, to joint working and to the avoidance of problems encountered elsewhere. The report on museum education which has stimulated much debate and positive action in the UK (Anderson 1997) was itself influenced by experiences of American museum educators (AAM 1992). The range of issues covered and the consultation that preceded the UK report owe much to liaison with American colleagues. New exhibition galleries (particularly those with interactive learning installations) have benefited from international links, as have efforts made to attract new audiences and respond to the needs of all possible visitors. The intellectual stimulation of established museum and gallery educators has also been a positive outcome of such links.

The research on which this chapter is based shows a lack of consistency about the commitment to establishing and sustaining these international links. The type of museum or gallery, be it local authority, independent, university or national, can influence whether a particular type of link exists. The determination of individuals also has a part to play in finding time and funding to start making contacts with colleagues abroad. Where educators have developed international links through the Internet, membership of associations such as ICOM-CECA, face-to-face meetings and visits to see the educational work of museums and galleries in other countries, their own work has been enriched and their institutions have benefited from the application of new ideas and information. All museums and galleries need to consider the extent to which they are taking full advantage of international links for their education work and build this into their policies, forward plans and evaluations.

Key points

- Just as learning in general is helped by making comparisons, so the whole range of education in museums and galleries benefits from the insights gained by developing international contacts to exchange ideas, information and skills.

- Ways of developing international links in museum and gallery education include acting as host to international visitors, using the Internet, joining international associations and

making study visits abroad. All museums and galleries, whatever their type, need to take full advantage of these links.

- Experiences gained from international contacts, especially visits abroad by museum and gallery educators, have brought about improvements in the educational input of exhibition planning, associated resources and programmes. They have also been a valuable source of professional stimulus in the careers of educators.

- To increase the effectiveness of their education services, museums and galleries need to evaluate their use of a variety of international links with a view to making systematic efforts to benefit from as wide a selection of such links as possible.

Notes

1. See, for example, Gesché (no date).
2. A paper prepared for a colloquium which contributed to this publication provides a detailed background. See Ambrose (1997).
3. The selection of institutions, a form of purposive sampling (Cohen and Manion 1994), was made from museums and galleries throughout the UK and included the following types: local authority (22); independent (18); national (12); university (8). In 90% of cases, interviews were held with education specialists. For the 10% of museum and gallery services that did not have education officers, interviews were held with staff responsible for education, including two directors and two curators. A third of the people who were asked to participate in this research were known to have international links. All of the people contacted agreed to participate and are thanked for their help.
4. An example of a group visit arranged after contacts were made by individuals is outlined in Paterson (1993). Visits made under British Council auspices are described in a newsletter for alumni issued by the British Council's Northern Ireland office (British Council 1998).
5. One example of how a visit by an American educator specialising in access issues contributed to training in the UK and to a publication is given in Pearson and Aloysius (1994).
6. This list is based on a workshop at the GEM conference in 1998 led by M. Bazeley of the Science Museum and on the ICOM Guide to the Internet for Museums, available at website <http://www.icom.org/-brochure.html>. An example of a website with news of current educational research is <http://www.pz.harvard.edu>. A website with

access to news of conferences is <http://www.listproc@mtn.org.>, while a website with a directory of online museums is <http://www.-icom.org/vlmp/>. For examples of galleries using the Internet see *engage* (5), Autumn 1998.

7. For details of the Museum Computer Network, see <http://www.world.std.com/~mcn/activities.html>.
8. For a description of the visit and discussion of issues raised, see Godfrey (1998).
9. One of these visits is described in Freshwater (1997).
10. Apart from sources of funding listed in Appendix 2, grants are available for joint projects from the European Commisson. Details are available from Euclid (see Appendix 3).

Key texts

Murray Thomas, R. (ed.) (1990). *International Comparative Education*. Pergamon Press.
This thorough review of comparative education, although focusing on the formal education sector, has many sections, such as one on research, which are applicable to museum and gallery education.

Pearson, A. and Aloysius, C. (1994). *The Big Foot: Museums and Children with Learning Difficulties*. British Museum Press.
As well as describing a project developed at the British Museum, this publication draws on longer-established work in the USA. Educators there have much experience of working with children and adults with a range of physical and learning disabilities. The sharing of results of this experience at a series of seminars and conferences in the UK, coupled with visits to the USA by UK-based educators to learn about the work at first hand, benefited the programme at the British Museum and other education initiatives in the UK.

Bibliography

AAM (1992). *Excellence and Equity: Education and the Public Dimension of Museums*. American Association of Museums.
Ambrose, T. (1997). *Britain and Abroad: Examples and Opportunities*. Victoria and Albert Museum.
Anderson, D. (1997). *A Common Wealth: Museums and Learning in the United Kingdom*. Department of National Heritage.
British Council (1998). *AlumNI Newsletter*.
Board of Education (1931). *Memorandum on the Possibility of Increased Co-operation Between Public Museums and Public Educational Institutions*. HMSO.

Cohen, L. and Manion, L. (1994). *Research Methods in Education*, 4th edn. Routledge.

Dodd, J. (1998). *Report re. Museums and Galleries Commission Travel Grant: Study Visit to North Eastern USA 23 March–5 April 1998*. Unpublished and held by the Museums and Galleries Commission.

Durbin, G. (ed.) (1996). *Developing Museum Exhibitions for Lifelong Learning*. The Stationery Office.

Freshwater, T. (1997). Postcard from Mombasa: toys on tour. *ICOM UK News* (48), 14.

Gesché, N. (ed.) (no date). *Museum Education Towards 2000*. ICOM-CECA.

Godfrey, F. (1998). Practice in an absence of policy: Japanese art museums and their education programmes. *engage* (4), 28–30.

Hawkey, R. (1998). Exploring and investigating on the Internet: virtually as good as the real thing? *Journal of Education in Museums* (19), 16–19.

Heisen, G. and Adams, D. (1990). Comparative educational research. In Murray Thomas (see Key texts).

MGC (1999). *Wish You Were Here: International Travel Grants from the MGC*. Museums and Galleries Commission.

Paterson, I. (1993). The Stockholm–Yorkshire exchange. *Journal of Education in Museums* (14), 28.

Appendix I GLOSSARY

The following definitions explain how various terms are used in this book. They are provided to aid clarity of understanding, rather than to suggest that they are the only ways in which the terms could be used.

Access
The process of enabling all potential museum and gallery visitors to have physical, intellectual, cultural and emotional access to the collections and to their interpretation, as well as physical access to the general facilities provided for members of the public.

Action plan
Outlines the long- and short-term goals needed to deliver an education policy and the strategies to be used to achieve those goals.

Advocacy
Promotion of museum and gallery education among and beyond museum and gallery staff through, for example, meetings, conferences, campaigns and publications to raise the profile of this aspect of museums' and galleries' work.

Area Museum Councils
These are middle-tier organisations in the UK which provide a range of services and training to museums in their area. They receive funding from the government through the Museums and Galleries Commission and from subscriptions from the museums themselves.

Audience
Either the totality of users of museums and galleries (either as visitors or as those who use services and resources offsite, for example, websites) or specific sections of the general public, both actual and potential visitors, which the museum or gallery wishes to target for particular exhibitions or activities.

Audience advocate
Working in the museum or gallery in general and exhibition teams in particular, an audience advocate 'helps to improve the general experience of the museum including facilities for physical comfort; spatial and intellectual orientation; varieties of pace, style and communicative approaches of successive displays within the building; and the interaction between the museum staff and the public' (Hooper-Greenhill, E. (1991). Museum and Gallery Education. Leicester University Press, pp. 191–2).

Audience development

Marketing and education professionals use this term to describe the programming of activities and information which will increase audience interest and visits. The term is used in a variety of contexts which can emphasise one or all three of the following interpretations:

- developing new audiences for museums as a whole (understood to be non-typical museum goers such as socially excluded groups and members of minority ethnic groups)
- providing clear learning pathways to develop existing audience knowledge, skills and understanding in a particular area, for instance in local history, bird watching or history of art
- introducing existing audiences to other art forms, for example by using theatre, music or dance in a museum setting.

Constructivism

'Constructivist learning situations require learners to use both their hands and minds to interact with the world: to increase their understanding about the phenomena with which they are engaged. Constructivism also postulates that conclusions reached by the learner are not validated by some external standard of truth but only within the experience of the learner' (Hein and Alexander 1998: 36–7).

Continuing professional development

An individual's plan for their professional progress in terms of the acquisition of skills, knowledge and experience in the workplace. It can be done independently or contribute towards a recognised award by a national professional body.

Core function

A function of museums and galleries, such as education, that is fundamental to their existence and is given appropriate status and funding.

Core funding

The allocation of part of the main budget of a museum or gallery to an essential function, such as education.

Education

The process of enabling people to learn from collections through the interpretation and programmes provided or through making their own meanings by drawing on memories, emotions and opinions. Formal education implies that the agenda for learning is established by an institution, while informal education allows individuals to determine

their own priorities and choose their own styles of learning. Museums and galleries can offer both these types of education.

Education policy
With specific reference to education, 'a policy is a statement of principle, endorsed by the museum's or the gallery's governing body, which guides the development of a detailed action plan' (MGC 1996: 7).

Evaluation
In general, evaluation provides feedback about the level of success achieved by the whole museum or gallery education service, or some specific part of it, when measured against clearly defined criteria, with a view to seeing if original intentions have been achieved and to bringing about any necessary improvement. Evaluation can be of various types: 'Front-end analysis takes place during the pre-planning and planning stages. It is conducted with the intention of identifying potential problems ... Formative evaluation takes place during the implementation of plans with the intention of providing directional guidance while work is in progress.' Summative evaluation takes place at the end and can be carried out, for example, through questionnaires. (Bull, P. (1998). A beginner's guide to evaluation. *Environmental Interpretation* July 1998.)

Handling collection
A collection of real or replica items that is made available in museum or gallery exhibition areas or which can be part of loan collections used for outreach work. The key element of handling collections is that there are no restrictions on touching the contents, although gloves may be provided in some cases.

Interactive
'The user must perform some kind of action to engage with the exhibit to which the exhibit will respond. Different kinds of actions elicit different responses from the exhibit.' Acton Discovery Museums' definition published in Pearce, J. (1998). *Centres for Curiosity and Imagination.* Calouste Gulbenkian Foundation, p. 29.

Learning society
A learning society creates conditions where everyone can have access to and be supported in both formal and informal opportunities to learn.

Lifelong learning
The view that learning is a process which continues throughout life and

which encourages all individuals to benefit from both formal and informal education.

Mission statement

A brief summary of a museum's or gallery's purpose, underpinning the development of all policies. The following example is from Te Papa Tongarewa, the Museum of New Zealand: 'The Museum's mission is to provide a national forum for presenting, exploring and preserving our cultural heritage and knowledge of our natural environment so we can better understand and treasure the past, enrich the present and meet the challenges of the future.' Larger museums and galleries sometimes develop specific mission statements for their education service, such as this one from the British Museum education service: 'The Education Service aims to make the Museum and its collections more accessible, providing training and events and producing material that contributes to a better experience for all visitors.'

Museums and galleries

In the UK, the definition of museums is that they are, in the main, buildings which contain collections for the public benefit. In the narrowest sense, the term 'gallery' may describe a space where modern and contemporary art collections are displayed; in a broader sense the term includes buildings which hold collections of historic works. These are often referred to as 'art museums'. The definition given by the International Council of Museums is broader and describes a museum as 'a non-profitmaking permanent institution in the service of society and its development, and open to the public, which acquires, conserves, researches, communicates and exhibits, for the purposes of study, education and enjoyment, material evidence of people and their environment'.

National Grid for Learning

Developed by the UK government, the National Grid for Learning is both a structure of educationally valuable content on the Internet and a programme for developing the means to access that content in, for example, schools, libraries, higher education institutions and work-places. With the arrival of digital, interactive broadcasting, the content will also become accessible on television sets. Further details can be obtained from the website <http://www.ngfl.gov.uk>.

Outreach

Activities which take place outside the museum or gallery. It implies that the activities target groups who, for a number of reasons, are less likely

to visit the museum or gallery. Outreach therefore increases opportunities for access to the museum's or gallery's collections.

Partnerships
These can be of several types, ranging from the setting up of networks to share ideas and information on specific topics to the exchange of staff and/or exhibitions. The whole of issue 17 of the *Journal of Education in Museums* (1996) focuses on a variety of partnerships in museum and gallery education.

Pilot project
An opportunity to trial or test a particular approach, such as an education programme, with a view to making any necessary modifications before establishing it as part of mainstream provision.

Placement
A placement is when an individual (such as a student or staff member) comes to the museum or gallery to carry out unpaid work for an agreed amount of time. The aim is to offer opportunities for work in a professional environment in order to develop skills and knowledge. Placement can be a part of continued professional development or of pre-entry training.

Programme
A group of activities for the public which follows a theme or takes place over a specific period of time. The term is used increasingly to describe all the activities carried out by an education department for all its audiences.

Study visit
This is one of many ways in which an individual can develop professionally. Study visits can be financed by the museum or gallery, or through grants, and allow individuals to visit one or a number of museums and galleries or related organisations by themselves or with other colleagues. The aim of the visit may be to pursue research, to note exhibition and education techniques or to interview individuals in the organisation about their philosophy and practice.

Appendix 2 EXAMPLES OF SOURCES OF FUNDING FOR OVERSEAS VISITS

Association of Independent Museums (AIM), Bob Harding Fund
c/o R. Shorland Ball, 216 Mount Vale, York YO2 2EL, UK
This fund contributes to the cost of attending training, including that held in venues abroad. The grants are for members of AIM, or for individuals who work for a member institution.

Churchill Travelling Fellowships
Winston Churchill Memorial Trust, 15 Queen's Gate Terrace, London SW7 5PR, UK
Provides travelling fellowships for different categories of professionals each year. Funding covers travelling expenses and living accommodation for up to eight weeks. Contact the organisation for details of specific categories each year.

Fellowships in Museum Practice
Center for Museum Studies, Arts and Industries Building, Suite 2235, 900 Jefferson Drive SW, Smithsonian Institution, Washington, DC 20560-0427, USA
The Smithsonian Institution funds short-term research via the fellowship programme, usually through attachment to one of its constituent museums.

Group for Education in Museums (GEM)
Membership enquiries, PO Box 988, Aylesford ME20 6AL, England
GEM offers one annual travel bursary of up to £1000 and one annual research bursary of up to £2500 (which may include travel) to its members. One of the main criteria for awarding these bursaries is that the work undertaken by the selected individuals must benefit GEM members generally. The funding can cover all the costs of an overseas study visit.

International Council of Museums (ICOM)/UK travel bursaries
c/o E. Sansom, SEMS Office, The Garden Room, Historic Dockyard, Chatham ME4 4TE, UK
These bursaries contribute to the cost of attending ICOM conferences abroad. They are for members of ICOM, or for individuals who work for a member institution. A post-visit report is required.

International Partnerships among Museums (IPAM)
Department of International Programs, 1575 Eye Street NW, 4th Floor, Washington, DC 20005, USA
IPAM enables museums in the USA and other countries to develop joint projects and assists a staff member from each institution to carry out

month-long visits to their partner museums. Museums of any size and discipline in the USA and abroad may participate.

Madeleine Mainstone Travel Bursary
c/o D. Anderson, Victoria and Albert Museum, Cromwell Road, London SW7 2RL, UK
This award is offered annually for either a UK-based museum educator or a Netherlands-based one. The bursary covers the full costs of travel and accommodation to the Netherlands or the UK. A post-visit report is required.

Museums and Galleries Commission (MGC)
16 Queen Anne's Gate, London SW1H 9AA, UK
Established in 1991, the travel grants pay up to £300 for travel in Europe and £500 for travel elsewhere although, in both cases, no more than half the total costs are provided. All recipients of MGC travel grants must produce reports of approximately 1500 words.

Appendix 3 USEFUL ADDRESSES

International
Council of Europe, Cultural Heritage Department, F-67075 Strasbourg
 Cedex, France.
European Commission, rue de la Loi 200, B-1049 Brussels, Belgium;
 website <http://www.europa.eu.int/comm/>.
International Council of Museums (ICOM), Maison de l'UNESCO, 1
 rue Miollis, 75732 Paris Cedex 15, France; website
 <http://www.icom.org> (this website also gives details of ICOM's
 international committees such as CECA and ICTOP).

Sweden
FUISM, Swedish Group of Education in Museums, c/o Secretary,
 Blekinge Museum, PO Box 111, S-371 22 Karlskrona.
The Swedish Institute, Box 7434, S-103 91 Stockholm.

UK
British Council, 10 Spring Gardens, London SW1A BN; website
 <http://www.britcoun.org/uk/>.
engage, 1 Herbal Hill, Clerkenwell, London EC1R 5EJ; website
 <http://www.engage.org>.
Euclid, 1st floor, 46–8 Mount Pleasant, Liverpool L3 5SD; website
 <http://www.euclid.co.uk>.
Group for Education in Museums (GEM), Membership enquiries,
 PO Box 988, Aylesford ME20 6AL; website
 <http://www.gem.org.uk/>.
Museums and Galleries Commission (MGC), 16 Queen Anne's Gate,
 London SW1H 9AA; website <http://museums.gov.uk>.
National Institute of Adult and Continuing Education, 21 De Montfort
 Street, Leicester LE1 7GE; website <http://niace.org.uk>.

USA
The Getty Center for Education in the Arts, 401 Wilshire Boulevard,
 Suite 950, Santa Monica, CA 90401-1455; website
 <http://www.artsednet.getty.edu>.
United States Information Agency, 301 4th Street SW, Washington DC
 20547; website <http://www.usia.gov>.

Institutions whose staff contributed to the manual
The Artists House, 12 Shmuel Hanagid Street, Jerusalem.
Auckland Museum, Private Bag 92018, Auckland, New Zealand.
Canadian Museum of Civilisation, 100 Laurier Street, PO Box 3100,
 Station B, Hull, Quebec, Canada.

City University, Department of Arts Policy and Management, Level 7, Frobisher Crescent, Barbican, Silk Street, London EC2Y 8HB, UK.

Kiasma Museum of Contemporary Art, Kaivokatu 2, 00100 Helsinki, Finland.

Horniman Museum and Gardens, London Road, Forest Hill, London SE23 3PQ, UK.

The Ruth Youth Wing, The Israel Museum, PO Box 71117, Jerusalem 91710, Israel.

Lawrence Wilson Art Gallery, The University of Western Australia, Nedlands, Perth, Western Australia 6907.

Museo Nacional de Colombia, Carrera 7 No 28-66, Santafé de Bogotá, Colombia.

Museum Boijmans Van Beuningen, Museumpark 18–20, Postbus 2277, NL-3000CG, Rotterdam, The Netherlands.

National Museums, Monuments and Art Gallery, Private Bag 114, Gaborone, Botswana.

Natural History Museums and Botanical Garden, University of Oslo, Sars gt. 1, N-0562 Oslo, Norway.

Reinwardt Academie, Dapperstraat 315, 1093 BS Amsterdam, The Netherlands.

South Australian Museum, North Terrace, Adelaide, South Australia 5000.

South Eastern Museums Education Unit (SEMEU), 3rd Floor, Unit 15, Docklands Enterprise Centre, 11 Marshalsea Road, Southwark, London SE1 1ET, UK.

Umetnostna Galerija Maribor, Strossmayerjeva 6, 2000 Maribor, Slovenia.

The Vasa Museum, PO Box 27 131, S-102 52 Stockholm, Sweden.

Appendix 4 SELECT BIBLIOGRAPHY

This bibliography combines all the references included in the key text sections at the end of each chapter. The chapter number is given after each reference so that the reader can refer to the annotated version if wished.

AAM (1992). *Excellence and Equity: Education and the Public Dimension of Museums.* American Association of Museums. (Chapter 10.)

Anderson, D. (1997). *A Common Wealth: Museums and Learning in the United Kingdom.* Department of National Heritage. New edition (1999) available from The Stationery Office. *A Common Wealth. Museums in the Learning Age.* (Chapters 1 and 11.)

Channel 4 Education (1995). *Using Museums.* (Video with accompanying teachers' booklet.) (Chapter 5.)

Côté, M. and Viel, A. (eds) (1995). *Museums: Where Knowledge is Shared / Le Musée: lieu de partage des savoirs.* Canadian Museum Association and Société des Musées Québécois. (Chapter 3.)

David, R. (1996). *History at Home.* English Heritage. (Chapter 7.)

Davies, S. (1994). *By Popular Demand: A Strategic Analysis of the Market Potential for Museums and Art Galleries in the UK.* Museums and Galleries Commission. (Chapter 2.)

Davies, S. (1996). *Producing a Forward Plan: MGC Guidelines for Good Practice.* Museums and Galleries Commission. (Chapter 2.)

Delors, J. (1996). *Learning: The Treasure Within.* UNESCO. (Chapter 8.)

Delacôte, G. (1996). *Savoir apprendre: les nouvelles méthodes.* Éditions Odile Jacob. (Chapter 3.)

DCMS (1998). *The Comprehensive Spending Review: A New Approach to Investment in Culture.* Department for Culture, Media and Sport. (Chapter 11.)

Dodd, J. and Sandell, R. (1998). *Building Bridges: Guidance for Museums and Galleries on Developing New Audiences.* Museums and Galleries Commission. (Chapter 2.)

Durbin, G. (ed.) (1996). *Developing Museum Exhibitions for Lifelong Learning.* The Stationery Office. (Chapters 2 and 9.)

Durbin, G., Morris, S. and Wilkinson, S. (1990). *A Teacher's Guide to Learning from Objects.* English Heritage. (Chapters 4 and 6.)

Falk, J. H. and Dierking, L. (1992). *The Museum Experience.* Whalesback Books. (Chapter 3.)

García Canclini, N. (1990). *Culturas híbridas: estrategias para entrar y salir de la modernidad.* Grijalbo. (Chapter 8.)

Giroux, H. (1993). *Border Crossings: Cultural Workers and the Politics of Education.* Routledge. (Chapter 5.)

Glasser, J. and Zenetou, A. (1996). *A Place to Work: Planning Museum Careers.* Routledge/Smithsonian. (Chapter 10.)

Harris Qualitative (1997). *Children as an Audience for Museums and Galleries.* Arts Council and Museum and Galleries Commission. (Chapter 7.)

Hein, G. E. (1998). *Learning in the Museum.* Routledge. (Chapter 3.)

Hein, G. E. and Alexander, M. (1998). *Museums: Places of Learning.* American Association of Museums. (Chapter 1.)

Hooper-Greenhill, E. (ed.) (1994). *Museums and their Visitors.* Routledge. (Chapter 8.)

Hooper-Greenhill, E. (ed.) (1996). *Improving Museum Learning.* East Midlands Museum Service. (Chapter 9.)

Hooper-Greenhill, E. (ed.) (1997). *Cultural Diversity: Developing Museum Audiences in Britain.* Leicester University Press. (Chapter 5.)

Hooper-Greenhill, E. (ed.) (1999). *The Educational Role of the Museum* (2nd edition). Routledge. (Chapter 8.)

Israel Museum (1991). *Stork, Stork How is our Land?* (Chapter 6.)

Johnson, G. and Scholes, K. (1993). *Exploring Corporate Strategies.* Prentice-Hall. (Chapter 2.)

Karp, I. and Lavine, S. (eds) (1991). *Exhibiting Cultures. The Poetics and Politics of Museum Exhibition.* Smithsonian Institution Press. (Chapter 8.)

Karp, I., Mullen, C. and Lavine, S. (eds) (1992). *Museums and Communities: The Politics of Public Culture.* Smithsonian Institution Press. (Chapter 8.)

Kilgour, E. and Martin, B. (1997). *Managing Training and Development in Museums: A Guide.* The Stationery Office/Scottish Museum Council. (Chapter 10.)

Moffat, H. and Woollard, V. (1996). Reflections on a course for museum and gallery educators. *GEM News* (63), 7–9. (Chapter 1.)

Murray Thomas, R. (ed.) (1990). *International Comparative Education.* Pergamon Press. (Chapter 12.)

MGC (1996). *Managing Museum and Gallery Education.* Museums and Galleries Commission. (Chapter 11.)

Pastor Homs, M. (1992). *El museo y la educación en la comunidad.* CEAC. (Chapter 8.)

Pearson, A. and Aloysius, C. (1994). *The Big Foot: Museums and Children with Learning Difficulties.* British Museum Press. (Chapter 12.)

Programma de naciones unidas para el desarrollo (PNUD) (1998). *Educación: La agenda del siglo XXI: hacia un desarrrollo humano.* Tercer Mundo Editores. (Chapter 8.)

Savater, F. (1997). *El valor de educar.* Ariel. (Chapter 8.)

Wahl, M. and Nordqvist, S. (1995). *The Vasa Sets Sail – Fantasy and Facts about a Ship and her Day.* Bonnier/Carlsen. (Chapter 4.)

Waterfall, M. and Grusin, S. (1989).*Where's the ME in Museum? Going to Museums with Children.* Vandamere Press. (Chapter 7.)

Wilkinson, S. (1997). *Education Basics: A Training Manual for Preparing Curators to Develop their Education Work.* Committee of Area Museum Councils. (Chapter 2.)

Wood, R. (1995) Museums, means and motivation: adult learning in a family context. In **Chadwick, A. and Stannett, A.** *Museums and the Education of Adults.* National Institute of Adult and Continuing Education, pp. 97–102. (Chapter 7.)

Appendix 5 OUTLINE OF THE 1997 BRITISH COUNCIL SEMINAR

This appendix lists the sessions in the 1997 seminar, entitled 'Towards an education policy for art galleries and museums'.

Day 1: Setting the scene
- Mission statements – clarity or confusion?
- Mission statements from delegates' own museums and the position education has within their organisations.
- Current issues in the UK today.
- Viewing of delegates' displays of educational material.

Day 2: The visitor – actual and potential
- Lecture: Involving new audiences.
- Seminar groups focusing on specific audience groups: adults, families and minority groups.
- Choice of visits to museums and galleries which have examples of innovative work in developing audiences.

Day 3: Collections and interpretation
- Lecture: Collections and exhibitions for learning.
- Seminar groups focusing on different forms of interpretation: drama, interactives, school activity sheets and gallery activities.
- Choice of visits to museum and galleries which have examples of innovative work in interpretation.

Day 4: Evaluation
- Lecture: Evaluating the visitor.
- Gallery observation.
- Choice of visits to museums and galleries which have examples of innovative work in evaluation.

Day 5: Writing a policy
- Workshop on writing a policy.
- Case study: Policy and reality.

Day 6: Museum and gallery education and its future
- Course feedback.
- Lecture: the future.

Appendix 6
Breda K. Sluga
Maribor
Art Gallery

REFLECTIONS ON THE 1997 BRITISH COUNCIL SEMINAR AND THE 1998 GEM CONFERENCE

The Maribor Art Gallery (Umetnostna galerija Maribor) was founded in 1954 in the historic city of Maribor. The basis of the gallery is the collection of about 2200 Slovenian works of art from the late 19th century to the present, thereby encompassing modern and contemporary art. In recent years, great emphasis has been put on artists from the north eastern part of Slovenia. The gallery organises 20 to 30 exhibitions each year, which are accompanied by learning resources, documentation and education programmes. The most famous gallery project is the triennial exhibition on ecology and art.

I was asked to comment on my attendance at a British Council seminar in London in 1997 and a Group for Education in Museums (GEM) conference held in conjunction with ICOM-CECA in York in 1998. Both were well organised with many positive features, but here I will try simply to outline some problems which emerged during my stays in the UK and which should be useful for future work.

Increasing importance is being given to education in Slovenia. Our gallery has accepted the need to develop a new education department, and we started this development in the autumn of 1996. After our first experiences we decided to examine our ideas. Education officers in Slovenia are quite well organised but in a small country like ours there are very few art galleries and we cannot exchange advice and information about our specific experiences. Consequently, the British Council's seminar, 'Towards an education policy for art galleries and museums' was a timely opportunity for such exchanges. Valuable experiences gained at this seminar in the autumn of 1997 led the gallery to send me to the GEM conference in York in September 1998.

The cost of the seminar in London was very high, although good organisation meant that it was worth the money. The conference in York was less expensive. I was fortunate that the gallery was able to cover the costs of both because it was impossible to find other financial support in the short time between information about the seminar and conference arriving and the events themselves. It would be helpful, in future, if such information could be disseminated among museums and galleries much earlier.

I am more conscious now of the value of the British Council seminar than I was during the seminar itself. Then, it seemed that there were too

many institutions doing work that was different from ours and with whom information could not be exchanged. But after the short-lived impatience of somebody who had travelled so far and had to pay a lot (and because I wanted to learn much and acquire useful information), I found out that there were far more experiences to share than I had realised. A year after the seminar many concrete ideas and working models from contemporary art galleries and other, very different museums, have been transferred to my work.

On my return from the seminar, I asked gallery staff what our aims should be and then analysed what we were capable of doing and developed the approach, staff and finances to make these decisions real. The clarity of aims and the way of working I learned in the seminar. The second part of the seminar was based on visiting museums and galleries and talking with colleagues: the simple idea of meeting people with whom ideas could be shared. This has also remained vivid in my memory since the seminar. The main problem with implementing change has arisen from the organisation of my duties at the gallery. I am a curator as well as an educator, so the work on education developed slowly.

One year passed very quickly and the date for the conference in York arrived. This conference was held in conjunction with ICOM-CECA in Europe and I expected members from other countries to attend. My aim in attending the York conference was to meet more educators in art galleries. I was very disappointed when I found out that I was one of the few European delegates and that there were not many delegates from art galleries. As a result, the conference focused largely on problems faced by museums and galleries in the UK. While they are not so far removed from more general problems, this focus showed the underlying thinking in the planning of the conference. As an observer in this context, I believe the delegates gained much specific knowledge and inspiration and it was good, anyway, to meet other professionals. However, this experience showed me that it is sometimes more useful to attend conferences for specialist groups, such as those dealing with contemporary art, in order to discuss the group's common problems.

Many people asked me what benefit I had from a lecture on how to apply for Lottery funding, and I have to admit that it was no benefit at all as far as applying for money is concerned. However, there was some relevance for my country. I was surprised to see the kind of projects that could be funded by the Lottery and to hear the questions raised about its purpose and the problems which might emerge in the future. In this sense I felt like a participant and not simply an observer; this was also

true when other matters were discussed. Generally, I learned more about how to organise and the ability to be clear and specific than about patterns for work in the gallery. I shall apply both of these skills in my work.

Index